PUNCTUATE
IT RIGHT!

PUNCTUATE IT RIGHT!

SECOND EDITION

HARRY SHAW

HarperPerennial
A Division of HarperCollins Publishers

HarperCollins books may be purchased for educational, business, or sales promotional use. For information, please call: Special Markets Department, HarperCollins Publishers, Inc., 10 East 53rd Street, New York, NY 10022.

FIRST EDITION

Library of Congress Cataloging-in-Publication Data
Shaw, Harry, 1905–
 Punctuate it right! / Harry Shaw.—2nd ed.
 p. cm.
 Includes bibliographical references and index.
 ISBN 0-06-461045-4
 1. English language—Punctuation. I. Title.
 PE1450.S45 1993
 428.2—dc20 92-8352

93 94 95 96 97 PS/RRD 10 9 8 7 6 5 4 3 2 1

CONTENTS

GLOSSARIES

FOREWORD

Punctuation and spelling apparently cause more people more trouble than any other aspect of writing with the possible exception of what is loosely known as "grammar." Both are somewhat mechanical and superficial phases of writing, nowhere near so important as having something significant to say and a genuine interest in saying that something, whatever it is. But neither punctuation nor spelling can be neglected because they have a direct bearing upon success or failure in communicating ideas from writer to reader—the primary aim of writing—and because errors in either one unfairly, and all too often, reflect adversely upon a writer's intelligence, knowledge, and social standing.

In another work,[1] I have done what I can to help with the pesky problem of spelling; in this, my aim is to provide helpful comment on all the marks of punctuation and mechanics which are likely to confront you in reading and which you may need in any writing of whatever kind you do. In fact, this book includes discussion and illustration of many marks which, properly speaking, are not matters of either punctuation or mechanics but are closely allied to each. It is, I believe, the most comprehensive work on punctuation ever designed for the general reader and writer; obviously, it is less bulky than books assembled for the guidance of such professional workers as copyreaders, copy editors, and printers.

[1] *Spell It Right!*, HarperCollins, 1993.

Much that it contains is based upon problems which I have encountered over the years in the usages of fellow workers in various offices and in the manuscripts which, as an editor, I have been reading for more than two decades. These studies have been supplemented by wide reading in contemporary magazines, newspapers, and books in an attempt to discover not what *should* be considered correct punctuation but what *is* actually being used in reputable publications. All of my findings have been compared to, and contrasted with, the suggestions of several excellent works of importance and distinction:

A Manual of Style, 13th ed. The University of Chicago Press, 1982.
Manual of Style and Usage, The New York *Times*, 1976.
Skillin, M. and Gay, R., *Words into Type*, 3rd. ed. 1986.
Style Manual of the United States Government Printing Office, revised edition, 1986.
Summey, Jr., George, *American Punctuation*, 1949.

These authoritative, superbly prepared books do not always agree with each other, but there is far more agreement than might be expected about so involved a subject as punctuation. When differences of opinion occur in these works, or where modern publication practices seem to differ, I have tried to suggest the more prevalent usage, the most generally accepted "rules," but have been careful to call your attention to these variations.

As you begin, or renew, your study of punctuation, always keep in mind that punctuation at times is simple, clear, and unchanging in its applications. But you must be equally sure to remember that punctuation, like spelling, is not always and uniformly subject to precise and unvarying rules. It is often illogical; common sense will not always be your salvation; certain punctuation practices are matters of convention, nothing else. And yet, punctuation is of basic importance in writing; it is truly organic, a genuine part of writing. Edgar Allan Poe was hardly exaggerating when he said: "Even where the sense is perfectly clear, a sentence may be deprived of half its force—its spirit—its point by improper punctuation."

In routine correspondence, and particularly in business affairs,

proper punctuation often has an importance out of proportion to the worth of ideas being expressed. Occasionally, however, you simply *must* punctuate correctly in order to communicate without error and without distortion. An 18th-century English writer once said: "Method is the very hinge of business; and there is no method without punctuality." The statement can be rephrased and expanded without too much stretching of the truth: "Method is the very hinge of business; and there is no method in business correspondence without proper punctuation." Whatever your writing *business* is—an informal letter, an order from a catalog, an application for a job, a tender missive to your beloved—make sure that your punctuation is working for and not against you. Doing so is easier than you may think.

H.S.

INTRODUCTION:

WHAT PUNCTUATION IS AND DOES

PUNCTUATION IS
FOR CLARITY

When you talk you do not depend upon words alone to tell your listener what you mean. Facial and body gestures can and do add much to the words themselves: you shrug a shoulder, wiggle a finger, raise an eyebrow, wink, clasp hands, bend forward or backward, grin or grimace, stamp your foot, nod or shake your head. The tone and stress of your voice can and do influence the meanings of words you speak: you yell or whisper; speak calmly or angrily; lower or raise your voice at the end of a statement or a question. Meaning in talk is affected by pauses and halts, which are often as significant as words themselves. Each of us has probably seen a skilled actor convey ideas and moods without using any words at all.

Similarly, when we write we cannot expect words alone to make clear to our reader what we have (or think we have) in mind. The pauses, stresses, and inflections which occur in speech must be represented in writing by various marks of punctuation if meaning is to be fully clear. The needs of the eye are quite different from those of the voice and ear.

Punctuation came into existence solely for the purpose of making clear the meaning of written words. Every mark of punctuation is a sort of shorthand device or road sign provided to help the reader along his way. Punctuation is effective if it helps the reader to understand; it is harmful or ineffective if it impedes the flow of thought from your mind to that of your readers.

Consider the matter this way: a question mark in writing is related to the rising inflection in one's voice when he asks a

question. The mark indicates to the reader, "You have just read a group of words which should be interpreted as a question." An exclamation point conveys an idea of surprise or determination or command that would be indicated by a strongly emotional tone in speaking. A period represents the pause that occurs in speaking when one idea has been stated and another is perhaps to be expressed; it signals to the reader, "What you have just read is a statement, a sentence or sentence-equivalent." A comma indicates a shorter pause than a period or question mark or exclamation point or, indeed, than several other marks of punctuation. Proper punctuation is essential to clear, correct, effective writing because it actually and realistically helps to express thoughts and the relationships of thoughts.

When you listen to conversation, you know who is speaking at any given moment, but when you read an account of such a conversation, the dialogue must be properly set off in paragraphs and the talk put between quotation marks if it is to be clear and meaningful. When you wish to refer in conversation to "a man's hat," you don't say *a man apostrophe s hat*, but when you write the phrase that is precisely what you convey: *a man's hat*. We say *mans*, but if we wrote the word that way we would be thought childish, or ignorant, or both.

Again, the relationship between parts of a sentence is revealed by word order; words in an English sentence have meaning largely because of their position. But word order in both spoken and written English is flexible and can be widely varied. *Beyond the door* and *the door beyond* may have quite different meanings. "*The door beyond* could be plainly seen, half open" is a clear and correct sentence. But what about "*Beyond the door* could be plainly seen, half open"? Note that the addition of a mark of punctuation will make the meaning of this second sentence instantly clear: "Beyond, the door could be plainly seen, half open."

In written English, various marks of punctuation both suggest and indicate the grouping and relationship required to convey meaning clearly. That is, punctuation shows what to take together and what to separate in quick, silent reading; it suggests the relationships of words and groups of words and indicates something about their emphasis and importance. Punctuation is organ-

ically related to the *sense* of a sentence, to "sentence flow," as it has been called.

A merchant who sold only *fuel oil* and *lumber* was horrified, and his telephones were swamped with calls, because one of his advertisements mistakenly read: WE SELL FUEL, OIL, AND LUMBER. The addition of two commas changed the description of his business and cost him time, trouble, and money.

Here is another true anecdote that will drive home the *necessity* of punctuation in writing and of correct pauses and inflections in speaking so that meaning will be clear. A man walked into a friend's office and asked the friend's secretary, "Is he overeating?"

"I hope not," was her prompt reply.

Now what both the visitor and the secretary well knew was that the former meant to inquire whether the other man was away, across the street at a popular restaurant, "over there" and engaged in "eating." That is, he meant to ask, "Is he over, eating?" or "Is he over—eating?" Without a pause in speaking after *over* or without punctuation after it in writing, the secretary may be considered to have made a sensible reply to the query. Those who feel that the main purpose of punctuation is to indicate the stops, or breathing spaces, suitable in reading have a little truth on their side, but not much.

If you came across them in your reading, what sense would you make of these famous "trick" sentences often used in stressing the importance of punctuation?

> Jones where Smith had had had had had had had had had had had the examiners approval.
> That that is is that that is not is not is not that it it is.

These sentences can be punctuated in several ways, but here are acceptable methods illustrating that punctuation is indeed essential for clarity in writing:

> Jones, where Smith had had "had," had had "had had." "Had had" had had the examiner's approval.
> That that is, is. That that is not, is not. Is not that it? It is.

Correct punctuation is organic, not merely mechanical and arbitrary. By *organic* is meant "belonging to, an essential part of." If you doubt that correct punctuation is an integral part of written

English, ask someone to copy a page from a book or a few paragraphs from a newspaper story, omitting all marks of punctuation and mechanics. Try to read what he has copied. Yes, you can probably make sense of the passage, but how much extra time and effort did you expend? Correct punctuation is in itself a form of communication. And communication is, or should be, the primary purpose of all writing.

Punctuation usage does vary with individual writers, but not so much as you may have thought and then only to the extent that communication from writer to reader is aided, not impeded. Possibly as much as one-fourth of punctuation is a matter of personal taste—but only to the extent that marks used help to make fully clear the words themselves. This leaves most practices in punctuation a fairly rigid matter of "rules." Certain basic practices and principles of punctuation remain steadfast and have done so for many decades. These principles may be called "descriptive rules," since they have been formulated from hundreds of thousands of examples as applied by reputable writers and, much more importantly, by professional editors and printers.

Variations in practice do occur, and writers do interpret in different ways the shorthand symbols of punctuation, but areas of agreement far exceed those of disagreement. What is normally considered correct punctuation has been fixed over the years by professional workers following the advice and suggestions set forth in standard guidebooks and dictionaries. These guidebooks have been slowly evolved from observed practices in carefully written English.

When a preponderant number of examples of one use of a mark of punctuation has been gathered, a general rule is phrased: "*Always* use the . . ." When the majority of examples agree, the rule is stated: "This mark is *usually* used . . ." When examples of the use of a mark of punctuation for a particular purpose are insufficient to make a generalization, the rule will state: "The mark is *occasionally* used . . ."

Certain marks are always used to accomplish a particular purpose. To fulfill other aims, other marks may be used somewhat indiscriminately and loosely. But the dominant aim of every mark of punctuation and mechanics is to aid in making writing clear. In fact, this is the one and only true aim of *all* punctuation.

A BRIEF SURVEY OF
PUNCTUATION

Practices in punctuation were not always so fixed, so apparently rigid, as they are today. Early Greek grammarians conceived punctuation, as they did so much else that still influences our language. They even gave names that persist today to some of the marks of punctuation, notably our two most important and most often used marks. The word *period* comes from *periodos* (a going round), which in turn was derived from *peri* (round, about) and *hodos* (a way). The meaning is clear: the end of a sentence, which most often requires a period, marks a cycle, a circumference, of thought and expression. The word *comma* is derived from Greek *komma* (clause), which came from *koptein* (to cut off). Indeed, a comma normally does "cut off" one part of a sentence from another.

For centuries after the "invention" of punctuation it was used haphazardly and illogically. William Caxton, who lived in the 15th century, is known to have been the first British printer. His use of marks of punctuation reveals no clear system and often causes more confusion for the reader than it relieves. For some 250 years after Caxton, printers both in the British Empire and in the United States felt an increasing need for an adequate, understandable, and orderly system of punctuation. Their efforts eventually resulted in a reasonably uniform code, but it was not until the middle of the 19th century that books, magazines, and newspapers in the English language adopted a system that generally would seem clear and organically helpful to present-day readers.

For example, the First Folio of Shakespeare's plays, issued in

1623, reveals use of the comma, period, colon, semicolon, exclamation point, parentheses, and question mark, but these marks were employed in ways that have led to endless argument and study concerning the true meanings which the playwright wished to convey. In fact, when the works of most writers prior to about 1850 are currently reprinted, editors and scholars frequently "modernize" punctuation so that the writings will be clear to today's readers. The majesty of the King James Version of the Bible is marred somewhat for skilled readers today because of its occasionally puzzling punctuation.

For another example, consider the American Declaration of Independence (July 4, 1776). It consists of 47 sentences and, consequently, of 47 terminal (end of sentence) marks. Of these, 35 are rarely if ever used today:

Period plus dash (.—) appears 25 times.
Comma plus dash (,—) appears 1 time.
Colon plus dash (:—) appears 9 times.

These strange-to-us marks do not actually confuse, but their appearance is peculiar to the modern eye; they interrupt the attention of today's normal reader.

Through tradition and long-observed practices, punctuation in the United States began to be somewhat standardized about the middle of the 19th century. Possibly Robert Hoe's invention of the rotary press (1846, 1847), which led to an increase in reading matter, had a direct influence. Perhaps even more important in the process was a growing realization that the meaning secured from silent reading without adequate and standardized punctuation would be vastly different from that of overheard speech.

Whatever the reasons, the practices and devices of punctuation in this country have remained fairly constant for more than one hundred years. This statement does not imply that practices have become rigid or inflexible. Nor does it mean that punctuation today is not different in some respects from that of a century ago. Language is a living thing and constantly changes; punctuation is an organic part of written language and consequently varies, too, with changing times and customs.

But compared with the wildly indiscriminate, quixotic, and to us weird punctuation practices of more than a century ago, mod-

ern American punctuation is reasonably well standardized and is yearly growing more so. Writers—and, much more influentially, editors and printers—are realizing increasingly that commonly accepted practices in punctuation are a genuine aid in making writing clear and fully intelligible.

TRENDS IN MODERN AMERICAN PUNCTUATION

Alterations in American punctuation practices during the past century are largely continuations of trends begun during the preceding two centuries. These trends continue today, but they are not nearly so rapid or sweeping as you may have been led to believe. Change in punctuation, as in language habits, is normally slow, even glacial. Furthermore, the practices of individual book, magazine, and newspaper publishers vary so widely that only loose generalizations about fixed and changing punctuation practices can be ventured. Some of these trends may be roughly summarized as follows:

(1) Standard guides for editors and printers are becoming increasingly important and influential and are constantly tending to "fix" punctuation practices in ever more rigid molds. The influence of the *Chicago Manual of Style* (*A Manual of Style*, The University of Chicago Press), the *U.S. Government Printing Office Style Manual*, and the *New York Times Manual of Style and Usage* is great and persuasive. These manuals are bibles for copy editors and printers. In addition, their comments appear and reappear in style books prepared by other newspaper, magazine, and book publishers for the guidance of staff writers and editors.

We do not have a national organization to determine correct word choice, as does, for example, France. But such influential manuals as those mentioned are the closest thing we have to an authoritative ruling power in punctuation and mechanics. Their

pervasive effect upon standard practice is not a vexing concern to a nation of individualistic and freedom-loving people. On the contrary, to the degree that their suggestions and mandates help make written English more meaningful and more readily under-standable to the reader, they are genuinely helpful. The counsel they provide differs on occasion and thus causes confusion; in the main they agree on basic principles and practices and conse-quently exert a strengthening and solidifying influence upon the language.

(2) The average number of marks of punctuation per sentence is gradually decreasing. But, despite the practices of some news-papers and magazines, and despite the advice of many editors and teachers of writing, this decrease has not been so great within the past century as you may have been led to suspect. In fact, some evidence exists that as our age grows increasingly complex and involved, some writers tend to construct sentences which require as much punctuation as was used a century ago in order to convey somewhat complex or confused thinking. But the general princi-ple holds true, as this study of the *New York Times* reveals:

TABLE A. PUNCTUATION IN 100 SENTENCES*

Source	Terminal Marks				Internal Sentence Marks							Total
	.	!	?	:	,	;	()	?	—	:	,—	
NEW YORK TIMES (Sept. 24, 25, and 30, 1851)	96	1	0	1	195	28	4	1	7	3	1	339
NEW YORK TIMES (Feb. 2, 3, 1911)	94	2	3	1	167	6	2	0	11	0	0	296
NEW YORK TIMES (Oct. 15, 1991)	97	0	3	0	117	6	1	0	14	2	0	240

* All sentences are consecutive and are from unsigned articles and news stories.

A decrease of marks-per-sentence from 3.39 to 2.40 is substan-tial. But careful study does not reveal that such a sizable decrease occurs in several other publications which are also noteworthy for their careful preparation—for example, the *Atlantic Monthly* and *Harper's Magazine*.

In general, however, much printed material, especially that

noted in random issues during 1990 and 1991 of five newspapers published in Chicago, Washington, San Francisco, and St. Louis shows approximately the decrease revealed in the *New York Times*.

TABLE B. PUNCTUATION IN 100 SENTENCES*

Source	Terminal Marks				Internal Sentence Marks							Total
	.	?	!	:	,	—	;	()	:	,—	!	
ATLANTIC MONTHLY (Feb., 1911)	90	5	5	0	172	13	14	0	1	9	1	310
ATLANTIC MONTHLY (Sept., 1991)	98	2	0	0	132	3	5	4	1	0	0	295
HARPER'S MAGAZINE (Feb., 1851)	99	0	0	1	175	7	17	0	0	0	0	299
HARPER'S MAGAZINE (Sept., 1991)	92	6	1	1	112	20	15	4	1	0	0	252

* All sentences are consecutive and are taken from unsigned (editorial) nonfiction.

More and more writers and editors, especially those engaged in preparing material for large groups of readers, are coming to realize that sentences which require considerable internal punctuation are usually involved and should be rephrased.

(3) Although the actual number of commas-per-sentence has not greatly decreased in the past century, a tendency exists to use fewer which are totally unnecessary or which slow up or impede understanding. Less and less are commas now used between the subject and verb of a sentence, between a noun and its appositive or defining modifier, between a verb and its object, or merely to represent a pause such as would be made in speaking.

This trend may be shown by an examination of Lincoln's superb Gettysburg Address. This majestic speech consists of only ten sentences; the sole marks of punctuation used in the authorized, printed version are periods, commas, and dashes. The total number of marks of punctuation is 38—or 3.8 per sentence. Commas total 21; of this number, approximately half would be omitted by skilled writers today. For example, all three of the commas ap-

pearing in the first sentence might be removed by current copy editors and experienced writers:

> Four score and seven years ago our fathers brought forth on this continent, a new nation, conceived in Liberty, and dedicated to the proposition that all men are created equal.[*]

Two observations may be pertinent: (1) the commas really signify pauses, such as President Lincoln probably made in speaking; (2) no writer alive today could approach the grandeur of this speech regardless of the punctuation used.

(4) Despite many statements to the contrary, printed sentences are not noticeably shorter now in all varieties and forms of publication than they were a century ago. In general, the majority of newspapers consulted tend to use shorter sentences than they did at the beginning of this century. Some magazines do likewise, but others do not. And books vary in sentence length to such an extent that any generalization is unsound. Since speech can usually be heard only once, radio and television broadcasters and announcers tend to shorten their sentences so as to be instantly understood. In ordinary conversation, most people presumably have always tended to use short sentences. But good writers vary the length of their sentences so much that striking an average even in one issue of one magazine is virtually meaningless.

About all that can be said with accuracy is that sentences in fiction tend to be shorter than those in nonfiction; that few writers today consistently use sentences as long as most writers did in the 18th century; that variety in sentence length is much more prevalent today than it formerly was.

These observations strengthen the concept that punctuation is truly organic; a writer who uses a lean, vigorous style will employ fewer marks of punctuation in shorter sentences than will another writer dealing with another subject in a different style. The short sentence is normally more easily understood than the long one, but a skilled writer, such as E. B. White, for example, will employ sentences ranging from one word to fifty or more in the same

[*] Lincoln's *Gettysburg Address*, November 19, 1863. From *The Works of Abraham Lincoln*, Federal Edition, VII, 20.

article. The trend in some publications toward shorter sentences which more nearly approach the patterns of ordinary conversation is obvious, but it is a slow and gradual one, which may require decades to become genuinely noteworthy.

(5) Certain marks of punctuation have gone out of favor and hence out of use. Others have become increasingly popular. Still others are being used less and less. Such combinations as a period, comma, or colon followed by a dash used in the Declaration of Independence (see p. 8) and elsewhere during the past two centuries are rare today. The period has gained in popularity, at least in most of the newspapers consulted, not only over such combinations as these but even over other terminal marks such as the exclamation point, the dash, and the colon. The ratio of the period and other terminal marks is about 95 to 5. The semicolon is not used so much as formerly it was in the majority of the newspapers and magazines consulted. The comma-dash combination has been superseded by the use of the dash alone; the dash is now usually dropped from the once prevalent colon-dash combination. Periods and other terminal marks are increasingly rare after chapter titles and running heads in books and in display advertising of all kinds. Such trends as these are a further illustration of the power and influence of the standardized guidebooks mentioned on page xii.

(6) Despite the fact that usage in punctuation has not varied so widely in the past century as some writers have suggested, it is safe to assume that an overpowering need for understanding among peoples will gradually but inevitably influence our punctuation practices. Sentences will surely tend to become shorter with less and less need for internal punctuation. We will strive ever harder to achieve a lean, vigorous, emphatic style so that we can communicate all the more clearly with others. Our need for global understanding, the tremendous influence of broadcasters and telecasters, the ever-quickening pace of our lives will all insure that writing will become less leisurely, less involved, with consequent lessening of a need for the supplementary and complementary punctuation which is an integral part of written language. The simple declarative sentence—which has been called

the greatest invention of the human intellect—normally requires little punctuation.

But what punctuation is used should be correct and should serve to make clear the meanings of words and groups of words which it introduces, separates, encloses, or terminates. The pages which follow are designed to show you precisely what is currently approved practice in the use of every mark of punctuation and of mechanics which can possibly confront you in writing.

But always keep in mind that punctuation is not properly thought of as an adornment of writing. At no time in this century has it been a salt shaker from which one could sprinkle his writing to suit his own taste. It is an integral part of all writing and it has only one legitimate aim: to make writing clear and understandable.

Punctuation is no longer a set of wholly absurd and arbitrary rules found only in style books and handbooks for writers and editors. The dots and lines (curved, straight, horizontal, vertical) which comprise punctuation are the most useful single device today's writer can employ to make meaning unmistakably clear to others.

Clear, logical thinking helps, too.

THE PRIMARY PURPOSES
OF PUNCTUATION
AND MECHANICS

As was noted earlier, punctuation is a system—call it a *method* if you wish—by which, through the use of certain marks, you make the meaning of written communication clear and, if possible, unmistakable. Mechanics, a somewhat vague and general term, is related to punctuation and applies to the correct and conventional uses of capitals and lower case letters, the writing of numbers in figures or words, abbreviations, italics (underlining), and other devices which also serve to make written communication more easily understood. Every mark of punctuation or use of mechanics has, or should have, a definite function leading to one goal: clarity.

In studying the pages which follow, ordinarily you will apply a principle or specific rule of punctuation and mechanics to a particular instance or sentence element. It may help you to keep in mind that all punctuation serves one of four general purposes: to *terminate*, to *introduce*, to *separate*, to *enclose*.

Termination

Even the most long-winded speaker eventually runs out of breath and must end a statement in order to inhale and start again. In writing, as in speech, the basic unit of thought is the sentence. Now, a sentence, in speech or in writing, may vary in length from one word to many hundreds, but it has to end somewhere, some time. When you come to the end of a statement in speech, you are

likely to lower (drop) your voice and to pause before proceeding. In writing, the end of a statement is always correctly noted by an end-stop (terminal mark of punctuation).

The period is used to end nine out of ten sentences. However, if your statement is in the form of a question, you use a question mark to end it. Or if the statement expresses surprise, strong emotion, or a command of some sort, it may properly be terminated by an exclamation point. The use of these three terminal marks will have a distinct influence upon the meaning conveyed:

> What do you mean? You are leaving this town.
> What? Do you mean you are leaving this town?
> What! Do you mean you are leaving this town!

Other marks of punctuation are occasionally used to terminate a statement. A colon may be used to end what is actually an introductory statement when that which follows begins with a capital letter. A statement which is broken off or interrupted may be ended with a dash. Also, a statement left unfinished may be terminated by ellipsis periods (three dots).[1]

> This is what he said to me: Start at once and keep going.
> "I hardly know what to say to express—" The speaker halted abruptly.
> Perhaps I should have kept quiet. Perhaps I should have protested. Perhaps . . .

Introduction

In writing as in speech, we often lead up to a statement with a preliminary one or pave the way for a comment with words which actually serve as an introduction. Only three of the marks of punctuation are regularly used to introduce words or statements: commas, colons, and dashes. (The sentence which you have just read illustrates this principle; what precedes the colon builds to what follows it.)

[1] Four dots may be used at the end of a sentence requiring a period; this practice is rarely observed in most contemporary publications.

I need only one thing, more time.
Your task is simple: get a job and hold it.
He has only one passion in life—dancing.

Separation

For writing to be clear, sometimes individual words or groups of words must be separated from others in the same sentence. To separate parts of a sentence, use a comma, a semicolon, a dash, a hyphen, or an apostrophe. Remember, though, that these five marks cannot be used interchangeably for this purpose.

> If you wish me to go, please lend me some money.
> This man loves his work and is happy; that one hates his and is miserable.
> To separate parts of a sentence—use a comma, semicolon, dash, hyphen, or apostrophe.
> He is now our president-elect.
> This store is crowded every day from noon until two o'clock.

Enclosure

To enclose parts of a sentence or longer units of expression, you may use commas, dashes, quotation marks, single quotation marks, parentheses, and brackets. Enclosing marks are always used in pairs (two of each) except when a capital letter at the beginning of a sentence takes the place of one of them or when a terminal mark of punctuation replaces the second.

> An unusual habit, eating two breakfasts every day, seemed to make him sluggish during morning hours.
> He was not—and everyone else knew this—a well man.
> "I am not an American," he said fatuously; "I am a citizen of the world."
> "To say this dance is 'peachy' is not a useful comment," remarked the fireman.
> When I am ready to go (and that will be soon) I shall let him know.

"The foreman on this job [Ned Stephens] is an excellent worker himself," remarked the superintendent.

Different marks indicating the four principal purposes of punctuation are not always interchangeable. Both the comma and the dash, for example, can introduce, separate, and enclose material, but this ability does not mean that one is not preferable to the other in a given sentence designed to convey a particular meaning. To achieve the specific purpose of punctuation that you have in mind, select the mark that will most effectively transmit the meaning intended.

You should also note that marks of punctuation have varying degrees of strength. A period is a stronger mark than a semicolon or comma; it points out the most important division of thought, the sentence. It also indicates the greatest remoteness of thought of any of the marks of punctuation. A semicolon is weaker than a period but stronger than a comma; used within the sentence, it points out longer or more important groups than the comma usually does. The comma indicates a brief pause or less complete separation than does the semicolon; it separates short groups within the sentence and suggests a comparatively close connection with what precedes and follows it.

Here is a further illustration of the strength of punctuation in relation to the strength of ideas: If you write a weakly parenthetic statement in a sentence, use no punctuation of any kind; if the parenthetical material seems to require some attention, use commas; if the material is strong or emphatic, use dashes or marks of parenthesis.

Conversely, you may indicate weak separation without any punctuation or with a comma. Strong separation may be revealed by a semicolon. Even stronger separation (between sentences) may be shown by one of the terminal (end-stop) marks: period, question mark, exclamation point.

This comment on the four primary purposes of punctuation may be useful, but normally you will be faced with specific problems of punctuation in specific circumstances. For this reason you will probably find the "Glossary of Applied Punctuation," pages

192–202, a timesaver and an excellent starting point. Always ask yourself, "Just what is it here that requires punctuation?" With a possible answer in mind, turn to the glossary.

A great deal in writing cannot be solved by a resort to common sense. Nor can all the rules and principles of punctuation be called sensible and logical. But if you are aware that something you are writing requires punctuation, you can follow the lead of the glossary to individual sections in this book and apply whatever common sense is involved. Some of the time, it's considerable.

THE
INDIVIDUAL MARKS

(ARRANGED IN
ALPHABETICAL ORDER
FOR QUICK REFERENCE)

1

ABBREVIATIONS

Abbreviations, shortened forms of words and phrases, help save time and space. In addition, proper use of abbreviations avoids the needless spelling out of often repeated phrases and words, a practice which annoys some readers. Coming across spelled-out items such as "Mister Jones" and "Mistress Adams" would be distracting and bothersome to most modern readers.

Actually, more and more abbreviations are being used as the tempo of living increases. Those who teach and critically judge writing often advise against using any abbreviations at all except very common and widely accepted ones, on the grounds that they are offensive and frequently confusing. Here, for example, are abbreviated forms used to indicate professions, industries, or types of business as they appear on one page of a city telephone directory; all save space and all appear without periods: *catrg, consltnt, dmnds, engrvr, frght forwdrs, furn, ins, jwlrs, ofc, pblctn, plmbg & heatg, pub accnt, restrnt, rl est, stk brkr*. Are all of these readily understandable? In writing, especially if space is not at a premium, it would be decidedly preferable to spell out *catering, consultant, diamonds, engraver, freight forwarders, furniture, insurance, jewelers, office, publication, plumbing and heating, public accountant, restaurant, real estate*, and *stock broker*.

As a general rule, spell out all words and phrases which would be puzzling if abbreviated and abbreviate correctly all terms which are frequently encountered and readily understood in shortened form.

Standard abbreviations follow the capitalization and hyphening of the words abbreviated and, with certain exceptions, require the use of periods (see p. 129):

Ariz. (Arizona)	bbl. (barrel)
ft.-lb. (foot pound)	U.N. or UN (United Nations)

Two special forms of abbreviations are *contractions* and *acronyms*. The former is a name for words written with an apostrophe to show the omission of a letter or numeral: *don't* (do not); *doesn't* (does not); class of '82 (1982); *weren't* (were not). An *acronym* is a word coined from the initial letters or syllables of successive parts of a term: *radar* (radio detecting and ranging); UNESCO (United Nations Educational, Scientific and Cultural Organization).

Several thousand abbreviations exist in the English language; entire books have been devoted to their meanings and correct use (see p. 32). Since the subject is too large for fully comprehensive treatment here, the following suggestions may be helpful:

(1) Avoid in successive sentences the use of so many abbreviations that your writing appears "telegraphic" in style and annoying to the reader's eye. Most readers would be perturbed by such a passage as "N.Y.C. is a lg. place. Its central boro, Manhattan, lies E. of the Hudson R., W. of the E. Riv., and S. of the Bx."

(2) Standard and easily understood abbreviations are often preferable to spelled-out expressions, but they should be uniform throughout your writing.

(3) Some groups (technical, scientific, cultural, industrial) have adopted specific forms of abbreviations for their specialized fields. In writing for publications within these groups, follow recommended forms which may differ, on occasion, from otherwise standard practice.

(4) Do not try to memorize the standard forms of all abbreviations you might have occasion to use. Consult a good dictionary when in doubt.

1.1 Addresses

a. After a name or number, the following standard abbreviations may be used:

Ave. (Avenue)	Pl. (Place)
Blvd. (Boulevard)	Rd. (Road)
Bldg. (Building)	Sq. (Square)
Ct. (Court)	St. (Street)
Dr. (Drive)	Ter. (Terrace)

b. However, in formal writing when the words (abbreviations) listed above appear as part of a name, it is generally preferable to spell all the words out:

Fifth Avenue Building Bronson Road Terrace

c. Do not abbreviate such address words as *county, parish, point,* and *port*: Lincoln County, the port of New Orleans.

d. The words *North, South, East, West* are preferably spelled out (but not necessarily with capitals) at all times except in scientific, technical, or unusually informal writing.

e. Sectional divisions of cities (NW, N.W., S.E., SE, etc.) and the postal designations RD and RFD are usually abbreviated.

1.2 Calendar Divisions

a. Names of days of the week are preferably not abbreviated. If space requires, or informality permits, the following are correct: Sun., Mon., Tues., Wed., Thurs., Fri., Sat.

b. Names of months are preferably spelled out in formal writing but may be abbreviated in the headings of letters, in business correspondence, and the like: Jan., Feb., Mar., Apr., Aug., Sept., Oct., Nov., Dec. Note that May, June and July should never be abbreviated (except possibly in tables of statistics, etc.).

c. References to decades may be spelled out or written as contractions: the gay *nineties*, in the '90's.

d. Spell out in full numbers of dynasties, sessions of Congress, and the like: Third Dynasty, Seventy-ninth Congress, first session. (The use of figures to refer to centuries has become increasingly accepted, particularly in nonformal writing: fifteenth century or 15th century.)

1.3 Geographic Names and Terms

a. Do not use abbreviations for the name of any foreign country. Occasionally you will see such abbreviations as *It.* (for Italy) or *Fr.* (for France), but their use is not recommended in ordinary writing.

b. The names of states, territories, and possessions of the United States should be spelled in full when standing alone. When they follow the name of a town, city, or any other capitalized geographical term (airport, military base, reservation, etc.), use the following standardized abbreviations:

Ala.	Ga.	Mich.	N.H.	S.D.
Ariz.	Ill.	Minn.	N.J.	Tenn.
Ark.	Ind.	Miss.	N.M.	Tex.
Calif.	Kan.	Mo.	N.Y.	Va.
Colo.	Ky.	Mont.	Okla.	Vt.
Conn.	La.	N.C.	Ore.	Wash.
D.C.	Mass.	N.D.	Pa.	Wis.
Del.	Md.	Neb.	R.I.	W. Va.
Fla.	Me.	Nev.	S.C.	Wyo.

The following are preferably not abbreviated: *Alaska, Hawaii, Idaho, Iowa, Ohio,* and *Utah.*

The U.S. Postal Service uses a different list of preferred abbreviations, each consisting of two capital letters:

Alabama	AL	Idaho	ID
Alaska	AK	Illinois	IL
Arizona	AZ	Indiana	IN
Arkansas	AR	Iowa	IA
California	CA	Kansas	KS
Colorado	CO	Kentucky	KY
Connecticut	CT	Louisiana	LA
Delaware	DE	Maine	ME
Florida	FL	Maryland	MD
Georgia	GA	Massachusetts	MA
Hawaii	HI	Michigan	MI

Minnesota	MN	Oregon	OR
Mississippi	MS	Pennsylvania	PA
Missouri	MO	Rhode Island	RI
Montana	MT	South Carolina	SC
Nebraska	NE	South Dakota	SD
Nevada	NV	Tennessee	TN
New Hampshire	NH	Texas	TX
New Jersey	NJ	Utah	UT
New Mexico	NM	Vermont	VT
New York	NY	Virginia	VA
North Carolina	NC	Washington	WA
North Dakota	ND	West Virginia	WV
Ohio	OH	Wisconsin	WI
Oklahoma	OK	Wyoming	WY

The following may be spelled in full or abbreviated if space is important: *Canal Zone* or *C.Z.*; *Puerto Rico* or *P.R.*; *Virgin Islands* or *V.I.*

c. The names of Canadian provinces are abbreviated when attached to the name of a geographical area, but otherwise are spelled out: Waterloo, *Ont.*, but the Province of *Ontario*.

d. The abbreviation *U.S.* is used as an adjective but the name is spelled out as a noun: the *U.S.* House of Representatives, the foreign policy of the *United States*.

e. Parts of certain geographic names may be abbreviated or spelled out: *Ft.* Madison or *Fort* Madison, *Mount* Everest or *Mt.* Everest.

f. Certain place names must always be abbreviated: *St. Louis* (not *Saint Louis*).

g. Avoid such abbreviations as *r.* (for *river*); *mtns.* (for *mountains*); *cos.* (for *counties*).

h. Avoid partial abbreviation. Write *South Carolina* or *S.C.*, not *S. Carolina* or *South Car.*

1.4 Measurements (Time, Quantity)

The use of abbreviations for citing dimensions, distances, time, degree, measures, and weights is complex and involved. Furthermore, the use of abbreviations for such citations has not been fully

standardized. A good composite rule is this: when giving measurements, use figures rather than words and only those abbreviations which are generally understood.

a. With abbreviations of measurement, including percentages and decimals, use figures, not words: 100 mi. (miles); 8 cm. (centimeters); 6 percent (per centum); 2.5 gm. (grams). Acceptable abbreviations include approx. (approximate); av. (average); diam. (diameter).

b. References to meridian (being at, or pertaining to, midday) are abbreviated thus: 9 a.m. or A.M.; 6:15 p.m. or P.M.; 12 A.M. or M. (noon); 12 p.m. or P.M. (midnight). The word *o'clock* is never used with abbreviations of time: 8 P.M. (not 8 o'clock P.M.).

c. Compass directions and the abbreviations for latitude and longitude may be expressed as follows:

9 N. 24 W. (nine degrees north, 24 degrees west)
lat. 50 23 05n. (latitude 50 degrees, 23 minutes, 5 seconds north)

d. Commonly used abbreviations based on the metric system, units of time, and the English system of weights and measures include, among scores of others:

bbl. (barrel)	mg. (milligram)
bu. (bushel)	mi. (mile)
cc. (cubic centimeter)	min. (minute)
cu. ft. (cubic foot)	mm. (millimeter)
cwt. (hundredweight)	mo. (month)
ft. (foot)	oz. (ounce)
gal. (gallon)	pt. (pint)
hr. (hour)	sec. (second)
in. (inch)	sq. yd. (square yard)
k. (kilo, one thousand)	v. (volt)
l. (liter)	w. (watt)
lb. (pound)	yd. (yard)
m. (meter)	yr. (year)

1.5 Money

Many scores of well-known abbreviations are available for indicating sums of money. Their use is both standardized and recommended.

a. Abbreviations for currency of the United States are as follows:

¢; c.; ct. (cent, cents); U.S. $ (used only in foreign trade); $; dol. (dollar).

Such terms as *fin* for *five dollars* and *C note* for *one hundred dollars* are corrupted abbreviations and should be used only in informal conversation.

b. Conventions for writing sums of money in foreign countries are similar to those in the United States: abbreviations are standardized and are placed before or after the sum. A period, comma, or additional space appears before any fractional part:

British: £15 12 s. 4d. (15 pounds, 12 shillings, 4 pence)
German: DM 900, 30 (900 deutsche marks, 30 pfennigs)

In Spain, the basic monetary unit is the peseta (Pts.). The principal fractional unit is the centimo. In Mexico, corresponding terms are the peso and the centavo (Mex. $ and ctvo).

1.6 Names and Titles

The use of abbreviations in writing names and titles is involved and somewhat illogical. A good general rule is this: When in doubt about the proper abbreviation to use, spell out the name or title in full. However, such familiar abbreviations as *Mr.* (Mister); *Messrs.* (plural of Mr.); *Mrs.*; and *St.* (Saint) are nearly always preferred. The titles *Dr.* (Doctor); *Rev.* (Reverend); *Hon.* (Honorable); and the French titles for Monsieur (*M.*), Messrs. (*MM.*), Madame (*Mme.*), and Mademoiselle (*Mlle.*) are usually written in abbreviated form. So, too, are *Sr.* (Senior); *Jr.*, (Junior), and *Esq.* (Esquire) following a name. Acceptable abbreviations include *Capt.* (Captain); *Col.* (Colonel); *Dem.* (Democrat); *Gen.* (General); *Lieut.* (Lieutenant); *Sgt.* (Sergeant); *Maj.* (Major); *Rep.*

(Representative or Republican); *Sen.* (Senator); *Pres.* (President); and *Vice-Pres.* (Vice-President).

a. In writing company names, abbreviations may be used: *Bro.* or *Bros.* (brothers); *Corp.* (corporation); *Inc.* (incorporated); *Ltd.* (limited); *&* (the ampersand, which designates *and*); *Co.* (company). In giving the name of a specific company always use abbreviations as the company itself does: *Grosset & Dunlap, Inc.; Houghton Mifflin Company; Best & Co.; American Telephone and Telegraph Co.; Smith Mfg. Co.; U.S. News and World Report.* The word *Association* is not usually abbreviated to *Assoc.*

b. In strictly formal usage, especially invitations and announcements, abbreviations are rarely used, particularly with titles. For example, the words *reverend, monsignor,* and *honorable* are usually spelled out when preceded by *the*: *the Reverend Harry Emerson Fosdick; the Right Reverend Monsignor Shamus Kelly; the Honorable Harry Flood Byrd.* Convention decrees that the abbreviation *Rev.* should never be used without a Christian name: *Rev. William Klein,* not *Rev. Klein.*

c. Certain shortened forms of names are not true abbreviations and should not be followed by periods: Ben (for Benjamin), Pete (for Peter), Will (for William), etc. Spell out Christian names except in copying a signature where the form used by the signer must be retained: *Geo. Ross, Wm Hooper, Thos Heyward Junr* thus signed their names to the Declaration of Independence.

d. Scholastic and honorary degrees are abbreviated when used with names: *J. Wilson Shore, Ph.D.; Timothy E. Smythe, M.A., LL.D., Litt.D.* Academic degrees used alone may also be abbreviated when the context is clear: "He earned his Ph.D. degree and then decided to study for his M.D."

Familiar abbreviations for scholarly degrees and titles of respect are:

A.B. Bachelor of Arts
B.A. Bachelor of Arts
B.D. Bachelor of Divinity
D.D.S. Doctor of Dental Surgery
J.D. Jurum Doctor (Doctor of Laws)

L.H.D. Litterarum Humaniorum Doctor (Doctor of
 Humanities)
Litt.D. Litterarum Doctor (Doctor of Letters)
LL.D. Legum Doctor (Doctor of Laws)
Ph.D. Philosophiae Doctor (Doctor of Philosophy)

1.7 School and College Subjects

Many words applying to subjects of study are commonly abbreviated in colloquial speech and in informal writing. Such abbreviations are usually considered colloquial and should be avoided. Prefer spelled-out words to *Amer. civ.*, *biol.*, *bot.*, *chem.*, *comp. lit.*, *eco.* or *econ.*, *Eng.*, *Fr.*, *geol.*, *Ger.* or *Germ.*, *gov.*, *hist.*, *math.*, *mus.*, *phil.*, *psy.* or *psyc.*, *soc.*, and other such subjects. That some of these abbreviations may not be clear to you is a good reason for avoiding them in writing.

1.8 Chemical Symbols

Chemical elements are designated by the initial letter or a shortened form of the English or Latin name. Examples:

As	arsenic	Hg	mercury
Ba	barium	Ni	nickel
Ca	calcium	N	nitrogen
Cl	chlorine	O	oxygen
Au	gold	Pt	platinum
H	hydrogen	Si	silicon
Fe	iron	Ag	silver
Mn	manganese	Zn	zinc

1.9 Latin Abbreviations

Some of the abbreviations listed here have lost currency but occasionally turn up in published works.

ab. init., *ab initio* (from the beginning)
ad lib., *ad libitum* (at will)

ca., *circa* (about, approximately)
e.g., *exempli gratia* (for example)
et al., *et alii* (and others)
i.e., *id est* (that is)
infra dig., *infra dignitatem* (undignified)
q.v., *quod vide* (which see)
sup., *supra* (above)
vs., v., *versus* (against)
viz., *videlicet* (namely)

1.10 Standard Abbreviations

No fully comprehensive list of standard abbreviations and coined words has ever been compiled. However, a number of partial attempts have been made, several of them careful and scholarly works, although admittedly incomplete. If you need to use abbreviations often, consult your dictionary. Many desk-size dictionaries provide both a brief separate list of abbreviations as well as individual entries, with definitions, in their proper alphabetical order. Here is a list of 150 abbreviations or acronyms (coined words), a few of them previously mentioned in this section. They were selected to show something of the range and interest possible with shortened forms. As you study them, note their punctuation, spacing, capitalization, and spelling:

A.B. or B.A. (bachelor of arts)
abbr. (abbreviation, abbreviated)
AC, a.c. (alternating current)
ac. (acre)
acct. (account, accountant)
A.D. (anno domini, in the year of our Lord)
ad inf. (*ad infinitum*, to infinity)
ad lib. (*ad libitum*, at will)
AEC (Atomic Energy Commission)

AFL-CIO (American Federation of Labor and Congress of Industrial Organizations)
a.k.a. (also known as)
anon. (anonymous)
APO (Army post office)
approx. (approximately)
art. (article)
at. wt. (atomic weight)
avdp. (avoirdupois)
A.W.O.L. (absent without official leave)

b. (born)

B.C. (before Christ)

bf. (boldface)

b.p.d. (barrels per day)

B.T.U., b.t.u. (British thermal unit)

C., c. (centigrade)

ca., *c.* (*circa*, about)

CAB (Civil Aeronautics Board)

caps. (capital letters)

CARE (Cooperative for American Remittances to Europe)

cf. (confer, compare)

ch., chap. (chapter)

CIA (Central Intelligence Agency)

c.i.f. (cost, insurance, and freight)

CIO, C.I.O. (Congress of Industrial Organizations)

CO (commanding officer)

c.o.d. (cash—or collect—on delivery)

col. (column)

conelrad (control of electromagnetic radiation)

CPA (certified public accountant)

c.p.m. (cycles per minute)

d. (died)

DAR (Daughters of the American Revolution)

d.b.a. (doing business as)

DC, d.c. (direct current)

dept. (department)

der. (derivation, derived)

do. (ditto, the same)

doz. (dozen)

dr. (debit, debtor, drachma, dram)

D.V.M. (doctor of veterinary medicine)

ed. (edition, editor)

esp. (especially)

et al. (*et alii*, and others)

etc. (*et cetera*, and so forth)

et seq. (and the following)

F. (Fahrenheit)

FCC (Federal Communications Commission)

FDIC (Federal Deposit Insurance Corporation)

fem. (feminine)

f.o.b. (free on board)

F.R.S. (Fellow of the Royal Society)

GAR (Grand Army of the Republic)

g.c.d. (greatest common divisor)

GI (general issue, government issue)

G.m.t. (Greenwich mean time)

Gov. (governor)

g.p.s. (gallons per second)

guar. (guaranteed)

HEW (Department of Health, Education, and Welfare)

hp., h.p. (horsepower)

ibid. (*ibidem*, in the same place)

ICBM (intercontinental ballistic missile)

i.e. (*id est*, that is)

introd., intro. (introduction)

IQ, I.Q. (intelligence quotient)

jg. (junior grade)

kw. (kilowatt)

lat. (latitude)

lc., lc (lower case)

l.c.l. (less-than-carload lot)

LL.B. (bachelor of laws)

loc. cit. (*loco citato*, in the place cited)

long. (longitude)

loran (long-range navigation)

lox (liquid oxygen)

l.w.m. (low watermark)

MATS (Military Air Transport Service)

mdse. (merchandise)

memo. (memorandum)

Mgr. (manager)

misc. (miscellaneous)

M.P. (Member of Parliament)

MP (Military police)

m.p. (melting point)

m.p.h., mph (miles per hour)

Ms, ms, MS (manuscript)

mt. (megaton)

m.t. (mountain time)

MV (motor vessel)

NATO (North American Treaty Organization)

N.B., n.b. (*nota bene*, note well)

n.e.c. (not elsewhere classified)

n.e.s. (not elsewhere specified)

NLRB (National Labor Relations Board)

N.T. (New Testament)

o.d. (olive drab)

p., pp. (page, pages)

pct. (percentage)

P.O., p.o. (post office, postal order)

Pfc. (private, first class)

p.o.d. (pay on delivery)

p.p.m. (parts per million)

P.S. (*post scriptum*, postscript)

P.s.t. (Pacific standard time)

PTA (parent-teachers' association)

PX (post exchange)

q.v. (*quod vide*, which see)

rato (rocket-assisted takeoff)

ROTC (Reserve Officers' Training Corps)

R.S.V.P., r.s.v.p. (*Répondez, s'il vous plaît*, please reply)

s.d. (*sine die*, without date)

SEATO (Southeast Asia Treaty Organization)

SEC (Securities and Exchange Commission)

SHAPE (Supreme Headquarters Allied Powers, Europe)

shoran (short-range radio)

sic (thus)

sonar (sound, navigation, and ranging)

SOS (wireless distress signal)

SP (shore patrol)

sp. (special, spelling, species)

SS (steamship)

S. Sgt. (staff sergeant)

subj. (subject, subjunctive)

supp., suppl. (supplement)

syn. (synonym)

TB (tuberculosis)

t.l.o. (total loss only)

tr. (transpose, translated)

UNICEF (United Nations Children's Fund)

U.S.A. (United States of America, United States Army, Union of South Africa)

USIA (United States Information Agency)

v., vs. (versus, against)

vid. (*vide*, see)

VIP (very important person)

viz. (*videlicet*, namely)

vol. (volume, volcano)

v.t. (verb transitive)

WAC (Women's Army Corps)

WAVES (women accepted for volunteer emergency service)

w.i. (when issued)

2

ACCENT MARKS

For many centuries, English has been borrowing words from other languages. This process continues; constantly the world seems to shrink and people increasingly mingle with those who speak and write other tongues.

When foreign words come into English, they usually do so with their original pronunciation and spelling, although most of them gradually become absorbed into English and tend to lose some of their "foreign" characteristics. For example, few of us stop to think of the familiar word *garage* as of foreign extraction, but it crossed the threshold into English from the French word *garer*, meaning "to protect," "to preserve." Some words, however, are more slowly Anglicized and continue to cause problems in spelling and pronunciation for English-speaking people.

One aspect of this problem is the use of accent marks with certain words borrowed from other languages. The principal accent marks are, in alphabetical order, *acute, cedilla, circumflex, dieresis, grave, tilde,* and *umlaut.* If they originally had them, recently borrowed words tend to keep one or more of these accent marks for a while but tend to drop them as the words themselves become more widely used in English. Retention of accent marks is not systematic or always logical; that is, some newspapers rarely use accent marks at all, whereas others employ them in stories about art, music, and fashion. Sometimes a word will appear in one publication with an accent mark and without it in an equally carefully prepared one: the French word *rôle* (the roll on which an

actor's part is written) may properly be written in English as *role* or *rôle*. In general, accent marks are retained in borrowed words only when needed to indicate pronunciation—and not always then.

2.1 Acute Accent

Depending upon the publication (book, magazine, newspaper, etc.), certain words appear sometimes with an acute accent, more often without. For example, the word *cafe* is so common, and its pronunciation is so well known, that it rarely appears in print as *café*. But the final vowel is pronounced as ā, a fact made unmistakably clear by the acute accent with which the word was originally spelled in English and still is in French. We are likely to write *cafe*, meaning a coffee shop or restaurant, without an acute accent, but to use one in the original meaning of the word (coffee) as in *café au lait* (coffee with milk). In strictly formal and unusually careful writing, each of these words and expressions could carry an acute accent:

attaché	élan
blasé	émigré
cliché	exposé
communiqué	fiancé (fiancée)
congé	idée fixe
coup d'état	maté (beverage)
coupé	matériel
curé	outré
début (débutante)	passé
décolletage	précis
décor	protégé (protégée)
éclair	résumé
éclat	touché

2.2 Cedilla

A cedilla is a hooklike mark placed under the letter *c* in some borrowed words to show that it is sounded like a voiceless *s*

and not as *k*, the more usual pronunciation. In English it is used mainly with words of French origin and, strictly speaking, has more to do with spelling and pronunciation than with marks of mechanics and punctuation. Use a cedilla under *c* in such words as these if you are writing unusually careful and formal English:

aperçu	garçon
façade	Provençal
Français	soupçon

2.3 Circumflex Accent

A circumflex accent is used over a vowel in some languages, notably French, to indicate a particular quality or tone in pronunciation. The following are uncommon in English but, on occasion, admit no adequate substitutes:

bête noire	pâté de foie gras
coup de grâce	raison d'être
crêpe de Chine	table d'hôte
papier-mâché	tête-à-tête

2.4 Dieresis

Dieresis, also spelled *diaeresis*, is a mark consisting of two dots. It is used to indicate the separation of two consecutive vowels into separate syllables. It is much less used than formerly, having been largely replaced by the hyphen or dropped entirely. For example, the dieresis was formerly used almost universally to show that the first two syllables of *cooperate* and *zoology* were pronounced separately: *coöperate, zoölogy*. The word *re + examine* is now spelled both *reexamine* and *re-examine* but no longer with a dieresis. However, you may wish to use the mark with words such as *Chlöe* and *naïve* to prevent any possible mispronunciation.

2.5 Grave Accent

A grave accent is used in French and in a few words Anglicized from French to indicate the quality of the open *e*, as in the word for "dear" (*chère*). A grave accent is also occasionally used by writers, chiefly poets, to indicate that full pronunciation is to be given to an ending or syllable normally elided (run together) in speech: *lovèd* is pronounced as *love-ed*. The grave accent is being increasingly dropped from the following words and expressions, but formal usage decrees that it appear:

à la carte	mise en scène
à la mode	père
crèche	pièce de résistance
crème (crème de la crème)	pied-à-terre
frère	suède

2.6 Tilde

A tilde is a diacritical mark placed over a letter, such as the *n* in Spanish and words Anglicized from Spanish, to indicate a nasal sound, which is represented in English by *ny*. The mark, like others discussed in this section, is being used less and less; for example, the word still spelled in Spanish as *cañon* is now always spelled *canyon* in English.

Precise writers continue to use the tilde in such words as *doña, mañana, piña, señor, vicuña,* and *São Paulo*. Gradual removal of the tilde from our writing is but another illustration of the vigorous way in which English borrows, assimilates, and usually completely absorbs what it needs for its constant enrichment.

2.7 Umlaut

The umlaut is a diacritical mark consisting of two dots (ü) used to indicate a vowel affected by partial assimilation to a succeeding sound. It is characteristic of Teutonic (German) languages and is sometimes used by especially careful writers. Currently, it is most

often used in writing proper names: *Dürer, Die Walküre, Tannhäuser, Büchner, Brüning.* The name of the former Nazi leader, *Göring,* is spelled *Goering* in this country because of the rarity of umlaut usage and also as an indication of the correct pronunciation of *ö.*

Summary

A good dictionary will indicate which of these seven accent marks is needed for any given word, but one caution is necessary: most entries in your dictionary will appear with what seems to be one or more acute accents. Actually, these are marks used to indicate stress (in pronunciation). Primary or heavy stress is usually shown by a heavy mark (′), and less heavy, or secondary, stress by a light (′) or double (″) mark: search′light′, search′light″. A word requiring an acute accent will be clearly indicated by a mark directly over the letter itself rather than following the accented syllable. (And surely you need hardly be told that the centered period that most dictionaries employ to indicate syllables in an entry is not really a period but merely a separation device.)

Remember that accent marks rarely are used with words such as:

aperitif	consomme	habitue
apropos	cortege	ingenue
blase	coupe	matinee
boutonniere	debut	naivete
brassiere	eclair	nee
cabana	entree	premiere
canape	facade	saute
cause celebre	fiance	seance
cliche	garcon	souffle
confrere	glace	table d'hote

3

APOSTROPHE

The apostrophe ('), a mark of punctuation and a spelling symbol, has three uses: to indicate omission of a letter or letters from words and of a figure or figures from numerals; to form the possessive (genitive) case of nouns and of certain pronouns; to indicate the plurals of letters, numerals, symbols, and certain abbreviations. The apostrophe is a somewhat silly, overused, and incongruous mark—as George Bernard Shaw and numerous other writers have suggested—but you must know how to employ it correctly for each of the purposes indicated if your writing is to be immediately clear and fully understandable to readers.

3.1 Omission

a. Place an apostrophe where a letter or letters have been omitted:

aren't (are not)	mustn't (must not)
can't (can not)	o'clock (of the clock)
couldn't (could not)	shan't (shall not)
doesn't (does not)	wasn't (was not)
hasn't (has not)	won't (will not)

b. Place an apostrophe where a figure or figures have been omitted:

class of '62 (1962)	the '50's (the nineteen—or other—fifties)
spirit of '76 (1776)	gold rush of '49 (1849)

c. Use an apostrophe to indicate pronunciation, usually in dialectal speech: "I say it's 'bout time you start tryin' hard and quit foolin' around."

The late Will Rogers is quoted as having said, "A lot of people who don't say *ain't*, ain't eatin'."

d. Use an apostrophe with certain abbreviated expressions such as "coined" verbs and participles: the truck driver CB'd for help; he *O.K.'d* the order.

e. Carefully distinguish between an expression with omitted letters (a contraction requiring the use of an apostrophe) and an abbreviation (a shortened form usually followed by a period). Don't use both an apostrophe and a period.

natl., nat'l	Dan, Dan'l
sec., sec'y	Benj., Ben

f. An apostrophe is usually omitted in shortened forms of certain words, although it is not incorrect—just overly precise—to use one:

coon (for raccoon)	the Fourth (for Fourth of July)
phone (for telephone)	plane (for airplane, aeroplane)
possum (for opossum)	copter (for helicopter)
cello (for violoncello)	chutist (for parachutist)

3.2 Possession

a. Use an apostrophe and *s* to form the possessive of a noun, either singular or plural, not ending in *s*:

man, man's	women, women's
men, men's	child, child's
woman, woman's	children, children's

b. Use an apostrophe alone to form the possessive of a plural noun ending in *s*:

doctors, doctors'	girls, girls'
lions, lions'	the Smiths, the Smiths'
countries, countries'	queens, queens'

c. Use an apostrophe alone or the apostrophe with *s* to form the possessive of singular nouns ending in *s*:

One-syllable proper names ending in *s* or an *s* sound add an apostrophe and *s*: *Keats's* poems; *Jones's* books; *Marx's* theories.

In words of more than one syllable ending in *s* or an *s* sound, add an apostrophe only: *Themistocles'* strategy, *Aristophanes'* plays, *Berlioz'* compositions.

Some common nouns not ending in *s* but having an *s* sound at the end add only the apostrophe: *for conscience' sake.*

d. In compound nouns add an apostrophe and *s* to the element nearest the word possessed: *the daughter-in-law's children, the daughters-in-law's children; Representative Smith of Colorado's vote.*

e. Use an apostrophe with the last element of a series to indicate joint possession: *Wolcott and Brown's store, a soldiers and sailors' home.*

f. Use an apostrophe with each element in a series to indicate alternative or individual possession: *Wilson's or Eisenhower's or Kennedy's administration, Authors' and Printers' Dictionary, Bob's and Jim's plans, bachelor's and master's degrees, soldiers' and sailors' uniforms.*

g. Use an apostrophe and *s* to form the possessive of indefinite pronouns:

anybody's	other's
everybody's	somebody's
no one's	someone's

Do not use an apostrophe to form the possessive of personal and relative pronouns: *ours*, not *our's; yours*, not *your's; hers*, not *her's; whose*, not *who's* (unless you mean *who is*); *its*, not *it's* (unless you mean *it is*).

h. With geographical terms and with names of firms, organizations, and institutions, follow the authentic form settled upon by usage or tradition: *Harpers Ferry, Hudson Bay, Hudson's Bay*

Company, St. Mary's Seminary, Citizens Union, Rutgers University, Columbia University Teachers College.

 i. Certain idiomatic expressions require the use of an apostrophe even though actual possession is not clearly indicated: *a day's wait; an hour's delay; a stone's throw; twenty cents' worth; at my wit's end.*

 j. Certain double possessives require both an apostrophe and *of: a book of my friend's; a brother of Jane's; a nephew of my cousin's.*

 k. A noun followed by a gerund (verbal noun) should have an apostrophe: We objected to the *foreman's* leaving early.

3.3 Plurals

a. Use an apostrophe and *s* to indicate the plurals of alphabetical letters: Mind your *p's* and *q's*. Dot your *i's* and *j's*. Your *i's* look like *e's*.

 b. Use an apostrophe and *s* to indicate the plurals of figures: We have no more size *8's*. He suffered every year during the *1930*'s. They came by *2's* and *3's*.

 c. Use an apostrophe and *s* to indicate the plurals of symbols and of some abbreviations: The three *R's*; Indent all ¶'s three spaces; How many *C.O.D.'s* did they receive?

 d. Do not use the apostrophe in forming the plural of nouns unless actual possession is shown: *The Smiths have arrived*, but *the Smiths' house was for sale.*

 e. Use an apostrophe to indicate the plurals of words referred to as words: Your remarks contained entirely too many *but's*.

As with several of the other marks of punctuation so with use of the apostrophe: there is a growing tendency to dispense with it. This practice is particularly noticeable in England. But also as with other marks of punctuation, the test for its use is clarity: does it help to make meaning clear? Without an apostrophe *she's* (she is) becomes *shes; he'll* (he will) becomes *hell; she'll* (she will) becomes *shell; three a's* becomes *three as; three as's* becomes *three ass.*

Exercises:

 A. Circle all the apostrophes on a page of printed material and give the reason for each.

B. Where are apostrophes needed in the following sen-
tences? Why?

1. You will find the visitors apartments in the east wing of
the building.
2. Its a pleasant feeling to know that someone thinks
youre brilliant.
3. After I receive my bachelors degree, I hope to con-
tinue on and obtain a masters degree.
4. By 12 oclock midnight I have all my next days plan-
ning done.
5. Stores in large cities feature by mail a personal shop-
pers service.
6. To me theres nothing in nature as beautiful as new-
fallen snow.
7. Our various families reunion last August was a great
success.
8. Recently I finished reading Nathaniel Hawthornes *The
Scarlet Letter.*
9. Now, lets look at some possible solutions to some of to-
days problems.
10. Alaska has always been built up in peoples minds as a
state where everythings big.

Answers to Exercise B

1. visitors'
2. It's . . . you're.
3. bachelor's . . . master's
4. o'clock . . . day's
5. shoppers'
6. there's
7. families'
8. Hawthorne's
9. let's . . . today's
10. people's . . . everything's

4

ASTERISK

An asterisk (*), a star-shaped figure now rarely used in non-scholarly writing, is a reference mark or a mark to indicate that something has been omitted. It is a conspicuous mark which calls attention to itself and is sparingly used even in footnotes and in reference books and technical writing.

As a reference mark, placed after a word or statement to be commented upon, the asterisk has now been largely replaced by the use of a superior number. The employment of asterisks to indicate omission of words from a sentence or entire sentences from a paragraph or even longer piece of writing has been almost universally abandoned in favor of ellipsis periods (see page 105). Formerly, asterisks were also often employed to suggest the passage of time in a story much as fades and dissolves are now used in television and motion pictures. Even for this purpose they have been largely replaced by ellipsis periods or by blank space.

You may use an asterisk to call attention to a word or sentence upon which you wish to comment further in a footnote or to which you wish to make a cross reference. But use the asterisk sparingly; it is glaring in appearance and its purpose can always be more effectively and quietly achieved by ellipsis periods or by figures.

5

BAR (VIRGULE)

A bar (/) is a short oblique stroke (a diagonal) used in printing and in some writing. Dictionaries usually refer to this slanting mark as a *virgule*, a word closely resembling the Latin word *virgula* (little rod) from which it is taken. Many printers and copy editors call this device a *bar*, or *slash*. Primarily a mark of separation or division, the bar has miscellaneous uses in modern English, all related in function.

It appears in such an expression as *and/or*, primarily a business and legal term used when three alternatives are present: *boys and/or girls* may mean "boys" or "girls" or "boys and girls." Some especially careful and precise writers object to the term *and/or*, but it is widely used and is undeniably a helpful timesaver.

A bar (virgule) is also used in quoting two or more lines of poetry in a prose passage when the lines are run together; use a bar to show the end of one line of poetry and the beginning of another. For example, these two lines from Pope's "An Essay on Man,"

And spite of Pride, in erring Reason's spite,
One truth is clear, Whatever is, is right.

might be written in a prose sentence: One of Pope's most quotable sayings, "And spite of Pride, in erring Reason's spite, / One truth is clear, Whatever is, is right." appears in his famous poem, "An Essay on Man."

Other uses of the bar are somewhat technical or informal. In

marking printer's proof, a bar normally follows a correction made in the margin and is also used to separate two or more corrections made in the same line: lc/?/cap.

Also, the bar sometimes is used to stand for the word *as*; an order for 500 copies of an item might read "520/500," which means that 520 copies would be shipped with only 500 being billed, the remainder being sent free to allow for damage in transit, promotional efforts, etc.

Occasionally, the bar (virgule) is used to represent a month-day-year combination in informal letters or memoranda: *November 11, 1918*, may be represented as *11/11/18*. Also, the expression "in care of" is shown informally as c/o. This device is sometimes used in writing fractions or in typewriting fractions not on standard keyboards: *7/8; 9/10*.

6

BRACE

A brace ({ }) is a mark most often used to connect two or more lines of writing and to group items in formulas, mathematical and chemical equations, and tables of statistics. Like all other marks of punctuation and mechanics, it is used solely for clarity: to make understandable to the reader the relation between one line or group of lines consisting of words, symbols, or figures and another line or group of lines. Here are simple examples of the use of braces:

Conn.
Mass.
R.I.
Me. } New England States
N.H.
Vt.

Wash.
Ore. } Pacific Coast States
Calif.

Intervals of payment {
daily
weekly
monthly
annually

Forces of Evolution {
mutation
migration
genetic drift
natural selection

7

BRACKETS

A bracket is one of two marks used primarily to enclose material that lies within quotation marks, but that is not part of the quoted passage. That is, brackets are editorial marks used to enclose comments, corrections, or additions to quoted material. The mark is often used in professional and academic writing but has limited use elsewhere. Brackets should never be confused with marks of parenthesis, which have entirely different uses. Parentheses are used to enclose your own parenthetical material; brackets are used solely to set off matter inserted by you in someone else's writing that you are quoting.

7.1 Inserted Comments

You may have occasion to make a comment on a quotation which you are using. You can give the quotation as it stands and make the comment you wish in a *following* sentence or phrase, perhaps enclosing your comment in parentheses. Usually you can save time and space by adding the comment within the quotation and enclosing it in brackets:

The speaker then said, "I am annoyed [obviously he was furious, not merely annoyed] by the neglect of our officials."

The foreman then remarked, "You may have the rest of the day off. [Cheers.] But you must report for work on time tomorrow."

7.2 Corrections

If the person whom you are quoting has made an error, or what you consider an error, you can add a correction and enclose it with brackets. If you wish not to make a correction but merely to call attention to the error, you may use the Latin word *sic*, which means *thus*, and enclose it with brackets:

> "In 1776 on the tenth [fourth] day of July, the Declaration of Independence was signed."
>
> "I was born in 1938," the candidate wrote, "in Walthum [Waltham] Massachusatts [Massachusetts] and have lived there all my life."
>
> "I am of English decent [sic] and am proud of my heritage."

7.3 Additions

Brackets may be used to add thoughts or to fill in where words have been omitted from a quotation.

> The advertisement read: "These shirts [oxford cloth, button-down collars] were designed by Oleg Rastrobi."
>
> "The jury awarded £200 [$560] to the plaintiff."
>
> "Later in the play," the lecturer continued, "he [Hotspur] is killed."
>
> "They [the Germans] were not any more at fault than their collaborators [the Russians]," the speaker concluded.

7.4 Miscellaneous Uses

Brackets are also used in printing stage directions for some plays, such as [*Macbeth enters*], and, on rare occasions, to enclose parenthetical remarks already set in parentheses: *This incident (it is related in Chapter XV of the authorized biography [1946 edition]) is not authentic.*

8

CAPITAL LETTERS

It is impossible to state all the rules for employing capital letters in English. The appearance of capitals is widespread; usage is not fixed and unchanging; exceptions occur for almost every "standard" rule of capitalization. For example, the latest printing of the *U.S. Government Printing Office Style Manual* devotes thirty-eight pages to the use of capitals—and thoughtfully adds a blank page on which one presumably may make notes of exceptions and variations.

Despite the confusion that exists about capital letters, the basic principles involved are somewhat clearer than they were at the turn of the century. In general, current tendency is toward a "down" style. (Capitals are sometimes called "upper-case" letters since they come from the upper case of a font of hand-set type. Small letters are correspondingly sometimes called "lower-case" letters.) Books, magazines, and especially newspapers are employing fewer and fewer capitals than they formerly did. A glance at a book or newspaper of a century or two ago will clearly indicate this trend. The best general rule to follow is this: Use capitals only for a specific purpose and in accordance with a clearly recognized principle. Unnecessary capital letters clutter up a page as much as do large numbers of dashes, asterisks, or other obtrusive marks.

With overlappings and duplications, the twenty-one sections (alphabetically arranged) which follow contain "rules" to guide you in every conceivable situation calling for capital letters. By applying the broad principles involved and by a certain amount of

common sense and judicious analogy you can usually decide whether to capitalize or not, even when the exact situation facing you is not covered precisely. Finally, you can always resort to your dictionary for specific guidance.

8.1 Calendar Divisions

Capitalize names of days of the week and months of the year: *Monday, Tuesday, Wednesday*, etc.; *January, February, March*, etc. Do not capitalize the seasons unless you wish to personify them (see 8.13): *winter, spring, summer, fall, autumn*. A century may be referred to with either small or capital letters, although the former usage is now more common than the latter: *twentieth century* or *Twentieth Century*.

8.2 First Words

a. Capitalize the first word of every sentence. This is *one* rule which all of us know.

But even this hard and fast practice is not necessarily always followed. Of course it applies in nearly all instances, but just to show you how involved and perplexing much of punctuation is, suppose you were to write the following:

Letters in the English language may be classified as vowels and consonants. *A, e, i, o*, and *u* are the principal vowels.

You do not mean that *a* is a principal vowel only when it is capitalized; the sentence really could logically begin with a lowercase (small) letter, couldn't it?

Or how about this?

The tree was not healthy (beetles are the natural enemy of leaves) and had to be cut down.

A sentence enclosed in parentheses inside another sentence *may* begin with a capital letter, but it rarely does.

Even so, remember the basic rule. But also remember that very little about punctuation can be taken for granted; very few of its "rules" admit *no* exception.

b. Capitalize the first word of a direct quotation and of a quoted sentence:

> Our shop foreman said, "You have done a good job."
> "I never met a man I didn't like" is a saying attributed to Will Rogers.
> "Yes," she replied. "You have my permission to leave now and my request never to return."
> Aldous Huxley once wrote: "That all men are created equal is a proposition to which, at ordinary times, no sane human being has ever given his assent."

When only part of a direct quotation is included within a sentence, it is usually not begun with a capital letter:

> The accident victim said that he felt "badly shaken," but he refused hospitalization.

c. The first word following a colon, question mark, or exclamation point is capitalized if it is a proper name or if it begins a complete sentence that expresses a different idea from that preceding the mark of punctuation.

> In suggesting that no one is indispensable Stevenson wrote: "Atlas was just a gentleman with a protracted nightmare."
> A wise man knows this: Advice when it is most needed is often least heeded.

The first word following one of these three marks is usually not capitalized if it introduces a supplementary remark that is closely related to what preceded the mark. Thus:

> Wars are never accidental: they are planned.
> Who is coming? Are you? your father? your mother?

d. In quoting (or writing) poetry, capitalize the first word of each line:

> And we are here as on a darkling plain,
> Swept with confused alarms of struggle and flight
> Where ignorant armies clash by night.
> —Matthew Arnold

Some modern poetry is written without capital letters at the beginnings of lines. Always use the capitalization employed in the poem you are quoting.

e. The first word following a resolving or enacting clause is capitalized. The first word following *Whereas* in contracts, resolutions, and the like is usually not capitalized:

Resolved, That the Congress do now . . .
Be it ordered, That . . .
Whereas the following parties . . .

f. Capitalize the first word and each noun in the salutation of a letter, but only the first words in the complimentary close:

My dear Sir: ; Dear Mr. and Mrs. Brown: ; Very truly yours, Yours sincerely,

8.3 Foreign Languages, Capitalization in

The use of capital letters, already involved and confusing, is made more chaotic by reason of the fact that several foreign languages employ capitals quite differently from English usage. Perhaps you know, for example, that *all* nouns and all words used as nouns are capitalized in German. But did you know that the adjectives derived from proper nouns (as *American* is derived from *America*) are *not* capitalized in French, Italian, Spanish, Portuguese, Danish, Norwegian, and Swedish? We would write "French literature"; the French write "littérature française."

If you know a foreign language well enough to write it, you probably know most of the rules for its capitalization. If you are reading a foreign language, do not think that its capitalization is necessarily incorrect merely because it does not follow English practices. And do not be misled by foreign-language capitalization; apply the "rules" given here for English and study a foreign-language textbook for capitalization elsewhere. As a matter of interest, here are a few scattered comments:

(1) In Greek and Latin poetry, only the first word of a paragraph (stanza) is capitalized, not each line of verse.

(2) In German family names, *van* and *von* are usually

capitalized, but not always. Follow the preference of personal signatures.

(3) Latin follows English practice in capitalizing proper nouns and proper adjectives; the Dutch capitalize all nouns (as the Germans do) and all proper adjectives (as the Germans do not except for those derived from persons' names).

(4) For our particle *the* the French use *le* and *la* (masculine and feminine); for *of the* they use *de la, du (de + le), des (de + les)*. These particles are capitalized when not preceded by a Christian name or title and are written in small letters when they are preceded by such a name or title. Italians use *di* and *da* and the Dutch *ter* as the French use *de* and *du*.

Guy de Maupassant; De Maupassant; La Salle; Du Barry; Leonardo da Vinci; Hans ter Zeeland.

8.4 Geographical Terms

Normally, use capitals for the names of countries, domains, territories, regions, localities, and geographic features. This is a mouth-filling rule; perhaps you would prefer simply to remember to use capital letters with all accepted and recognized geographical names. But even this simple rule has an exception: normally do not capitalize a descriptive place reference: the valley (not Valley) of the Missouri; north, south, east, west; eastern seaboard; southern France. The following sketchy list will serve as a guide to most capitalization of geographical terms:

the Seine River (but: the river Seine)

New York State (but: the state of New York)

British Columbia

the United States Government

the Commonwealth of Virginia

the Union of South Africa

the Far East

the Solid South

the Sahara Desert

Lake Huron

Roman Empire (but: an empire of the Romans)

our Park Avenue branch

the Orient (but: in oriental lands)

the British Commonwealth of Nations

the Gulf of Mexico

the North Pole

the Dominion of Canada

the Western Hemisphere (but:
 the Western world)
the Blue Ridge Mountains
the Torrid Zone
the Continental Divide
Des Moines
New York City (but: the city of
 New York)

the Swiss Confederation
the South Atlantic States
American Samoa
the Eternal City
an American republic (but: the
 Republic, for United States)
the North End of Boston (but:
 the northern part of Boston)

8.5 Governmental Terms

The names of administrative, legislative, and judiciary bodies and departments on both national and local levels are usually capitalized:

the House of Representatives
the Senate
the federal Congress (but: the
 federal government)
the Department of Labor
the Bureau of the Census
the General Assembly of Utah
the Circuit Court of Sumter
 County

the British Embassy
the United Nations
the U.S. Army, U.S. Navy, U.S.
 Air Force
the Iowa State Highway Commission

8.6 Historic Events, Eras

Commonly accepted names for historic events and eras are normally capitalized. If the term includes the word *days* or *era* or *epoch* or *period*, the name itself is capitalized and so is the following word if there is any possibility of confusion, but not otherwise. Thus you might correctly write *in Colonial days* but refer to the *Colonial Period* in United States history.

Christian Era
Revolutionary War
Cenozoic era
the Middle Ages

Battle of Shiloh
Louisiana Purchase
the Renaissance
Fall of Constantinople

Acadian epoch Stone Age
World War II (Second World the Treaty of Versailles
 War)

8.7 Holidays, Festivals

The names of most holidays and of many feast, festival, and fast days are capitalized:

Christmas Holy Week
Easter Boxing Day
Yom Kippur Shrove Tuesday
Passover Feast of Tabernacles
the Fourth of July V-J Day
Memorial Day Veterans Day

8.8 Initials, Abbreviations

Many abbreviations for titles and degrees and several miscellaneous one-letter symbols are capitalized. Exceptions occur, but this brief list will be a helpful guide:

Mr. Smythe F. (Fahrenheit)
Gen. George Washington C. (centigrade)
Samuel Slade, Ph.D. C (one hundred)
Sir John Eller, M.P. M (one thousand)
James C. Wing, D.D.S. R_x (prescription; take)
the Hon. Alfred Brown N. (North)
James Wilson, Sr. A.P. Herbert

8.9 Interjections

Interjections (exclamations of surprise, anger, etc.) often appear at the beginnings of sentences and are capitalized for this reason only. However, the single-letter interjection *O* is always capitalized regardless of its position in the sentence:

Please come early and, oh, be sure to bring some food.

"Sail on, O Ship of State."

Oh, she cried, and O! I replied
Mid cries of *bravo* from every side.

8.10 Names

Names of people and of titles used to refer to specific people are always capitalized; so also are names of specific places. Also capitalized are names of organized bodies and groups. So many categories of names are involved that it may help to classify those which require capitalization.

a. *Proper names*: Theodore Roosevelt, John Smith, Margaret, Asia, Rome, the Brown family, Illinois, President Clinton.

b. *Derivatives of proper names*: Asian, Roman, French, North American, Portuguese, Elizabethan, Norwegian.

c. *Common nouns and adjectives in proper names:* the *boulevard*, but *Sunset Boulevard; eastern* and *shore*, but the *Eastern Shore; river*, but the *Yellow River; canal*, but the *Suez Canal.*

d. *Organized bodies and groups and members of same:* Cornell University, the Southern Railway System, University Club, New Salem High School, Republican Party (party), San Francisco Giants, Bureau of the Census, Italian Ministry of Foreign Affairs, a Shriner, a Boy Scout, an Odd Fellow, U.S. Navy.

These four categories provide examples of most uses of capital letters with names of varied sorts. Tricky exceptions abound, however. A few of the more important may be briefly stated:

(1) Some proper names have acquired so general and well understood a meaning that they no longer require capitals: *venetian blinds, pasteurized milk, platonic love, oxford cloth, turkish bath, watt, boycott, macadam, buncombe, davenport, bohemian.*

(2) Nouns of kinship are not capitalized unless used as a substitute for a proper name. When such nouns are preceded by an article or possessive, they should not be written in capitals:

My mother; I want you to meet Mother; her cousin; Cousin George.

(3) Names of courses of study other than those derived from proper names are capitalized only if they refer to a specific course:

He is interested in science, especially biology, and plans to take Biology 1 next year.

The French language; an algebra course; Chemistry 12.

(4) Capitalization of the article *the* with proper names is not standardized. Normally we write *The Hague* when referring to the city but are likely to refer to the *Atlantic Monthly* or the *Netherlands*.

As with other marks of punctuation and mechanics, a good dictionary is a genuine help in deciding on the use of capitals with names of all sorts.

8.11 Ordinal Numbers

An ordinal number (first, second, third, etc.) is capitalized when used with the name of a person or a period of time. Such numbers are spelled out if they precede the name; Roman numerals may follow the name of the person or era:

the Forty-ninth Congress; George VI; Pope John XXIII; the Second New York Regiment

8.12 Peoples and Races

The names of so-called divisions of humanity based on such matters as skin color and head shape, geographical origin, and other classifications are always capitalized: *Aryan, Celtic, Anglo-Saxon, Caucasian, Nordic, Negro, Alpine, Mediterranean, Norman, Eskimo, Tasman, Indian, Malayan, Hottentot.*

8.13 Personification

Personification involves attributing to an abstract idea or non-living object the features and characteristics of personality, of human life. Poets, especially those of an earlier day, were fond of this figure of speech. You will probably rarely need to capitalize for this somewhat unusual purpose.

"The Angel of Death is abroad in the land . . ."

There Honor comes, a pilgrim gray,
To bless the turf that wraps their clay;
And Freedom shall a while repair,
To dwell a weeping hermit there!
 —William Collins

Other related examples of such figures of speech are *the Chair* (for chairman); the *Nutmeg State* (for Connecticut); the *New Frontier* (for the Kennedy administration). Such fanciful names and figures are always capitalized.

8.14 Political Parties, Alliances

The specific names of political organizations, associations, and movements are always capitalized: the *Democratic party; a Communist; Bolsheviki; Fascist; Nazi; Socialist Democratic Party; Holy Alliance; Conservative party.* (Note the word "party" is sometimes capitalized following a name, especially in a list of organizations; but the lower-case spelling has become more common.)

8.15 Religions, Sacred Writings

Most religious terms are usually capitalized. These include names of the Deity and personal pronouns referring to the Deity; names for the Bible and other sacred writings, and the names of religions and religious groups. Even Satan is not neglected; he gets a capital letter, too.

God, Heavenly Father, Jesus Christ, the Almighty, the Creator, Jehovah, the Lord, the Bible, the Scriptures, the Book of Genesis, the Koran, the Talmud, Protestantism, Roman Catholic, Jesuit, Unitarian, Presbyterian, Moslem, Hinduism, His Satanic Majesty, Ursuline Sisters, the Apostles' Creed, the Blessed Virgin, the Messiah, the Holy Ghost, Vulgate, Vedas, Pentateuch, King James Version, the Ten Commandments, the Upanishads, the Apocrypha.

Note that not all adjectives derived from religious terms are

capitalized. It is not customary to spell with a capital such words as *apocryphal, vedic, biblical, scriptural,* and *gospel* (as in *gospel truth*).

8.16 Scientific Names

Many scientific publications fix their own rules for capitalization and several other matters of punctuation and mechanics. Therefore, it is impossible to state rigid rules, but in general the name of a scientific class, order, genus, or family is capitalized: *Carnivora, Crustacea, Felidae, Arthropoda.*

Usage differs so widely that you must be guided in the capitalization of scientific terms by the style book (or other directions) of a particular publication. If you can distinguish between the Latin and English origins of scientific terms, it is usually safe to capitalize the former (the Latin, scientific names) and to put the English derivatives of orders, species, and the like in lower-case letters.

8.17 Streets, Roads, Parks

The names of specific streets, roads, thoroughfares, toll roads, buildings, and the like are usually capitalized:

Fifth Avenue	Route 66
Long Lots Boulevard	Flatiron Building
Ninety-sixth Street	Hayden Planetarium
Massachusetts Turnpike	the Outer Drive
Lincoln Highway	Sixth and I streets
Times Square	Bronx Park
Golden Gate Bridge	the Colosseum

8.18 Titles of Persons

All titles or other similar designations preceding names of persons are capitalized. Such titles are usually (but not always) capitalized when they follow the name of a person:

President Jefferson; Thomas Jefferson, third President of the United States; Ambassador Bohlen; Professor Johnson; Dr.

Johnson, a professor at Davidson College; Chairman Thomas; the Chief Magistrate; former President Reagan; Dean Acheson, former Secretary of State; Elizabeth II, Queen of England; Your Honor; Your Highness; Nurse Thompson; Alexander the Great; John T. Doe, ex-Governor of Utah; Chief of Staff, U.S. Navy; the Reverend Stanley Houston; Senator Bob Dole, chairman of the committee.

Even when used without a name, a title referring to a specific person is often capitalized: *the King gave up his crown in 1634; the Governor was re-elected in 1984.* Titles which do not refer to a specific person should be in lower case: *the king of any nation would accept this proposal.*

Ordinarily, we do not think of words like *sir* and *gentlemen* as titles, but they become titles in the salutations of business letters and thus should be capitalized:

Dear Sir: Gentlemen: Dear Madam:

8.19 Titles of Publications

Capitalize the first and all important words in the titles of publications, historic documents, works of art, annual reports, and the like:

Saturday Evening Post; the *Post; The Grapes of Wrath;* Gray's *Elegy Written in a Country Churchyard;* the Constitution (for U.S. Constitution); the Massachusetts constitution; Gainsborough's *The Blue Boy;* the Jay Treaty; Senate Document 60; *The Journal of Religion;* the *St. Louis Post-Dispatch.*

You may well ask what are "important" words in a title. Normally, you do not need to capitalize articles, prepositions, or conjunctions unless they come first or last in the title or consist of five or more letters. (The number five was settled upon as a curious convention of which no one knows the origin.) All words other than articles, conjunctions, and prepositions are considered "important."

The Library of Congress advocates capitalizing only the first word and any proper nouns or adjectives in a title: *Dominant*

types in British and American literature. This usage may become widespread; until it does, follow the principles stated above.

8.20 Trade Names

Trade names, variety names, and some market terms should be capitalized. (A number of firms have spent considerable money and entered into numerous lawsuits to enforce recognition and capitalization of their trade-marks and trade names.) Common nouns which follow such capitalized terms are put in small letters:

> Bon Ami; Palmolive; Mr. Clean; Ry-Krisp; Frigidaire; Wheaties; Diet Coke; Plexiglas; Pyrex dishes; Pepsi Cola (but a *cola* drink); Choice (grade); Yellow Radiance rose (variety).

8.21 Unnecessary Capitals

By way of summary, remember to use capitals only when there is a specific reason to do so. It is a worse error to use too many capitals than too few. Above all, avoid the unwise and unnecessary use of capitals. Specifically:

(1) Do not capitalize names of points of the compass unless they refer to a specific section or area.

(2) Do not capitalize names of the seasons unless you wish to personify them—which is hardly likely.

(3) Do not capitalize a noun or adjective if the reference is to any one of a class of things or persons rather than something or someone specific. Is the word a name given to a particular unit which is not shared by other units of its sort?

(4) Do not carelessly write small letters so large that they resemble capitals and thus confuse your reader.

Exercises

 A. Circle all the capitals on two paragraphs of a magazine or newspaper. Give the reason for each capital letter.

Answers to Exercise B

1 . . . English . . . "You" . . . 2 . . . Bible . . . books . . . God . . . His . . . 3 . . . states . . . cities . . . Indian . . . 4 . . . freshman . . . College of Home Economics . . . Lakeside University . . . 5 . . . "How . . ." "Thursday or Friday?" . . . "Fine!" 6 . . . Plant Science 140 . . . English Composition 101 . . . Chemistry 111 and 112 . . . Zoology 161 . . . Speech 114. . . . 7 . . . The Mississippi River . . . in American history; the Kankakee River . . . 8 . . . Rome, Italy . . . December, January, and February. 9 . . . happiness . . . A . . . English paper. 10 . . . Aunt Laura and Aunt Ida . . . 11 . . . chemistry, guns, airplanes, rockets, and the planet Earth. 12 . . . English . . . topic sentences and transitional sentences . . . 13 . . . Chatsworth . . . U.S. Highway 52 to Junction #24 . . . State Route 124. . . . 14 . . . my father . . . in the East and in the South. 15 . . . Shelley . . . "Ode to the West Wind," . . . "O Wind, if Winter comes, can Spring . . . ?"

B. Correct the misuse or nonuse of capitals in these sentences:

1. Our english teacher often told us, "you can't judge a book by its cover."

2. Numerous examples can be cited from the bible and other Books about god and the greatness of his works.

3. The names of some of our States and many of our Cities have an indian origin.

4. I am registered as a Freshman in the college of home economics here at lakeside university.

5. She blurted out, "how about thursday or friday?" to which he replied, "fine!"

6. My freshman courses consist of plant science 140, english composition 101, chemistry 111 and 112, zoology 161, and speech 114.

7. The mississippi river is the most famous river in American history; the Kankakee river is not so well known.

8. The climate is mild in rome, italy; the coldest months are december, january, and february.

9. In little things Happiness is sometimes found, like an a on an english paper.

10. Every summer aunt laura and aunt ida come to visit us.

11. My main interests deal with the subjects of Chemistry, Guns, Airplanes, Rockets, and the Planet Earth.

12. Some english teachers hunt for Topic Sentences and Transitional Sentences the way a hunter hunts for game.

13. To reach chatsworth you must take u.s. highway 5 to junction 24, and then turn left on state route 2

14. During his term of service my Father was sent t live in several places in the east and in the south

15. The poet shelley ends his famous poem, "ode t the west wind," with these words: "o Wind, if ter comes, can spring be far behind?"

9

CARET

A caret ($_\wedge$) is an inverted v-shaped mark used to show that something between lines or in the margin should be added at the point indicated. The word *caret* has been taken over from Latin, in which language it means "there is lacking," "there is wanting."

The caret is a useful device for making insertions, but do not overuse it. It is preferable for an entire page to be handwritten again or retyped to avoid too many unsightly additions. Here is an example of how a caret may be used:

the autumn of

The first clubhouse, at 9 Brevoort Place, was leased in $_\wedge$1865.

10

COLON

The colon (:) is a mark of expectation or addition. Its primary function is to signal the reader to "watch for what's coming." That is, it signals to the reader that the next group of words will fulfill what the last group promised. What does come after the colon is usually explanatory or illustrative material that has been prepared for by a word, or words, preceding the colon.

Major uses of the colon are to introduce lists, tabulations, enumerations; to introduce a word, phrase, or even a to-be-emphasized clause; to precede an example or clarification of an idea suggested before the colon; to introduce a restatement of a preceding phrase or clause; to spell out details of a generalization; to introduce a formal quotation.

The colon is a somewhat formal mark of punctuation and is not used at all by some writers. It does have its specific purposes, however, and should not be carelessly replaced by a dash, semi-colon, or comma. Neither should it be overused, since it does mark a definite break in sentence thought and is a rather obtrusive mark.

The colon is also a mark of separation in certain instances involving several miscellaneous constructions.

10.1 The Introductory Colon

Here are examples of the colon used in its primary function:

My goal in this job is simple: success.

Only one course remains: to get out of here at once.

To sum up: work hard, save your money, watch your health, and trust in God.

This is my next problem: what do I do now?

"We are never deceived: we deceive ourselves."

Do this before you leave: check your passport, buy traveler's checks, have your smallpox vaccination.

Everything was in order: chairs were arranged, windows were closed, lights were turned on.

The purpose of study is not learning alone: it is also enjoyment.

Gray behaved well at the party: he spoke to all visitors, unwrapped his presents slowly, expressed his thanks, and ate his ice cream carefully.

Respect is not seized, it is earned: it is bestowed most often upon those not directly seeking it.

He thought that this was the main difficulty with giving back the country to the Indians: they would never take it and assume all the mortgages.

Jefferson concluded his First Inaugural Address as follows: "And may that Infinite Power which rules the destinies of the universe lead our councils to what is best and give them a favorable issue for your peace and prosperity."

10.2 The Separating Colon

It is not always easy to decide whether a colon introduces or separates. But in the following illustrations, the colon seems to separate more than to introduce.

a. *In business letters*, the salutation is separated from the body of the letter by a colon: *Dear Sir: Dear Mr. James: Gentlemen: My Dear Mr. Burnside:*

It is customary to place a comma after the salutation of a friendly or personal letter (*Dear Jim,*), but the colon is not so formal a mark as to repulse friendship. Use either a colon or a comma after the salutation in such letters.

b. *Titles and subtitles of books* may be separated by a colon: *The*

English Novel: A Panorama; Education for College: Improving the High School Curriculum.

c. *Hour and minute figures* in writing time may be separated by a colon: 10:15; 4:46 P.M. In England, a period is often substituted for the colon in such uses, a practice being increasingly adopted by some American publications, particularly newspapers. You are urged to use the colon, however, since it is both clear and customary.

d. *Scenes and acts of plays* may be separated by a colon: Shakespeare's *Twelfth Night,* II:v. The use of a period for the colon in this construction is increasing, but the colon seems clearer.

e. *Bible chapters and verses* may be separated by a colon: Exodus 12:31. Some authorities, including the *Chicago Manual of Style* and the *Government Printing Office Style Manual,* recommend that no italics be used for names of books of the Bible but both insist on the colon rather than the period in this construction.

f. *Volume and page references* may be separated by a colon: *The History of the English Novel,* IV:77.

g. *A publisher's name and location* may be separated by a colon: *New York: W.W. Norton & Company.*

h. *In stating proportions,* both a single colon and double colon may be used: fertilizer mixed 6:3:3; 2:4::4:8 (two is to four as four . . .).

10.3 Position of the Colon

A colon is placed outside quotation marks. If introductory material calling for the use of a colon ends with words in parentheses, place the colon outside the closing parenthesis. Note these examples:

This is the first line of Jonson's "Song to Celia": "Drink to me only with thine eyes."

For his tardiness he had an excuse (a silly one): he had failed to set his alarm clock.

10.4 Overuse of the Colon

The colon is a useful mark adding clarity to writing, but it should be used to accomplish only the two purposes suggested on pages 68–70. Used in other constructions, the colon becomes both obstructive and intrusive. Specifically:

(1) Do not place a colon between a preposition and its object:

I am fond of: New Orleans, Seattle, and Denver. (There is no need for the colon or, indeed, for any mark of punctuation after *of.*)

(2) Do not place a colon between a verb and its object or object complement:

He likes to see: TV plays, movies, and football games. (Use no mark of punctuation after *see.*)
She likes a number of activities, such as: swimming, dancing, and cooking. (Use no mark after *such as.*)

(3) Do not indiscriminately use the colon instead of the dash as a summarizing mark. The colon anticipates whereas a summarizing dash suggests that something has preceded:

Mutual funds, savings accounts, common stocks: these are popular methods of investing. (A colon can be used in this construction, but a dash is preferable.)

(4) Do not use a colon after such introductory words as "namely" and "for instance" unless what follows consists of a complete statement. Otherwise, use a comma, not a colon. "As follows" or "the following" normally requires the use of a colon inasmuch as the introducing words are incomplete without the illustrative or listed items that do follow.

(5) A good general rule for avoiding incorrect overuse of the colon is this: *Never use a colon directly after any verb or after the conjunction "that."*

For the use of small letters or capitals to begin the first word following a colon, see page 54.

11

THE COMMA

Because the comma (,) serves so many different purposes it is the most widely used of all punctuation marks. Its varied and distinct uses result in its being by far the most troublesome of the marks; in fact, comma usage varies so greatly that only a few rules can be considered unchanging. But this mark of punctuation, more than any others, can and does help to clarify the meaning of writing. Its overuse and misuse also obscure meaning more than the misapplication of any of the other marks. If you can master the uses of the comma—or even the basic ones—no other mark can hold any terrors for you.

As has been noted, the comma is a relatively weak mark as compared with the period, semicolon, etc. It shows a brief pause, less complete separation than other marks. Always used within the sentence, it serves several purposes: to introduce, to separate, to enclose, to show omission.

Before undertaking the somewhat detailed study that follows of these four purposes of the comma, it may help you to consider six basic, broad principles of comma use. Learning these six fundamental applications of the comma won't solve all your problems with this mark, but doing so will solve the majority of them.

(1) Use a comma to separate long independent clauses in a compound sentence:

Jack has not replied to my letter, nor do I think that he ever will.

She tried to interest him in the stock, but he insisted that he would invest his money in real estate.

(2) Use a comma to set off a long introductory phrase or clause from an independent clause which follows:

A retiring and unusually timid man, he refused even to consider the nomination.

When they had finished eating dinner and washing the dishes, they left for the theater.

(3) Use a pair of commas to set off words and groups of words inserted within a sentence:

The manager did not say that, as you would know if you had listened carefully, nor did he even hint at it.

On that occasion, it seems, he was driving carelessly.

(4) Use commas to divide elements in a series:

She blushed, stammered, and finally burst into tears.

Joe collected a change of clothing, shoes, and golf gear before he set off for the day.

(5) Use commas with transposed initials, with titles, in dates, etc.:

Dexter Lenci, M.D., and Francis Coffin, D.D., attended the services.

Both Smythe, H.M., and Smythe, J.W., were nominated for the position.

The boys sailed for Europe on June 22, 1962.

(6) Use a comma, or commas, to prevent misreading:

The morning after a policeman came to the door.

In 1942 361 men from this town entered military service.

(These two sentences *can* be unscrambled, but even momentary misreading will be prevented if commas follow *after* and *1942*.)

Learning these six principles of comma use will be an effective start; each is more fully explained and illustrated in the sections

which follow, together with additional comment, exceptions, and still other examples of comma usage.

11.1 Commas to Introduce

a. Use a comma to introduce a word, phrase, or, on occasion, a clause:

> He needed only one thing, encouragement.
> Only one course is left, to get a job.
> She had an important decision to make, whether she should get married or return to college.

Either a dash or a colon could replace the comma in each of these illustrative sentences. The comma is less emphatic than either of these other marks; which you use depends upon your specific purpose, your stylistic aim.

b. Use a comma to introduce a direct question that is preceded by a mental question or by musing aloud:

> You will refuse, won't you?
> I wondered, should I tell the foreman of my mistake?

c. Use a comma to introduce a short quotation:

> Sue replied, "I'll never speak to him again."

If the "Sue replied" or "she said" or an equivalent expression follows the quotation, it is separated by a comma unless a question mark or exclamation point is needed:

> "I'll never speak to him again," Sue replied.
> "Do you think I'll ever speak to him again?" Sue replied.

If the "Sue replied" or its equivalent is inserted within a quotation, it is enclosed by commas unless a stronger mark of punctuation is called for:

> "I'll never speak to him again," Sue replied, "unless he speaks to me first."
> "I'll never speak to him again," Sue replied; "he insulted me."

When the quotation being introduced is either long or formal, use a colon rather than a comma; see Section 10.1.

d. Use a comma after the salutation to introduce a friendly or informal letter: *Dear Nancy, Dear Hank,*

11.2 Commas to Separate

a. Use a comma to separate independent clauses joined by such conjunctions as *and, but, nor, or, neither, yet, for, so.*

> She did not like her work, and her distaste for it was evident to everyone.
>
> It is one of the busiest streets in town, but motorists should avoid it because it is filled with potholes.
>
> My brother had no reason for staying at home, yet he refused to go with us.
>
> The dancers wore few clothes, but they were all wrapped up in themselves.

This use of the comma is one of the most frequently illustrated in all writing. However, its very frequency allows considerable flexibility in application. For example, if the clauses are short, the comma may be omitted before the conjunction. But "How short is short?" If each clause consists of only four or five words or less, obviously each is short. If the clauses consist of only subject and predicate, the comma is usually omitted:

> The grass grew and the flowers bloomed.
> Janet did not come nor did Harry.

Even long clauses connected by a conjunction are sometimes written without a comma if their thought relationship is close or if the subject of both clauses is the same:

> Henry dressed as carefully as he could for he wished to make a good impression on the personnel manager.

In applying this general rule, the principle to keep in mind is as follows: use a comma regardless of the length of the clauses involved if you wish to provide special emphasis; omit it if no particular emphasis is desired and there is no danger of misreading.

He needs medical help now, or he will die.

". . . they toil not, neither do they spin."

Just after midnight the storm increased in fury and I became more and more terrified.

b. Use a comma to separate an introductory modifying phrase or adverbial clause from the independent clause that follows:

By working hard and pleasing his employers, Steve got several promotions.

When you have finished with this load, start on that one.

Note that the introductory phrase should be a modifying one *and* should contain a verb form in order to be followed by a comma. "Earning a big salary" contains a verb form, *earning*, but it does not modify in such a sentence as "Earning a big salary was his goal" and therefore does not require a following comma. Similarly, "Because of poor health" does not contain a verb form and, although it modifies in such a sentence as "Because of poor health the man could not work," it is not followed by a comma.

Also note that the comma follows only *introductory adverbial* clauses. Use no comma in a sentence such as "That you were late for work this morning is not my fault"; the noun clause, "that you were late for work this morning," is the subject of the verb *is*. As the subject of the verb it should not be separated from what follows.

This "rule" for separating introductory modifying phrases and adverbial clauses is time-honored and, until recently, was almost universally followed. Nothing, however, better illustrates the trend toward lessening punctuation than increasing elimination of the comma in such situations. Here, for example, is a sentence from the *New York Times* (August 3, 1961):

When a stubborn juror holds out against all persuasion and obvious facts he is sometimes acting upon deep-seated convictions that fully justify his stand . . .

The "standard rule" clearly calls for a comma after *facts*, but none appears here nor in three other similarly constructed sen-

tences on the same page of the same issue of this newspaper. Take your choice; but isn't the added comma an aid to clarity?

c. Use commas to separate words, phrases, and clauses in a series:

> Jocelyn, Virginia, and Helen have good parents.
> In the huge jail were what seemed miles of narrow, sunless, low-ceilinged corridors.
> Because of his morbid curiosity he read all he could find about Jesse James, John Dillinger, Jumbo, two-headed calves, and the Cardiff Giant.
> In this book, Mark Twain revealed the gloom, pessimism, skepticism, and fury which darkened his last years.

Some writers omit the comma before the conjunction and punctuate such series as those illustrated as A, B *and* C; A, B *or* C. Greater clarity—the main purpose of punctuation—is usually achieved by the comma with the conjunction. For this reason its use is recommended, although it may be omitted.

A variation on this series is three or more items with the last two not joined by a conjunction. Commas are used after each member except the last:

> This general store sells groceries, clothing, fishing supplies, camp equipment.

When a conjunction is used to join each pair in a series, use commas if emphasis is desired and omit them if it is not:

> I have seen nothing of Jim or Joe or Mary Sue.
> Jack has no energy, or enthusiasm, or desire left. (Emphasis)

d. Use a comma to separate two or more adjectives when they equally modify the same noun:

> She wore an old, faded dress and a new, pretty, expensive hat.

When the adjectives do not modify equally—that is, when they are not co-ordinate—use no commas:

A large green bug settled on the torn autumn leaf.

It is not always easy to determine whether modifying adjectives are really co-ordinate. One test is mentally to insert the co-ordinate conjunction *and* between adjectives; only if it naturally fits, use a comma. In the illustrative sentence immediately above, you can fit *and* between *large* and *green* and between *torn* and *autumn*, but the fit does not seem natural. "Large," for example, seems to modify "green bug." Also, truly co-ordinate adjectives can be reversed: "torn autumn leaf" makes sense whereas "autumn torn leaf" does not.

e. Use a comma to separate contrasted elements in a sentence. Such contrasted elements may be letters, numbers, words, phrases, or clauses:

> The word begins with an *s*, not a *c*.
> The answer should be 26, not 25.
> Your error is due to carelessness, not ignorance.
> Put your hat on the shelf, not on the floor.
> The harder he tried, the less he succeeded.

f. Use a comma to separate words or other sentence elements which might be misread.

Sentences in which commas are needed to prevent misreading are usually faulty in construction and should be rephrased. At times, however, a comma is essential to clarify meaning; without commas, the following sentences would be at least momentarily misunderstood:

> The stock advanced five points, to twenty-one. (The comma makes clear that the range of advance was sixteen upward, not between five and twenty-one.)
> Instead of scores, hundreds telephoned the station.
> He arrived on February 10, 1986.
> The day after, the supervisor was absent himself.
> In 1990, 331 people took this same test.
> To Barbara, the president was very kind.
> "They prefer an education to drills and forced marches, and college dormitories to army barracks."
> Soon after, she got up and left the house.

g. Use a comma (or commas) to separate thousands, millions, etc., in writing figures:

> In this contest 4,962 entries were received.
> The deficit that year amounted to $8,786,983,000.

Commas are used with all numbers of four or more digits except telephone numbers, years, and house numbers:

> He was born in 1952.
> She lives at 11002 Prospect Avenue.

The comma is also usually omitted from numbers in specialized use: motor number 136592; serial number 825364; 8.0946 inches; $^8/_{1200}$ of one inch.

11.3 Commas to Enclose

a. Use commas to enclose parenthetical words, phrases, or clauses.

A parenthetical expression (word, phrase, clause) may be omitted from a sentence without materially affecting meaning. Usually, but not always, a parenthetical expression may shift its position in a sentence without changing meaning:

> *However*, the order was not filled that day.
> The order, *however*, was not filled that day.
> Oh, *yes*, I shall be glad to go.
> You are, *on the other hand*, well suited for this work.
> Note, *for example*, the illegally parked bus.
> I believe, *whether or not you care for my opinion*, that our company was mistaken in its policy.

Parenthetical elements vary in intensity; you may indicate their relative strength by punctuation. Many expressions, for example, are so weak that they require no punctuation:

> *In fact* I agree with you.
> The foreman *also* believed that you tried.

If you wish to add strength to the parenthetical material of a sentence, enclose it with dashes, not commas:

He requested—*no, he demanded*—that the arrest be made.

I have an excuse—*a very good excuse*—for not paying the bill.

If the parenthetical material is only remotely connected with the idea expressed by the essential part of the sentence, it may be enclosed by parentheses:

He had an excuse (a flimsy one) for his lateness.

Dee (being the youngest child) was left at home that day.

b. Use commas to enclose inserted sentence elements.

Inserted sentence elements are similar to parenthetical words, phrases, and clauses but normally are more essential to the full meaning of a sentence than are the latter. They do not restrict the meaning of the sentence but they do add some degree of emphasis. Such emphatic expressions are set off by commas to indicate that they are to be considered forceful. Again, an inserted sentence element may interrupt or delay the meaning of a sentence, withholding (or suspending) important material until near the end of a sentence. Finally, an inserted sentence element may be transposed and thus require punctuation unnecessary in normal word order. Consider these examples of inserted sentence elements which are emphatic or suspending or transposed:

He is an honest man, a man of complete integrity, and has my full confidence. (Emphatic)

He is an honest man, not only because he keeps the letter of the law, but because he exceeds even the teachings of the Golden Rule. (Suspending)

A personable boy, tall and dark and handsome, was what she expected as an escort. (Transposed)

c. Use commas to enclose nonrestrictive phrases and clauses within a sentence.

This is the most involved of all rules concerning the comma: it is not easy always to determine whether a group of words is restrictive or nonrestrictive in essential function.

As a broad distinction, restrictive phrases and clauses so limit and identify the word or words they modify that their contribu-

tion to the meaning of a sentence is essential. Nonrestrictive phrases and clauses do not limit or actually restrict the word or words they modify. Observe what the identical clause does in each of these sentences:

> Denver, *which is the capital of Colorado*, has an altitude of one mile.
> The city *which is the capital of Colorado* has an altitude of one mile.

In the first of these sentences, the italicized clause may be omitted without materially affecting central meaning; the purpose of the clause is to supply additional information. The clear and controlling idea of the sentence is "Denver has an altitude of one mile." But the same clause in the second sentence is essential; it identifies, it tells *what* city "has an altitude of one mile." True, the italicized clause in the second sentence could be omitted and a grammatically complete sentence would remain, but it would lack full meaning.

Therefore we say that the clause in the first sentence is *nonrestrictive*, and we enclose it in commas to set it off from the remainder of the sentence. The second is *restrictive* and should not be enclosed by commas or by any other mark of punctuation.

If you will carefully note comma usage in the following sentences, the principle of restrictive and nonrestrictive phrases and clauses should become clear:

> Our son Stephen, *who was 17 last year*, hopes to become a physician.
> Our son *who was 17 last year* hopes to become a physician.
> The books *that I own* are all paperbacks.
> The books, *those that I own*, are all paperbacks.
> The suit *lying there on my bed* has had long wear.
> The suit, *a blue one lying there on my bed*, has had long wear.
> The girl *sitting in the front row* is a secretary.
> The girl wearing a green dress and hat, *sitting in the front row*, is a secretary.
> The Dover *which is in England* is quite unlike *the Dover which is in Delaware*.

This Dover, *which is in England*, is quite unlike that Dover, *which is in Delaware*.

d. Use commas to enclose absolute phrases.

An absolute phrase is a group of words having no grammatical relation to any other word in a sentence. It is called "absolute" because it stands apart and conveys only its own meaning. Such a phrase may appear at various positions within a sentence:

> *The performance over*, we rose to leave.
> He entered the office, *hat in hand*, to seek the job.
> They were lonely that year, *their only son being away on military duty*.

e. Use commas to enclose words in apposition.

Words in apposition follow another word or group of words and serve to identify or explain them. A word in apposition, called an *appositive*, is a noun or pronoun, or a phrase acting as one of these two parts of speech, which provides explanation and is usually nonrestrictive in function. When the words in apposition actually limit or restrict meaning, then no enclosing commas are used:

> James Greene, *our foreman*, was a kindly man. (Nonrestrictive)
> Our foreman, *James Greene*, was a kindly man. (Nonrestrictive)
> *Foreman James Greene* was a kindly man. (Restrictive)
> Barry Smith, *Republican*, is a senator from Ohio.
> My assignment, *to wash all the dishes*, seemed endless.
> Here comes Mary Perry, *our gardening expert*.

f. Use commas to enclose vocatives.

A vocative is a noun, pronoun, or noun phrase used in direct address. That is, a vocative indicates to whom something is said. A vocative may appear at various positions within a sentence:

> *Mr. Noble*, may I ask you a question?
> May I, *Mr. Noble*, ask you a question?
> May I ask you a question, *Mr. Noble*?
> Let me tell you, *all of you workers*, that you have done a splendid job.

Thank you, *ladies and gentlemen.*

g. Use commas to enclose initials or titles following a person's name:

Joseph Clardy, Ph.D., and Robert Furth, D.D., are on the school board.
The letter was addressed to Marion High, Esq.
Miriam Jones, chairman, was a handsome woman.
Are you referring to Roosevelt, T., or Roosevelt, F.D.?
James Exeter, Jr., was chosen as the first speaker.

h. Use commas to enclose places and dates explaining preceding places and dates within a sentence:

He left on July 20, 1991, for a trip around the world.
He lives in Columbia, Missouri, having been transferred there from Akron, Ohio.
Her new home is at 1607 Ravinia Road, Peru, Illinois.

(1) Commas may be omitted when the complete date is not given: July, 1960, *or* July 1960.

(2) A second comma must be used when the state follows town or city and when the year follows both month and day. When only month and year are used, employ either two commas or none at all: "In July, 1990, . . ." or "In July 1990 . . ."

(3) Punctuation in the date line of a letter is optional. Formerly it was common practice to write *June 6, 1962*; increasingly popular is the form *6 June 1962*. Both are acceptable. For the sake of clarity, always separate two numerals; where a word intervenes, the comma may be omitted, as shown, if you prefer.

11.4 Commas to Indicate Omission

Most sentences which require a comma to make clear that something has been left out are poorly constructed and should be rephrased. In rare instances, however, using a comma to show omission helps to avoid wordiness:

In this office are ten workers; in that one are sixteen.
In this office are ten workers; in that, sixteen.

The comma in the second sentence clearly and correctly replaces the words *one are*.

Other examples:

> Smith is a collector of taxes; Jones, of stamps; Duane, of women.
>
> He takes his work seriously, himself lightly.
>
> A decade ago they were rich and powerful; only five years later, poor and weak.

11.5 Unnecessary Commas

Comma usage varies with different writers and editors. Modern punctuation tends to omit many commas that were formerly used, although this decrease is not so obvious in well-edited magazines and books as it is in most newspapers. Reputable writers and editors do deviate on occasion from normally accepted practices, but their actions do not thereby establish new principles.

However, you should be able to justify the appearance of every comma you use. It is as great a sin against clarity to overuse or misuse commas as it is to omit them where they are needed as an organic part of writing. The most common misuses and overuses of the comma are discussed in the following "do not use" suggestions:

a. Do not use a comma before the first or after the last member of a series.

> Chromatic colors include, red, green, purple, and brown.
> The tea was a cold, sweet, refreshing, drink.

Omit the first comma in the first sentence; the last in the second.

b. Do not use a comma to separate a subject from its predicate. No comma is needed in any of these sentences:

> We requested that the road be paved.
> I quickly learned what sort of man he was.
> They soon found the weather to be too cold.

c. Do not use a comma before the indirect part of a quotation. No comma is needed in a sentence such as this:

The candidate stated that he was against higher taxes.

d. Do not use a comma between two independent clauses where a stronger mark of punctuation (semicolon, period) is required.

This misuse, sometimes called the "comma fault" or "comma splice," always causes confusion. Use a semicolon or period for the misused comma in such a statement as this:

The foreman told me to be there early, I told him I couldn't.

e. Do not use a comma, or pair of commas, with words in apposition which are actually restrictive.

The italicized words which follow really limit, identify, or define. To enclose them with commas is a mistake:

My sister *Margaret* is a lovely woman.
Shakespeare's play *Macbeth* is one of his greatest.
Eleanor *of Aquitaine* was the mother of Richard *the Lion-Hearted*.

f. Do not use a comma indiscriminately to replace a word omitted.

On occasion, a comma can correctly and clearly be substituted for a word or even a group of words, but rarely can it take the place of pronouns such as *that, who, whom, which.* In "Robin said, he would come to see me soon" the comma is incorrectly used for *that*; in "The person, I saw was a friend of mine" *whom* should replace the comma. "He thought, that child was sick" should be written "He thought that that child was sick."

g. Do not use a comma and a dash in combination.

Formerly, the comma followed by a dash was often used. Today, the combination never occurs in well-edited material.

h. Do not use a comma between the name and number of an organization or unit.

In such items as the following, name and number are considered either in apposition or mutually restrictive:

Lucius D. Clarke Lodge No. 15
Upholsterer's Union Local No. 239

i. Do not use a comma before the ampersand (&).

There are rare exceptions to this suggestion, but normally you should omit the second comma in writing items such as the following:

Baker, Weeks & Company
Chefs, Cooks & Pastry Cooks Association

j. Do not use a comma in any situation unless it adds to clarity and understanding.

This is a catchall suggestion. Admittedly vague, it should call attention to the fact that comma usage is slowly growing more and more "open" and less and less "closed." Every comma in the following can be justified, but every comma could equally well be omitted since clarity is not affected in the slightest degree:

Naturally, the first thing you should do, after reporting for work, is to see the supervisor.

After the play, Martha and I went home, by taxicab, because we wanted, at all costs, to avoid subway crowds.

Commas are the most frequently used and most important-for-clarity of all marks of punctuation. Use them when necessary to make your meaning clear but avoid using them when they interrupt or slow down thought or make a page of writing look as though someone had used a comma shaker.

Proper use of the comma is the most difficult problem in punctuation usage. To reinforce your knowledge of this most widely used mark of punctuation, try these two tests:

Exercises

A. Choose a paragraph from a book or magazine or newspaper you are reading. Underline or circle every comma. Give a reason for each comma or pair of commas. Do not be surprised if a few of the commas are unconventionally used, unnecessary, or incorrectly placed.

B. In the following sentences commas are omitted. Where should they be inserted?

1. Should you take the wrong road you may never find the right road again.
2. You may choose easy courses and get high grades or you may choose difficult courses and really learn something.
3. When one gets there she has the feeling of having conquered the mountains for she can see for miles around.
4. Through a careful examination of ourselves our ability and the requirements for safe driving everyone can live in a safer world.
5. We have not made our decision yet nor can I tell you how soon we shall.
6. If everybody would ask what he or she has to be thankful for I know many of us would be surprised.
7. Once the plane takes off the flight attendant is always there to help you.
8. By working hard for three months I received my first increase in pay.
9. Florida is visited all the year round but the busy season starts in December and lasts through March.
10. After wandering through the woods all afternoon I found enough mushrooms for our supper.
11. To demonstrate what I mean by a mean trick I'll relate an experience that happened to me.
12. The atmosphere of Holland Michigan is of the Old World and all the charm of old Holland can be found there.
13. As reckless drivers we are always one jump ahead of the safety experts for we can think of other ways to kill ourselves.
14. A person who is susceptible to colds should avoid exposure to cold wet or snowy weather.
15. Many times when the snow falls and the wind blows the road to our house is drifted with the snow.
16. Little siblings come in assorted sizes shapes and dispositions.

17. In the play the king had a long curly black beard.
18. You have been in town three months now haven't you?
19. The longer I watched the ice show the more I thought I would like to be a great skater too.
20. I unloaded my clothes and my friends left immediately for home.

Answer Key

1. . . road, you . . . 2. . . grades, or . . . 3. . . there, she . . . mountains, for . . . 4. . . ourselves, our ability, and . . . 5. . . yet, nor . . . 6. . . thankful for, I know . . . 7. . . off, the . . . 8. . . months, I . . . 9. . . round, but . . . 10. . . afternoon, I . . . 11. . . trick, I'll . . . 12. . . Holland, Michigan. . . World, and . . . 13. . . experts, for . . . 14. . . . to cold, wet, or snowy weather. 15. . . blows, the road . . . 16. . . sizes, shapes and dispositions. 17. . . long, curly, black beard. 18. . . now, haven't you? . . . 19. . . show, the more . . . 20. . . my clothes, and . . . (In several of these sentences, such as 1, 2, 5, and 8, commas may be conventionally omitted.)

12

COMPOUND WORDS

A compound word consists of two or more distinct words which may be written as one word (*bathroom*), with a hyphen (*mother-in-law*), or as two separate words which express something more than, or different from, the sum of the words (*post office*).

Compound words are more a spelling problem than one of punctuation, but many of them do involve the use of a hyphen—a definite mark of punctuation as often used in compound words as in other applications which are discussed on pages 101–104 and 111–112. Paradoxically, the hyphen is a device to *separate* the parts of a word (as at the end of a line of writing) and to *unify* certain compound words.

The use of a hyphen in compound words varies so greatly that it can safely (and sadly) be said that no rule will cover all possible combinations. Two or more words used as a unit are so common that thousands of them do not appear in even a good dictionary. Fortunately, many of them do; the best possible advice is to consult your dictionary and use it as a guide in hyphenating and compounding. If you cannot find what you are seeking, the suggestions which follow should be helpful.

Neither you nor I, nor indeed any writer or copy editor alive, can always be right in compounding words. The goal, and it is a counsel of perfection no one can achieve, is

(A) Do not write as one word two or more words which should be completely separated.

(B) Do not write as two separate words any two words which should be written solid (together).

(C) Do not write as two or more words any word combination (compound) which should be hyphenated.

No rules about compounding are rigid or inflexible. Our language is fluid and constantly changing; word forms undergo frequent modification. However, it is true that the general principle of word joining is dictated by usage. When two or more words first become associated, through usage, with a single meaning, they are usually written as two words. As time goes on and the new compound grows to be more of a unit in thought and writing, it is likely to be written with a hyphen—a mark which in one sense separates the parts but in a more specific way joins them. Eventually, the separate parts lose their hyphen (or hyphens) and become one word, written solid.

This principle of growth, of evolution, may be seen in a word like *railroad*. It was formerly written as two words, *rail road*; then it was written with a hyphen, *rail-road*; now it is considered a solid compound and is rarely written except as *railroad*. This same principle may be illustrated by *base ball; base-ball, baseball; basket ball, basket-ball, basketball; step son, step-son, stepson; super market, super-market, supermarket*. The third word in each of these series is now the universally accepted form.

But you cannot always count on this principle; some common expressions which have been in use for a long time have never progressed beyond the first stage. You may occasionally see the compound word *highschool*, but nearly all copy experts and most publications still employ the separate form: *high school*. And you are not likely to see such common expressions as these written other than as two separate words: *cover girl, station wagon, Boy Scout, White House, sports car, black hole, summer vacation, stock market, postal card, real estate, blood pressure*. Other combinations still remain in the second stage (spelled with a hyphen) despite their having been used so often that they might well have reached the third stage (written solid): *son-in-law, post-mortem, clear-cut, hard-featured, heart-free*.

Still another problem with compounds should be mentioned: their form (two words, hyphenated, or solid) may depend upon

meaning. That is, a word group may have one meaning, and even one pronunciation, written one way and quite a different meaning and stress in pronunciation in another form. Note the difference in meaning in these sentences:

Driving down the *middle of the road* is not recommended.
This candidate for office follows a *middle-of-the-road* course.

The advertisement was for a *light housekeeper,* not a *lighthouse keeper.*

Lee was a *go-between* in the office quarrel.
In order to count, the ball must *go between* the goal posts.

The little boy played with a *black ball.*
Joe wishes to *blackball* this applicant.

This man is *well-known* in his community.
This man is *well, known* never to have been ill in his life.

Jim was a *battle-scarred* veteran of World War II.
The *battle scarred* Jim's body and soul.

Now you can see, if you did not already know, how confusing and involved the writing of compounds can be. (It is small wonder that the latest edition of the *Government Printing Office Style Manual* devotes forty-three closely printed pages to compound words.)

Despite the exceptions and variations involved, however, certain general statements about compound words can be made. Most of them involve exceptions, but they provide a few guidelines. It may also help you to remember that present-day tendency is to avoid using hyphens whenever possible.

The hyphen is used with several groups, or classes, of compound words:

(1) Between two or more words modifying a substantive (noun, pronoun, etc.) and used as an adjective:

able-bodied	bad-tempered
above-mentioned	bell-shaped
absent-minded	best-known
Anglo-Saxon	city-wide

far-fetched	olive-skinned
fast-moving	open-minded
first-rate	pink-blossomed
good-natured	quick-witted
light-haired	razor-keen
long-needed	sad-looking
narrow-minded	six-room
never-to-be-forgotten	slow-witted
nineteenth-century	twelve-foot
old-fashioned	velvet-draped

Note, however, that such compound words as these when used as adjectives are not necessarily hyphenated. They usually are when they precede the word they modify but may be written as two separate words when they follow a substantive:

> Beulah touched the red-hot coil.
> The coil was soon red hot.

Furthermore, adverb and verb compounds (especially with present participles) are often written as separate words preceding a noun; the *ever quickening* pace. But if the meaning is doubtful without the hyphen, by all means use it.

(2) Compound nouns.

Compound nouns consist of from two to as many as four parts. Nearly every part of speech can become a component of a compound noun. For example, *by-product* is a compound noun consisting of a preposition and a noun; *jack-of-all-trades* consists of a noun, preposition, adjective, and noun. Examples of familiar compound nouns which require a hyphen (or hyphens):

brother-in-law	leveling-off
court-martial	looker-on
fellow-citizen	major-domo
forget-me-not	secretary-treasurer
go-between	take-off
great-uncle	trade-mark

(3) Combining forms attached to a capitalized word.

Prefixes and suffixes attached to common words usually become

a part of the word, written solid. Dictionaries have long lists of such combined forms; see, for example, the entries under *non, over, un, under,* in your dictionary: *nonessential, overtake, unarmed, understate.*

However, you should use a hyphen to join a prefix or other combining form to a *capitalized* word:

anti-British	pseudo-Protestantism
pan-German	trans-Andean
post–Civil War	ultra-Spanish
pro-Arab	un-American

(4) Following a single capital letter joined to a noun or participle.

Our language contains many coined words of this kind, all of which should be hyphenated:

A-flat	T-square
H-bomb	U-turn
I-beam	V-neck
S-curve	X-ray

(5) Between elements of an improvised compound:

blue-pencil (as verb)	never-say-die
a let-George-do-it response	a high-wide-and-handsome air
verbal give-and-take	long-to-be-remembered
hard-and-fast rule	stick-in-the-mud

Any ordinary good-gracious-what-next novelist would be content to spin out this plot to book length.

This salesman of securities gave me a now-you-see-it-now-you-don't impression.

Note, however, that many writers who improvise compounds do not use hyphens. James Joyce, for instance, was famous for running words together to achieve new stylistic effects. In *Ulysses* appear such compounds as *biscuitmush, lifebrightening, teadust,* and *wavenoise.* Granted that such words might be more readily understandable if they were hyphenated or written separately, yet they do add flavor and vigor to writing. And James Jones, in a

1962 novel titled *The Thin Red Line*, coined adjectives like *handleopened*, *longpicklenosed*, and *wavywhitehaired*. To refer to an individual, for example, as "longpicklenosed" is more picturesque and economical than to mention a person "who has a long nose which is shaped like a pickle." In general, however, new coinages (neologisms) are clearer if they are written with a hyphen so that familiar individual elements can register with your reader.

(6) Some, but not all, compounds having *father, mother, sister,* etc., as the first element:

brother-workers	mother-of-pearl
father-in-law	parent-teacher
fellow-citizens	sister-nations

Note, however, that many compounds beginning with these words are not hyphenated: *father love, mother church, sister ship,* etc.

(7) Between the parts of compound numerals from twenty-one to ninety-nine, if written out:

twenty-one	forty-three
twenty-first	ninety-two

(8) In certain fractions.

Hyphenate fractions if written out, but omit the hyphen if one already appears in either the numerator or denominator:

two-thirds	twenty one-thousandths
four-fifths	twenty-three thirtieths
ten-thousandths	twenty-four thirty-eighths

(9) Between a numbered figure and its unit of measurement:

a 4-yard gain	a 10-day vacation
a 35-hour week	an 8-foot board

(10) Usually, but not always, when *ex* or *self* is the first element:

ex-serviceman	self-control
ex-vice-president	self-respect

Note, however, that other words fitting into this classification are not hyphenated: *selfsame, excommunicate.*

(11) To avoid doubling a vowel or tripling a consonant:

anti-imperialistic shell-like
semi-independent will-less

Note, however, that after certain short prefixes no hyphen is used: *coeducation, defraud, redouble.*

(12) To prevent mispronunciation:

recover as distinguished from *re-cover*
recreation as distinguished from *re-creation*
retreat distinguished from *re-treat*

(13) As a suspensive hyphen in pairs.

When the first or second part of a compound word is used only once, a suspensive (carrying-over) hyphen is occasionally used:

This was a group of six- and seven-year-olds.
He bought some 6-, 8-, and 10-penny nails.

This baker's dozen group of words requiring a hyphen could be doubled. Also, not all exceptions within the groups mentioned have been noted—in the interests of not compounding confusion as well as words.

A final word of advice, reiterated: when in doubt, *consult your dictionary.* Dictionaries often differ among themselves about compound words. Never mind: choose one good dictionary and follow it consistently.

13

THE DASH

The dash (—) is an emphatic mark of punctuation most often used to indicate a sudden interruption in thought, a sharp break, a shift in thought. It has been called, as George Summey, Jr., remarks in his excellent book, *American Punctuation*, "the interruption, the mark of abruptness, the sob, the stammer, and the mark of ignorance." This colorful definition implies that the dash is a vigorous mark which has emotional qualities and which may be misused and overused.

A dash is the only standard mark of punctuation not represented on the usual typewriter or computer keyboard. In typing, the dash is made by two hyphens (--); in handwriting, it is shown by a line about as long as two hyphens. In printing, the mark is referred to as an *em dash*. Actually, printers use three dashes: an *en dash* (which in typing and handwriting is represented by a mark the length of a hyphen), the *em dash* (two hyphens), and the *2-em* (or sometimes longer) dash. The double dash, or long dash, is rarely needed in writing. The em dash (—) is what we usually have in mind when we talk about dashes in writing.

Some other mark of punctuation can always be substituted for a dash. It does have functions roughly equivalent to those of a comma and, moreover, resembles a terminal mark of punctuation (period, exclamation point, question mark) in certain situations. However, a dash lends a certain air of surprise or emotional tone on occasion and, if used sparingly, is a useful device for adding movement, or a sense of movement, to writing. But it is rightly

called a "mark of ignorance" since some writers use it indiscriminately and far too often.

This versatile mark of punctuation can be used, and perhaps too often is used, to separate, terminate, interrupt, introduce, enclose, and to indicate omission of words, figures, or letters. You should restrict use of the dash to the purposes suggested below; overuse of the dash is one hallmark of a gushy, overly emotional style, which is sometimes unkindly referred to as "schoolgirl."

13.1 Separation

Use a dash to separate a final clause summarizing an idea, or series of ideas, from that which precedes it:

> Freedom to work as we please and where we wish, freedom to worship or not to worship, freedom to travel or stay at home—these are basic desires of most of us.
>
> Money, fame, power—these were his goals in life.

In this separating and summarizing use of the dash, no other marks of punctuation should appear with it. A colon could replace the dash but normally would be less effective.

13.2 Termination

Use a dash (or double dash) to indicate an unfinished statement or unfinished word. Usually, such a situation will occur in dialogue:

> "Neither of us could spell the word *erysip*—"
>
> When he entered, Jack began, "Mr. Pope, may I ask—" Quickly, Mr. Pope broke in, "You may not."
>
> *Query.* Did you start—*Answer.* No, Judge.

A double dash is normally used at the end of a statement, a regular em dash within the line. When a statement ends with a dash, use no other mark of punctuation.

13.3 Interruption

Use a dash to indicate an interruption in thought. Such an interruption may be a break, shift, or turn in thought by the speaker or writer or it may be caused by someone other than the speaker or writer:

> When I was in college—but I have already talked about that.
> Do we—can we—dare we ask for more money?
> I started to say, "But—" "But me no *but's*," roared the supervisor.

13.4 Introduction

Use a dash to introduce a word or group of words to which you wish to give emphasis:

> What he needed most he never got—love.
> This is our most serious question—can we find a buyer for our product?

In such constructions as these, either a colon or comma could be used; the dash adds vigor, emphasis, and a tonal quality of emotion.

13.5 Enclosure

Use a pair of dashes to enclose words or ideas which you wish to emphasize sharply or emphatically or with which you wish to achieve some other distinct stylistic effect. Long appositional phrases are often enclosed by dashes.

> I think—no, I am positive—that you should go.
> My mother can bandage that—she's a trained nurse, you know—so that it won't hurt at all.
> If you do succeed—and try hard!—telephone me promptly.
> Through clandestine channels—a small man wearing red suspenders—I discovered that the idea originated with one of the secretaries.
> Only three candidates for office—Wilson of the order de-

partment, Jones of Sales, and Thomas of Shipping—were present at the meeting.

A pair of commas or two parentheses could replace the dashes in each of these sentences, but they would not so sharply set off and distinguish the parenthetical material.

13.6 Omission

A dash is used to indicate the omission of letters or words—but not in contractions; apostrophes are used with them—and to connect combinations of letters and figures.

> Senator S— was from my home town.
> We were in one h— of a predicament when that happened.
> June–October (June to or through October)
> She lived in that city 1960–1962.
>
> Ed used to fly a DC–8 on the New York–Dallas run.
> The speech was carried on a CBS–NBC–ABC hookup.

In typing or handwriting, a hyphen (-) might be substituted in each of the examples above except the first two where a long dash could also be used.

Do not use a dash in such expressions as those above when the word *from* or *between* appears:

> From June to (or through) October (not *From June–October*)
> Between 1978 and 1982 (not *Between 1978–1982*)

A final word about the dash: use it sparingly. It is a strong and noticeable mark and should not be employed as a lazy substitute for more exact marks of punctuation or to indicate omitted ideas where you have nothing particular in mind. Also, with rare exceptions, do not use it in combination with other marks. The combinations of colon-dash, semicolon-dash, comma-dash, and period-dash have largely disappeared in American usage. The dash is powerful enough to stand on its own.

14

DITTO MARKS

Ditto marks (") are a time- and effort-saving mechanical device employed frequently in tables of names, in bills, accounts, and similar types of writing where much repetition occurs. The word *ditto* comes from the Latin word for "saying," *dictum*, and actually means "the aforesaid," "the same as before." Ditto marks, often abbreviated by printers to *do. marks*, are correctly used in preparing lists and tabulations but are rare in ordinary writing unless it is highly informal.

On the typewriter, dittos are made by using quotation marks.

Stir in one-half pound of melted butter.
Then add " " " " salted nuts.

15

DIVISION OF WORDS

When you are writing in longhand or on the typewriter, you often come toward the right-hand side of your sheet of paper with enough space left to begin a word but not to complete it. Typesetters have the same problem. The result is that large numbers of "rules" for the division of words have been devised. In fact, the situation is so common and the problem so vexing that the United States Printing Office has issued a supplement to its *Style Manual* devoted solely to word division. The supplement runs to 132 pages consisting of the basic rules for word division and the actual breaking up of more than 12,500 words.

By "division of words" is meant the marking off, or separation, of the parts of a word known as *syllables*. A syllable in writing refers to a character or set of characters (letters of the alphabet) representing one sound; in general, a syllable refers to the smallest amount, or least portion, of speech or writing. The separation of a word into syllables is known as *syllabication* (or *syllabification*).

Breaking many words with division hyphens at the ends of lines on a page causes a jagged appearance; it is often preferable to leave a short space blank and carry the whole word over to the next line. (Most typesetters will recast an entire line in order to avoid having more than two consecutive division hyphens appear.) Occasionally, however, you have no choice but to divide a word; this you do by proper division of the word and the use of a hyphen.

It is not always easy to divide words correctly into syllables. When in doubt, consult your dictionary; all good dictionaries show the syllabication of words. If you remember that syllabication in the United States is determined largely by pronunciation, however, you will not need to consult your dictionary so often. *Democrat* may be broken into dem·o·crat, but *democracy* into de·moc·ra·cy. In Great Britain, on the other hand, division is determined more by word origin than by pronunciation; an Englishman would break up *democracy* into demo·cracy, although his pronunciation of the word would not differ markedly from that of an American.

When using a division hyphen at the end of a line, keep the following rules in mind:

(1) Always divide according to pronunciation.

> knowl·edge, *not* know·ledge
> ste·nog·ra·pher, *not* sten·og·ra·pher
> sten·o·graphic·ic, *not* ste·nog·ra·phic
> grum·ble, *not* grumb·le

(2) Place the hyphen at the end of the first line, never at the beginning of the second:

> The botanist used only two specimens in his demon-
> stration.

(3) Never divide a monosyllable.

Some rather long words have only one syllable and cannot be divided. Write such words as *breath, ground, laughed,* and *through* in their entirety on the first line; if this is not possible, carry the whole word over to the next line. Also, such parts of words as *-geous* (advantageous) and *-tious* (contentious) cannot be divided.

(4) Do not divide a one-letter syllable from the remainder of the word.

A word such as *about* does have two syllables, a·bout, but it should not be broken up. Do not divide other such words as *able, among, enough, item, many, unit, very.*

(5) Do not divide on a syllable with a silent vowel.

The ending *-ed* is not fully pronounced in many words and

should not be separated from the word of which it is a part. Avoid breaking up such words as *asked, attacked, climbed, massed, yelled*. But see *grave accent*, page 39.

(6) Do not divide a word with only four letters.

A word of only four letters can usually be crowded into the first line, if necessary. If space does not permit, carry over to the second line in their entirety such words as *also, into, only, open, real, veto*.

(7) Divide two consonants standing between vowels when pronunciation warrants.

This principle is illustrated by words such as alter·native, exis··ten·tialism, struc·ture, strin·gent.

(8) Present participles may be divided before their *-ing* ending: ask·ing, carry·ing, giv·ing, sing·ing, talk·ing, walk·ing.

However, you should note that when the ending-consonant sounds of the main word occur in a syllable with a silent vowel, such consonant-sounds become a part of the added *-ing*: buck··ling, chuck·ling, han·dling, muf·fling, twink·ling.

Also note that when the *-ing* ending results in doubling a consonant, separation should occur between the consonants: sin··ning, *not* sinn·ing.

(9) Most prefixes and suffixes may be divided from main words.

Such affixes should not be separated if they consist of only one letter, but others can be set apart: ante·cedent, convert·ible, pre·pare, argu·able.

(10) Do not divide sums of money, initials in a name, proper nouns, and units of time.

Write in their entirety on the first or second line such items as these and all others which might be misinterpreted or misread. For example, if you refer to $3,654,987.00, write the entire unit on one line. Or if a person's initials are *J.L.*, put them together, not on separate lines.

(11) Divide compound words between their main parts.

Avoid dividing *understanding*, for example, into un·der·stand··ing. It is preferable for each main part to stand by itself: under··standing.

(12) Let pronunciation be your guide when three consonants come together.

Such a combination of letters is fairly common in English. Note the division of the following words: punc·ture, chil·dren, watch-ing, hail·stone, self·made.

Enough. If the comments above don't answer your questions, then consult your dictionary. That is better advice than to trust pronunciation or to memorize the principles just cited.

16

ELLIPSIS

By *ellipsis* is usually meant the omission from a sentence of a word or words which would fill out or strengthen meaning. Such omission is indicated by punctuation known as elliptical marks.

The most widely used elliptical mark is *ellipsis periods* (. . .). *Asterisks* may also be employed to indicate omission, but their use has declined in the last few decades because the asterisk is a conspicuous and even glaring mark. For the rather infrequent use of commas to indicate omission, see Section 11.4, page 83. *Dashes* may show omission, but use of the dash should be sparing and should be restricted to the purposes discussed for that mark (see pages 96–99). An *apostrophe* should be used to indicate omission of only letters (not words), as in contractions (don't) and of figures, as in dates ('53 for 1953).

When you do need to indicate ellipsis, prefer three periods. When ellipsis periods come at the end of a statement requiring a period, then four of these "suspension periods" or "suspension points," as they are also called, are used.

Ellipsis periods have the following uses:

(1) To indicate an intentional omission from a sentence or quotation.

Some carried baskets, others carried blankets, still others carried folding chairs.

Some carried baskets, others . . . blankets, still others . . . folding chairs. (Normally, you would write such a sentence as this without repeating the verb or using ellipsis periods. The

105

sentence is merely illustrative. Also, such an elliptical sentence could be written with semicolons and commas, the latter indicating the omission. See Section 11.4, page 83.)

Some carried baskets; others, blankets; still others, folding chairs.

"In the spring a young man's fancy . . ."

"Some books are to be tasted, others . . . swallowed, and some few . . . chewed and digested."

(2) To indicate that an enumeration or listing continues beyond the items named.

Six of my best friends were there: Sam, Ed, Carol . . .

Sugar, flour, shortening . . . add all the ingredients carefully.

The little girl began to recite the alphabet (a, b, c . . .).

In this use, ellipsis periods have the meaning of *etc.* (*et cetera*, "and so forth").

(3) To indicate the passage of time.

The day wore on from sunrise to midmorning . . . steaming noon . . . blistering afternoon . . . cooling sunset.

(4) To indicate that a statement is left unfinished.

Some writers use ellipsis periods with the implication that much more could be said on a subject. It is doubtful that they often have anything particular in mind, and the device seems a rather cheap one. However, ellipsis periods can be used to indicate hesitation or a kind of "dying away" of thought or action:

He loved her deeply, but something told him to go slowly, to take his time, to think, to . . .

Be careful about leaving statements unfinished. Alert readers will probably assume the truth: more might be said but the writer wasn't certain just what or how. Don Marquis once wrote:

When you see . . . three little dots . . . such as these . . . in the stuff of a modern versifier . . . even in our stuff . . . it means that the writer . . . is trying to suggest something rather . . . well, elusive, if you get what we mean . . . and the reason he suggests it instead of expressing it . . . is . . . very often . . . because it is an almost idea . . . instead of a real idea. . . .

(5) To indicate lacunae in something being quoted.

Lacunae is a ten-dollar word meaning "gaps" or "blank spaces." Probably you will have little need for ellipsis periods in this situation, but you may use them to note that a word has been left out of what you are quoting or that something is illegible because of poor handwriting or mutilation.

(6) To separate short groups of words for emphasis.

Such use of ellipsis periods is a favorite device of advertising writers. Here, ellipsis periods are used not so much to indicate omission as to set off, to emphasize, the selling message itself:

Do it soon . . . Do it today . . . Do it now. See . . . Your local dealer.

(7) To mark the omission of longer passages.

Occasionally you may wish to omit a considerable amount from something you are quoting. When you leave out as much as one entire line of poetry or one or more whole paragraphs in prose, use a full line of periods to indicate what is being dropped. Some newspapers, including the *New York Times*, use a centered line of three periods to indicate the omission of one or more paragraphs.

A final word about ellipsis:

a. Do not use ellipsis periods purely as a stylistic device. They can be as much overused as even the dash.

b. A question mark or exclamation point may follow ellipsis periods (three only).

c. Do not use ellipsis periods to mark breaks which should be indicated by paragraph indention. This is a space-saving device used by some magazines, including *Newsweek* and *Time*.

d. For showing omission, always prefer ellipsis periods to other marks of punctuation and mechanics. Especially remember never to put inside parentheses material that you wish to omit from your own writing. Draw a line through such material, or erase it and rewrite.

e. For the use of terminal marks of punctuation (end-stops) with certain kinds of elliptical sentences (sentence fragments) see page 128.

17

EXCLAMATION POINT

This mark of punctuation (!) has been called "the period that blew its top." This description is both amusing and apt. An exclamation point really is a period wearing a conical hat and resembles the period in that it is usually, but not always, a terminal mark. And it has "blown its top" in appearance and in that it is a mark to suggest strong emotion, surprise, emphasis, or a direct command of some sort.

The exclamation point (or exclamation mark) should be used thoughtfully and sparingly. Overuse of this device—as is frequent in advertisements, informal letters, and many short stories, plays, and novels—causes it to lose much of its effectiveness. The emotion expressed should be strong, the surprise genuine, the emphasis or command really vigorous, even imperative, to warrant its use.

Punctuation is truly an organic part of writing, but an exclamation point in itself will not add emotion to otherwise colorless or tame prose. Exclamation points, dashes, and double and triple underlinings are hallmarks of what is impolitely called "schoolgirl style"—gushy, artificial, and self-defeating prose that palls on the reader.

Unless you wish your writing to seem juvenile or empty-headed, follow this rule: Never use an exclamation point when another mark will serve adequately and properly. If you follow this advice, the only rare exclamation point appearing in your writing will have added force.

The exclamation point has several legitimate uses:

(1) To express surprise, emphasis, or strong emotion.

For this purpose the mark may be used both within the sentence and as a terminal mark of punctuation. In exclamatory sentences, the mark is usually held until the end, but not always:

What an incredibly rude thing to say!

So you really decided to go! What an idiot!

The doctor said—how lucky you are!—that you may leave the hospital tomorrow.

How silly can you be? What a mess you have made!

"I am dying!" she screamed. "Can't you see that?"

He came up with a startling suggestion: poison every trading stamp in the country!

(2) To express a command or vigorous request.

Get moving at once!

Think up things for other people to do! That's a real key to success.

"Please leave me alone!" the wounded man begged.

May I ask you—please!—to give to this worthy cause.

(3) To express sarcasm or irony.

An exclamation point may be used after a phrase or sentence to express derision of some sort. When used for this purpose, the mark is often (but not always) placed within parentheses. When used in an ironical sense, an exclamation point calls attention to the contradictory nature of what precedes it: one thing is said but another is meant. As an indication of sarcasm, the mark emphasizes the harsh or cutting quality of what is said:

"Big deal!" he replied scornfully.

"Gorgeous day!" (Uttered during a blizzard)

People as stupid as you should have an attendant!

Labor negotiations having smoothly (!) run their course, the only thing to do is strike.

She thought that she might condescend (!) to write.

Do not use the exclamation point frequently to indicate irony or sarcasm. Usually you can convey what you have in mind without artificial use of the always obtrusive exclamation point.

(4) After certain interjections.

A strong and impelling interjection—a word which expresses surprise, dismay, anger, pain, etc.—may be followed by an exclamation point. One which is fairly mild and quiet is usually followed by a comma. Strong interjections are words like *ahoy, bravo, gosh, hurrah*, and *ouch*. Mild interjections include *oh, so, well*.

However, a mild interjection can be used in a strongly emotional manner, a strong one in a mild sense. For example, *indeed* and *huh* can be followed by either a comma or an exclamation point depending upon what they are intended to express.

The interjection *O* is always capitalized and is usually followed by an exclamation point at the end of the phrase or sentence in which it occurs; *oh* is usually, but not always, followed by a comma.

Pshaw! I should be in the left lane to make this turn.

Indeed, as someone has said, every man has a right to be conceited until he is successful.

Oh, I wouldn't worry if I were you.

O Lord, please help me now!

Well, you still have some money left even if you have been "automated" out of a job.

A final word about exclamation points:

a. Use them sparingly and only for a definite and clear reason.

b. When you do use an exclamation mark, use only one. Adolescents and comic-strip writers try to intensify by using two or more in one place; don't make this mistake yourself.

c. An exclamation point after a long sentence looks silly. Most of us don't have sufficient breath to exclaim more than a few words at a time.

18

THE HYPHEN

The hyphen (-) is a definite mark of punctuation, but it is most frequently used in spelling *compound words* (see pp. 89–95) and in *dividing words* at the ends of lines (see pp. 101–104). On those pages are covered all of the more important functions of the hyphen, but it does have a few miscellaneous and minor uses:

(1) Use a hyphen (or hyphens) to indicate the structure or spelling of a word.

Notice that r-o-u-g-h and c-o-u-g-h are pronounced quite differently.

The prefix of this word should be p-r-e, not p-e-r.

If you have s-e-n-s-e you should be able to make a lot of c-e-n-t-s.

(2) Use a hyphen (or hyphens) to suggest stuttering or any hesitant manner of expression.

W-e-ll, I think I can go with you; y-y-es, I'm sure I can.

Jim said, "I like t-t-tomatoes but not p-p-potatoes."

(3) Use a hyphen to represent dialectal or careless pronunciation.

The horse came a-tearin' to the barn when it heard my whistle.

There they sat most of the night, just a-gassin' and a-drinkin'.

(4) Use a hyphen with certain street addresses:

He lives at 109-82 109th Street, St. Albans, Mass.

(5) Use a hyphen with certain telephone numbers:

(203) 259-1800 554-3374

19

ITALICS (UNDERLINING)

In longhand and typewritten copy, certain words and groups of words should be underlined to correspond to the conventions of using italic type. These conventions, however, have never been standardized, and the use of italic type varies widely from publication to publication.

To a printer, italic type means letters with a slope to the right, which look quite unlike the so-called roman type ordinarily used. To a reader, italic type indicates that some word or group of words has been singled out for emphasis or other distinction. To a writer, the use of italics (underlining) is a troublesome problem in the mechanics of writing about which few authoritative statements may be made.

One flat statement can be made: the use of italics has greatly decreased in the last century. Few newspapers now use italic type except for directions to readers, such as "continued" lines, or unless it is specified in display advertising. Magazines, even carefully edited ones, currently use italic type in fewer and fewer instances where formerly it was regularly employed by convention. The trend toward disuse of italics is not so noticeable in scientific journals and in books, but it is unmistakable to the careful observer.

Another statement can also be made with some accuracy: quotation marks may be used to identify or emphasize words or groups of words precisely as can italic type. In fact, publications of varied sorts regularly use quotation marks for such purposes—

although many words which, by convention, would be distinguished often appear in roman type without either italics or quotation marks.

As a careful and thoughtful writer, you are urged to employ italics (underlining) in the specific situations cited below and quotation marks (see pages 139–141) in other constructions.

In correct and careful writing you should indicate italic type by underlining *once* the following groups and classes of words:

(1) Titles of books and magazines.

> *Foundations of Western Thought*
> *All the King's Men*
> *Saturday Review*
> *The Atlantic Monthly*

In such titles, the first, last, and all important words are capitalized (see pages 63–64). If *the* is the first word in the actual title of either a book or a magazine, it may be retained, in which case it should begin with a capital, although it is often dropped: *The Atlantic Monthly,* or the *Atlantic Monthly,* or *Atlantic Monthly.*

(2) Titles of plays, operas, long poems, and motion pictures.

> *Strange Interlude* (play)
> *The Girl of the Golden West* (opera)
> *Paradise Lost* (long poem)
> *Duel in the Sun* (motion picture)

(3) Names of ships, trains, and aircraft.

> the *Caronia* (steamship)
> the *City of Denver* (train)
> the *Bermuda Clipper* (aircraft)

(4) Names of newspapers.

> The *New York Times*
> The *San Francisco Chronicle*

Usage here can, and does, vary. Some authorities suggest that the article *the* be dropped when such names are cited. Others recommend that only the actual name of the newspaper be underlined (italicized) and not the place of its publication: Chicago *Trib-*

une. Newspapers themselves, as well as many other publications, rarely italicize such names at all. Formal writing requires that *at least* the name of a newspaper be underlined (set in italic type).

(5) Names of legal cases.

> *John Doe* v. *Mary Doe* or John Doe *v.* Mary Doe

Citation of legal cases is not likely to concern you often, but the use of italics in such instances is standard. However, convention requires that the *v.* (for Latin *versus,* against) appear in roman type if italics are used elsewhere in the citation and in italics if roman is used for the actual names involved.

(6) Scientific names.

> *Ursus arctos* (European brown bear)
> *Canis familiaris* (a plain *dog* to you and me)

Convention decrees that the Latin (scientific) names of genus and species appear in italics. The names of groups higher than genera are usually printed in roman type, but may appear in italics if you wish to show off your learning or your careful use of a dictionary.

(7) Foreign words and phrases.

> *Zeitgeist* (German for "spirit of the time")
> *honi soit qui mal y pense* (French for "shamed be he who thinks evil of it" or "evil to him who evil thinks.")

Note that thousands of words and phrases have been so thoroughly absorbed into the English language that they need no longer be italicized. Such words as these can safely be written without italics (underlining):

ad infinitum	ex officio
alias	gratis
billet doux	hors d'oeuvres
bona fide	matinee
carte blanche	mores
delicatessen	prima facie
en route	sauerkraut
et cetera	vice versa

When uncertain whether a word is still considered foreign enough to be underlined, you should consult a dictionary. All good dictionaries use some device for indicating the domestic-foreign status of words. For example, the sixteen expressions, or words, just cited are not indicated as foreign by *Webster's New Collegiate Dictionary.* What does your dictionary indicate about them? And do you know the meaning of each of the terms?

(8) Items for specific reference.

Italics (underlining) may be used to refer to a word, letter, number, or phrase which is spoken of as such:

> The word should have been *dollar*; it appears as *collar.*
> Your *l*'s look exactly like *t*'s. (Only the letter should be ital-
> icized, not the apostrophe or the *s*.)
> Is this a 6 or a 9?
> The advertiser who wrote *Come Dye With Me* should have
> been a cleaner, not a funeral director.

(9) Items for emphasis.

On occasion—and it should be a rare occasion—you can add emphasis by underlining. When you do single out a word or phrase for emphasis, use only one line, not the two or three which sometimes appear in the informal notes of adolescents or otherwise immature writers.

> You should *never* show your bankroll in a public place.
> Whatever you think, *whatever you even suspect*, keep to
> yourself for the present.
> The late Will Rogers was never more humorous than when
> he said: "Don't gamble. Take all your savings, buy some good
> stock, and hold it until it goes up. Then sell it. *If it doesn't go
> up, don't buy it.*"

A final word about italics:

a. Compare and contrast suggested uses for underlining with those for quotation marks (pages 135–142).

b. Underlined words, like italic type, are conspicuous. Be sparing in your use of them; never underline without a specific and clear purpose in mind.

20

NUMERALS

Writing words for numerals or using numbers for words is a matter of convention and custom. A few general principles about this vexing problem in mechanics can be stated; but variations do occur, and the stylebooks of reputable newspapers, magazines, and book publishers differ widely.

In general, proceed on the correct assumption that your reader comprehends actual numerals more readily than word expressions for numbers, especially in scientific, technical, and statistical matter: for example, *197* is clearer to most readers than *one hundred ninety-seven*. Despite this principle, numbers should actually be spelled out in certain instances as shown below. Some of these instances are matters of typographic appearance, such as the rule about not beginning a sentence with a numeral. Others are merely matters of convention that have been adopted through the years for no obvious reason.

Since exact and unchanging rules for representing numerals cannot be cited, it is preferable to adopt a general system and to use it consistently. In arriving at a formula that will cover most of your uses of numerals, remember these generally accepted principles:

(A) Never begin a sentence with an actual numeral.

(B) Use words for numbers between one and ten. This rule does not apply to all numbers (see pages 119–120).

(C) Use figures for words above ten.

(D) When a number can be expressed in not more than two words, write it in words.

(E) When a number can be expressed in no less than three words, use figures.

Memorizing these five principles, which are usually but not always consistent, will save you much trouble. Yet not even they are observed by all publications. For example, many reputable newspapers use words for figures up to ten only and figures for all higher numbers. Also, you must use some common sense in applying the rule about not beginning a sentence with a numeral. This is an undesirable sentence:

"Two thousand two hundred dollars and fifty cents was his bank balance."

Recast the sentence to make it clearer and still avoid beginning with a numeral: "His bank balance was $2,200.50."

Again, these five principles admit certain exceptions which are explained below. But mastering these "rules" will clear up most of your problems about numbers; applying them consistently will help to make your writing clear.

(1) Use words to represent numbers in special uses.

a. Indefinite expressions and round numbers.

> This stadium will seat several thousand people.
> If he lives to be a million, he will still be a bore.
> The mid-twenties was a frantic, mad era in this country.

b. One number or related numbers at the beginning of a sentence.

> Three of the clerks were ill that day.
> Four hundred employees were covered by group insurance.

c. Fractions standing alone or followed by the expressions *of a* and *of an*.

> This cardboard is one-eighth inch thick.
> His home is one-fourth of a mile from the store.

d. Numbers used with dignified and serious subjects.

Utah is not one of the Thirteen Original Colonies.

He died while he was a member of the Seventy-eighth Congress.

e. Numbers preceding a compound modifier containing a figure.

The platform was supported by eight 6-foot poles.
Now we need six ¼-inch strips of canvas.

(2) Use figures to represent numbers in special uses.

a. Units of measurement.

Such units include age, degrees of temperature and angular distance, size, weight, etc. These units are always expressed in figures regardless of the appearance of other numerical expressions within a sentence.

Tom's employer is 42 years old, but he himself is 64.
He lived for 54 years, 11 months, and 6 days.
The latitude is 49° 24′ 12 ″ N.
The thermometer registered 12° this morning.
A high temperature of 16 degrees was reported.
The rows were planted 3 feet apart.
All his stationery measures 8½-by-11 inches.
He poured 2 gallons into a 5-gallon can.
This huge book weighs 3 pounds and 12 ounces.
A "10-foot pole" is a "3.302-meter pole."

b. Dates, including the day or the day and the year.

Please report for work on July 1.
My birth date was August 19, 1939.
He was in the armed services from July 15 to November 30, 1991, when he was discharged.
The proper date line for a letter is May 10, 1992.
The proper date line for a letter is 10 May 1992 (no comma).

c. Time.

12 P.M. (noon) 3:46 P.M. half past 7
11 o'clock (*not* 11 o'clock A.M. *or* 11:00 in the morning)
He was in a coma for 4 hours, 15 minutes, and 30 seconds.

d. House, room, and telephone numbers.

His room number is 906; his telephone number is 304-6795, but it formerly was Clearwater 9-1848.

e. Highway and other comparable numbers.

We took U.S. Highway 95 to New Haven.
On this set we cannot get Channel 6.
Train #176 is due to come in on Track 7.
Flight 126 will depart from Gate 4.

f. Percentage and other mathematical expressions.

The interest rate is 6%.
He bought two 4½ percent bonds.
The ratio of 2 to 8 is the same as 8 to 32.
The specific gravity is 0.9567.
Multiply by 3 to find the correct number.

g. Money.

$0.50 50 cents $5.50 10 cents each (apiece)
$4 per 100 pounds $7 a pound £2 5s. 4d.

h. Unit modifiers.

7-hour day 5-day week 8-inch plank
10-million-dollar loan 5-foot wide entrance

i. Chapter, page, and footnote numbers.

Chapter 16 See page 14 pages 306–363
See Footnote 4 on page 65 for an explanation.

(3) Use ordinal numbers correctly.

Numbers previously discussed in this section are *cardinal* numbers, those we use in counting: one, two, three or 1, 2, 3. *Ordinal* numbers indicate rank or order: first, second, third or 1st, 2nd, 3rd. On occasion, you may need to express figures and alphabetical letters in combination. Such combinations are correctly and appropriately used in tables, in numbering paragraphs, in indicating a numbered street from 10th on, and sometimes in dates (but not when the year follows immediately).

The conventions applicable in this combination are numerous and involved, but the following illustrations show correct form in several common expressions.

Your June 15th letter (or your letter of June 15) was welcome.
Your June 15, 1991, letter was welcome.
686 North Second Street 105 Fifth Avenue
The corner of 10th Road and Sixth Avenue
36th parallel fifth precinct 7th Air Force

When two or more ordinal numbers appear in a sentence and one of them is *10th* or more, use figures for each number: He campaigned in the 1st, 4th, and 12th wards.

(4) Use Roman numerals correctly.

The figures with which we are most familiar came from the Arabs and hence are called Arabic numerals: 1, 2, 3, etc. But Roman letters were used exclusively up until the 10th century and still have certain conventional uses today. For example, the cornerstones of most buildings and the plaques on most public monuments carry dates in Roman numerals. Such numerals also are used to number the preliminary pages of a book (such as this one), to indicate the acts and scenes of a play, to refer to different individuals with the same name, and in other somewhat stylized situations.

Falstaff first appears in Act I, Scene ii, of *Henry IV.*

Louis was the name of eighteen kings of France ranging from Louis I to Louis XVIII.

Jack had the same name as his father and grandfather and thus signed his name John William Smith, III.

That article appears in Volume XIII of my encyclopedia.

The date is faded somewhat, but you can make it out— MCMXII.

Roman numerals are rarely preferable to Arabic numbers, but you should know how they are formed in order to use them correctly when an infrequent need arises and also to understand what you read on cornerstones, tombstones, and monuments of varied kinds. A repeated letter repeats a value; a letter before one of greater value subtracts from it; a letter following one of greater

value adds to it; a dashline over a letter means "multiplied by 1,000." The following table of Roman numerals is placed here for reference; don't waste your time memorizing it:

I	1	LXX	70
II	2	LXXV	75
III	3	LXXIX	79
IV	4	LXXX	80
V	5	LXXXV	85
VI	6	LXXXIX	89
VII	7	XC	90
VIII	8	XCV	95
IX	9	XCIX	99
X	10	C	100
XV	15	CL	150
XIX	19	CC	200
XX	20	CCC	300
XXV	25	CD	400
XXIX	29	D	500
XXX	30	DC	600
XXXV	35	DCC	700
XXXIX	39	DCCC	800
XL	40	CM	900
XLV	45	M	1,000
XLIX	49	MD	1,500
L	50	MM	2,000
LV	55	MMM	3,000
LIX	59	MMMM or M$\overline{\text{V}}$	4,000
LX	60	$\overline{\text{V}}$	5,000
LXV	65	$\overline{\text{M}}$	1,000,000
LXIX	69		

Dates

MDC	1600	MCMXX	1920
MDCC	1700	MCMXXX	1930
MDCCC	1800	MCMXL	1940
MCM or MDCCCC	1900	MCMXC	1990

21

PARENTHESES

Parentheses () are curved punctuation marks principally used to enclose incidental explanatory matter in a sentence. Such material is important enough to be included but is not intended to be a part of the main statement and often has no direct grammatical relationship to the sentence in which it appears. Marks of parenthesis (or *parentheses* or *curves* as they are usually called) signal to the reader what a speaker means when he says "By the way," or "Incidentally," or "Here's something to consider but it's only a side remark."

You may set off incidental (parenthetical) material by commas, dashes, or marks of parenthesis. Each of these marks is acceptable for this purpose; your choice will usually depend upon the closeness of relationship between the material inserted and the remainder of the sentence. No specific rule can be stated, but commas are ordinarily used to enclose parenthetical material closely related in thought and structure to the sentence in which it occurs; dashes enclose parenthetical material which more forcefully and abruptly breaks into the sentence or may be used in a somewhat informal style; parentheses are used to enclose material more remote in thought and structure or material which runs to some length and may itself contain internal punctuation, such as commas. The following sentences will illustrate this general tendency, although the marks conceivably could be used interchangeably:

a. Denmark, which is where he was born, was his favorite
European country.

b. Denmark—he lived there until he was seven—was his
favorite European country.

c. Denmark (he was a native of that country and lived there
until he was seven) was his favorite European country.

Parentheses are rather formal and conspicuous marks of punc-
tuation; therefore, do not overuse them. Also, if your writing
contains many parenthetical statements requiring punctuation,
look to your sentence structure; it is likely that you are not using a
clear, straight-forward, logical style. Parentheses are actually *in-
terrupters* and tend to slow up communication from writer to
reader. Most sentences can be rephrased to avoid using par-
enthetical statements at all. For example, the first illustrative
sentence above may be recast into a sentence containing no par-
enthetical material: "Because he was born there, Denmark was
his favorite country."

When you do need this mark to enclose inserted material
(words, a sentence, numbers, letters) follow these general princi-
ples:

(1) Use parentheses to enclose material remotely connected
with its context.

This illustration (see p. 35) is quite clear.

Your attitude (I am certain it is important) should be carefully
explained.

This issue of the magazine (September 1961) is particularly
interesting.

This politician (about whom I shall have more to say later) is
not worth your support.

The accident victim was taken to the Washington (Georgia)
General Hospital.

For his position on states' rights, the candidate kept referring
to one sentence (Article X) in the Constitution of the United
States.

The general properties of sets of continuous real numbers
(which exclude imaginary numbers such as those based on the
square root of minus 1) are called mathematical analysis.

(2) Use parentheses to enclose figures or letters indicating divisions.

Two parentheses are recommended, although some publications use only the second.

The committee decided to (1) adopt the suggested budget, (2) set a date for the next meeting, (3) adjourn.

He left hurriedly for several reasons: (a) poor health, (b) lack of money, (c) dull companions, (d) a job in the city.

(3) Use parentheses to enclose sums of money.

His total bill was four hundred dollars ($400.00).
The wholesale price is eighty cents (80¢) per dozen.

Sums of money repeated for accuracy and enclosed in parentheses occur most often in business writing and in legal papers. Ordinarily you need not resort to this device; either words or numerals will suffice.

(4) Use parentheses to enclose question marks or exclamation points used to express irony, doubt, etc.

Sam is in good shape; he needs to lose only (!) fifty pounds.
This baby was born on April 24 (?) last year.

As is suggested elsewhere (see pages 109 and 133), you should rarely use this form of expression. Irony and sarcasm can usually be expressed more forcefully in other ways; do not use a question mark as a lazy excuse for not finding out exact information.

(5) Use parentheses to indicate errors or omissions in something being quoted.

Brackets (see page 51) are preferable for this purpose but are rarely used by newspapers and magazines. Parentheses are being increasingly used, somewhat inexactly and contrary to conventions of punctuation, either to correct material or to call attention to an error or oversight. (But never enclose in parentheses material in your own writing which you wish to omit or change; draw a line through it, erase, or rewrite.)

The student wrote: "The Straights (Straits) Settlements is a former British crown colony in Malaya."

In this novel, Janet is portrayed as a fallen angle (angel).

In this novel, Janet is portrayed as a fallen angle (*sic*). (*Sic* is a Latin word meaning "thus." By using it, you call attention to an error but do not correct it.)

"Bill, Sue, Mike, and all of the other(s) are going."

22

PERIOD

Second only to the comma, the period (.) is the most widely used of all marks of punctuation. Its use also causes less trouble than that of any other mark; even small children are accustomed to seeing, and putting, periods at the ends of sentences. More than 95% of all sentences end with a period, regardless of who writes them or where they appear. There are, however, a few simple principles regarding the use of periods which require attention.

It should be noted, for example, that periods have functions other than to end sentences. For the use of periods with abbreviations, see page 24. For the use of periods (ellipsis periods or suspension dots) to indicate omission from a sentence, see page 105. Important and minor additional uses of the period are detailed in the section which follow. Just because the period is a familiar mark, do not thereby assume that its use presents no problems.

(1) Use a period at the end of a declarative sentence.

A declarative sentence states a fact, a condition, or a possibility and is distinguished from an interrogative sentence (which asks a question), an imperative sentence (which expresses a command or a strong request), and an exclamatory sentence (which expresses strong feeling or surprise). Sometimes, only punctuation will indicate whether a written sentence is declarative, interrogative, exclamatory, or imperative; in speech, this distinction is shown by tone of voice and inflection.

His trip began with an inspection of the missile base.
He prefers winter to summer vacations.

127

These are obvious statements of fact, or supposed fact, and are terminated by a period. But they might be spoken, or written, to indicate something other than a statement of fact:

His trip began with an inspection of the missile base?
Did it really? What a surprise!

He prefers winter to summer vacations! Isn't this an unusual attitude? I have a different opinion.

We are here concerned with punctuation, not with so-called grammar or rhetoric. But it might help to comment on the grammar of a *sentence:* by definition, a sentence is a group of words containing a subject and a predicate and expressing a complete thought. Yet various kinds of statements express a complete thought without a stated or implied subject or predicate. Do they require a period or other terminal mark of punctuation? Is it incorrect so to punctuate such "sentence fragments," as they are called?

Perhaps you noticed the illustrative sentence above, "What a surprise!" By definition, this is not a complete sentence; it contains no verb (predicate). But it does express a complete thought and may be ended with a terminal mark. You should be careful to write sentence fragments (or "period faults," as they are sometimes called) only for stylistic effect—and not because you don't know what a sentence is or should be. However, such sentence fragments as these are justifiable and effective and may be punctuated as complete statements:

"Where have you been?"
"Eating."
"Where?"
"Across the street at Dirty Joe's."
"Fricasseed hummingbird wings, no doubt!"
"At Dirty Joe's? Ham and eggs—burned."

He walked as though he were in a trance. Dreaming. Dreaming? Not likely. He was more detached than that. Further away. Lost in his own world.

(2) Use a period after an indirect question.

A sentence asking a direct question must be ended with a question mark. But words such as *when* and *what* often introduce parts of sentences which ask a question so indirectly, so obliquely, that no question mark is called for although the tone of the sentence is mildly interrogative.

> The foreman asked me when I could come to work.
> Please tell me what he said and how he said it.
> The judge wanted to know why I couldn't pay the fine.

A question mark after any of these three sentences would confuse your reader by distorting meaning.

(3) Use a period after a mild command or polite request.

A direct command is usually followed by an exclamation point (see page 108); a direct question is followed by a question mark (see page 132). On occasion, however, a command or question may be so mildly imperative or interrogative that a period should be used; the purpose is to suggest rather than to issue a command or ask a question requiring an answer.

> Take your time and work carefully.
> Come up and see me some time.
> May we please have a prompt reply to this letter.
> Will you kindly sign and return the enclosed form.

(4) Use a period after a standard abbreviation.

The use of abbreviations is treated on pages 23–35. A number of exceptions to the use of periods with abbreviations is noted on those pages; be sure not to omit periods where convention calls for them and do not add them where they are not needed or are not customary. In short, a period must follow an abbreviation unless otherwise specified. Also, keep in mind these further comments on the use of periods with abbreviations or apparent abbreviations:

a. If a declarative sentence ends with an abbreviation, use only one period:

> His home was in Baltimore, Md.

b. If an interrogative or exclamatory sentence ends with an abbreviation, the question mark or exclamation point follows the abbreviation period:

> Does he make his home in Baltimore, Md.?
> You say he lives in Baltimore, Md.! Surely you are mistaken.

c. Inside the sentence, an abbreviation period is followed by any mark which normally would be used:

> He lives in Baltimore, Md.; my home is in Philadelphia.
> This is the meaning of A.W.O.L.: absent without official leave.

d. Use no periods after contractions (shortened words but not true abbreviations): *don't, isn't, shan't,* etc.

e. Use no periods after ordinal numbers when written thus: 1st, 2nd, etc.: *the 1st Battalion*.

f. Use no periods after nicknames or names which are not truly abbreviations of longer forms: *Bill, Al, Alex, Sam, Pam, Flo*.

g. Use no periods after familiar shortened forms of words, such as *ad, taxi, cab, auto, phone, exam, percent,* and *lab*.

h. Use no periods after certain specialized abbreviations and most acronyms (see page 24): *Station KDKA, NBC, UNESCO, WAVES, TB* (for *tuberculosis*), *TV* (for *television*).

i. Use no periods after chemical symbols, even though they are abbreviations: *O* (for *oxygen*); *NaCl* (for *sodium chloride*).

j. Use no periods after Roman numerals: *Louis XIV, Chapter VII,* etc.

k. British practice usually omits the period after such standard abbreviations as *Mr., Mrs., Dr., St., Co.* In the United States such omission may be considered either an experiment or an affectation. In other words, *don't* omit.

l. When in doubt about the use of periods with abbreviations, consult your dictionary. Dictionaries differ among themselves, but you cannot be "faulted" if you follow the dictates of any one good dictionary.

(5) Use a period before a decimal, to separate dollars and cents, to precede cents written alone, and in writing metric symbols.

3.75 percent $10.63 $0.85 (85¢) 3 cc. (cubic centimeters)

Periods have other minor miscellaneous uses of little practical concern to the average writer:

a. A line of periods (called *leaders*) is sometimes employed in such places as the tables of contents of books to guide the reader's eye across to a page reference.

b. Most dictionaries use periods, usually centered on a line, to mark the syllables of entry words.

c. Many continental European languages employ periods to mark thousands where we would use commas: $1.230.456 for $1,230,456.

d. Periods are occasionally used instead of parentheses to mark divisions in a series (see page 106).

These infrequent or minor uses need hardly concern you; concentrate on the five principal rules given above. And isn't it comforting to come across *one* mark of punctuation which gives little trouble, the uses of which are fairly well standardized and easily learned?

23

QUESTION MARK

The question mark (?) is mainly used to terminate a direct question. Most people ask many more questions in speaking than in writing: only about one sentence in ten in ordinary writing is a direct question. Actually, the consistent, repeated appearance of question marks (sometimes called "interrogation points") in writing is both conspicuous and annoying. Occasionally, you may need to ask a series of questions; sometimes a direct question is a good way to get your reader's attention and draw him into consideration of your subject. But the mark is not one to be trifled with; it should normally be used sparingly and only for good reason.

All situations calling for the approved use of question marks are indicated in the paragraphs which follow.

(1) Use a question mark at the end of every direct question.

It is usually easy to recognize a direct query, but you should remember that sometimes a sentence which is declarative in form may actually be interrogative in sense. Also, remember that a question mark should never be used after an indirect question (see page 129). Again, remember that although the question mark is considered a terminal (end of sentence) mark, it may appear elsewhere in a sentence than at the end. Note the punctuation of the following:

> Does he really love her?
> He really does love her?
> John asked, "May I go with you today?"

"May I go with you today?" John asked.

John asked whether he might go today.

What is the penalty for late payment? is the question.

Who asked "When?" (Note the single question mark.)

(2) Use question marks to indicate a series of queries in the same sentence.

Will you go with me? or will your friend? or someone?

Who will be there? Sam? Violet? Carol? Marion?

Do you remember when you had to empty a drip pan under the icebox? When car windshields opened to let in a breeze? When men's shoestrings laced halfway up through eyes and the rest of the way 'round the hooks? When radios came in two pieces, the speaker being separate? You could mail a letter with a two-cent stamp? Men wore garters? Grandmothers were elderly women?

Note that in the first illustration given, small letters rather than capitals follow the question marks. Actually, capital letters could be used in this situation, but they are normally employed when each of the series of questions is a sentence or nearly a sentence, as in the third illustration, or when the series consists of proper names, as in the second illustration. That is, an individual sentence normally has only one terminal mark of punctuation, and all letters preceding it are small except the first word in the sentence and others capitalized because they are proper names or require capitals for some other reason.

(3) Use a question mark enclosed in parentheses to express doubt or uncertainty.

As noted elsewhere (see pages 125–126), this employment of the question mark is not recommended for regular and consistent use. Usually the mark suggests that we have been lazy in not securing exact information or that we are afraid to speak our minds clearly and forcefully. Sometimes, however, we have no other recourse.

This is a genuine (?) diamond, or at least it looks like one.

Shakespeare was born on April 23 (?), 1564.

If you are not an expert and have no access to one, the question mark in the first illustrative sentence is justified. It is clearly indicated in the second illustration inasmuch as experts themselves differ about the exact date.

(4) Use a question mark enclosed in parentheses to indicate an ironical or humorous meaning.

This use of the question mark should be avoided whenever and wherever possible. See page 125 for further discussion. It is doubtful that good writers ever resort to such punctuation as the following:

> When he slipped on the ice he gave a gentle (?) roar of pain.
> This candidate pleaded his cause in a modest (?) speech.

(5) Do not overuse the question mark.

Like the exclamation point, asterisk, and certain other marks of punctuation and mechanics, the question mark is conspicuous and, if overused, is annoying to many readers. Never use the question mark without good reason.

In addition to using the mark sparingly to indicate doubt or to express irony, sarcasm, and the like, you should guard against using it with only a technically or superficially interrogative sentence. As is suggested on page 129, a period, not a question mark, is ordinarily used with a polite request. We often write sentences which appear to ask a question but which actually do not. "Will you please return the coat as soon as possible" usually means "We want our coat back right now." It does not really mean "Will you please return the coat?" If it did, a question mark would be needed. Such an expression as "How dare you" probably should be followed by a period or an exclamation point. Rarely would it be prompted by curiosity; most often it is the result of anger or some other strong emotion. "May I have your hat" is most often an expression prompted by courtesy, not curiosity.

In general and in short, use question marks primarily for purposes indicated in the first two "rules" cited above and rarely, if ever, at any other times or for any other reasons.

24

QUOTATION MARKS

Quotation marks, both double ("...") and single ('...'), are marks of enclosure for words, phrases, clauses, sentences, and even paragraphs and groups of paragraphs. By definition, *quotation* means repeating (or copying) what someone has said or written; *quotation marks* are a device used principally to indicate the beginning and end of material so quoted. These marks, often called *quotes*, consist of two (or one) inverted commas at the beginning (*open-quote*) and two (or one) apostrophes for closing a quotation (*close-quote*). On a standard typewriter or computer keyboard, single and double quotation marks are the same at beginning and end.

In some books and magazines and in most newspapers, either no quotation marks at all or single quotation marks are printed where, according to convention, double ones would be used. For example, the *New York Times* invariably uses single quotes in all headlines and subheads where quotations are involved. A few book publishers, presumably as a typographic experiment or in an attempt to be "different," often use single quotes where American convention calls for two. Also, those of you accustomed to reading material printed in the British Empire are familiar with the use of single and double quotes exactly reversed from American usage.

You are advised to employ these marks in accord with conventions set forth in this section. Unless there is sound reason to proceed otherwise, use quotation marks in the following situations and circumstances:

(1) Direct quotations.

A direct quotation is the exact words of the person being quoted, the original writer or speaker. You must be careful to enclose in quotes, precisely as written or spoken (even though obvious errors occur), verbatim material carefully set down or copied. In most general writing, such quotations consist of words really used; in fiction, they consist of imagined words in dialogue or monologue. Indirect quotation, in which the sense but not the exact phrasing is quoted, should not be enclosed in quotes.

"What will my starting salary be?" I asked the manager.
"Well," he replied, "I'm not sure." Then, pausing, he inquired, "What do you think is fair?"

The professor looked up the quotation he had had in mind all during the argument with his teen-age son. He found it in Plato's *Laws:* "You are young, my son, and, as the years go by, time will change and even reverse many of your present opinions. Refrain therefore awhile from setting yourself up as a judge of the highest matters." He smiled ruefully and recalled that Plato had also written, "Of all the animals, the boy is the most unmanageable."

Note that in the first brief passage above, direct quotations are interrupted by other words and that quotation marks are used to enclose each part of the broken-into quotation. The most common of such interrupters are word groups like "he said," "said he," "she replied," "I answered," etc. Such an interrupter is preceded by a comma, unless a question mark or exclamation point is required. It is followed by a comma or an even stronger mark of punctuation, such as a period or semicolon, if the grammatical elements involved require it. Selecting the correct mark of punctuation will be aided by this test: What mark of punctuation would be used if the interrupter ("he said," etc.) were omitted? Use that mark after the inserted part indicating the speaker.

Sandy is a good friend, but I have not seen her for a year.
"Sandy is a good friend," she said, "but I have not seen her for a year."

There is no opening here; however, we will keep your application on file.

"There is no opening here," the personnel manager said; "however, we will keep your application on file."

He bought the car at Fairport. It was on sale.

"I bought the car at Fairport," Harry said. "It was on sale."

On occasion, you may be writing your own account of someone's comment but desire to give his exact words now and then. Be careful to enclose in quotes only the actual words used, not your restatement of remarks made:

> The farm agent sternly declared that "it makes no sense at all" for the Congress to support aid for farmers with oratory but "wilfully and maliciously" to oppose all bills designed to support farm prices.

> Criminals of today, the bondsman declared, don't have the "solid respectability" of those of forty or fifty years ago.

(2) Lengthy direct quotations.

Direct quotations must be enclosed in double quotes, yet if such a quotation extends for more than one paragraph, place quotes at the beginning of each paragraph but at the end of only the last.

> "To measure and mark time has always been a concern of people. Early systems for noting the passage of time were based on the sun, stars, and moon.

> "Egyptian priests established a year of 365 days as early as 4200 B.C. and based their calculations on the passage of the seasons, the sun's shadow, and the behavior of stars.

> "Under Julius Caesar, astronomers prepared the Julian calendar in which twelve months were given arbitrary lengths and every fourth year was made a leap year."

Quotation marks enclosing lengthy quotes may be omitted if you make the lines of the quotation shorter than full measure. That is, if you indent each line of each paragraph of the quotation a

half-inch or so, so that it is clearly distinguished from the remainder of the text, quotes may be dropped. This is a device commonly employed by many book and magazine publishers and may be adapted for your own use. (In double-spaced typewritten copy, such indented quoted material is usually single-spaced.)

(3) Change of speaker.

In dialogue (the conversation of two or more persons) it is conventional to use a separate paragraph for each change of speaker. If this is done, and exceptions do occur in even careful writing, quotation marks are needed at the beginning and end of each separate comment. Here is a sample of short speeches of dialogue, separately paragraphed and separately enclosed in quotes:

> Larry was dressing for tennis when Bill walked into the room.
>
> "What's up?" Bill asked. He walked over to the sofa in the corner and sat down leisurely.
>
> "Game with Sue at noon," Larry replied. "But I was up so late last night that I think I'll be awful."
>
> "Well, who was your date?"
>
> "Sue," replied Larry sheepishly. Bill grinned, picked up a copy of *Esquire,* and began looking for cartoons.

(4) Words with a different level of usage.

If a word or expression is appropriate, no matter what its level of usage, no quotation marks should enclose it as a form of apology. This suggestion applies to slangy or colloquial expressions, even profanity. If the expression is not appropriate, you can usually find a substitute which is.

Occasionally, however, you may wish to shift to an expression having a specific, limited usage or level of usage in order to convey a thought realistically and emphatically. Such expressions may be illiteracies, technical words, or common words with a specialized or technical meaning; they are enclosed by double quotation marks.

> Most of the executives are estimable men, but the president is a "stuffed shirt."

Our congressman voted for the "lameduck" amendment.

He referred to it as a "gentleman's agreement," but to me it was sheer "bunk."

This issue of stock was so heavily "watered" that it caused an investigation by the New York Stock Exchange.

When the foreman "lit into" me for my error, I "lit out" for the front office to explain to the superintendent.

If we judge that we "have it taped," we are not likely to be curious about the ways in which other races of man have answered questions that are also our questions.

He has "had it" so far as all religion is concerned and finds televangelism positively repugnant.

Quotation marks are conspicuous and sharply focus attention upon the words or expressions which they enclose. Therefore, do not overuse them for the purpose just mentioned or as an excuse for inexact choice of words. Also, words which are labeled *colloquial* in your dictionary are in reputable informal use and should not be enclosed unless they represent a marked shift from the level of writing you are employing.

(5) Titles and names.

If there is no chance of confusion, quotation marks may be used instead of italics (underlining) to indicate the names of ships, trains, airplanes, and the like, but underlining is preferable (see page 114). When both a chapter heading and the title of a book are cited, or when both the name of an article and that of the magazine in which it appears are given, you will need to use italics and quotes. The general rule is to use quotation marks with chapter headings; with the titles of articles, short stories, and short poems; with art objects and the like. Use italics (underlining) with all other names and titles as indicated on pages 114–115.

Book publishers tend to use more italics (underlining) than either magazines or newspapers. The appearance of italics in most newspapers is so rare as to be almost nonexistent, but this is no criterion for the use of italics in your own writing, which is not dependent upon the kinds of type which may be available in the printing plant of a newspaper. Note the preferred use of italics and quotation marks in the following:

He found the quotation from Longfellow's "The Children's Hour" in Bartlett's *Familiar Quotations*.

The article was from *National Review* and was entitled "Freedom and Virtue."

Grant Wood's famed painting, "American Gothic," was recently reproduced in *American Heritage*.

His most famous short story is called "The Devil and Daniel Webster." It first appeared in the *Saturday Evening Post* and was later published in a book entitled *Thirteen O'Clock*.

Some titles, it should be noted, require neither quotation marks nor italics. It is not necessary to quote or underline the names of books of the Bible or even the words Bible, Old Testament, and New Testament. Such famed titles as the Gettysburg Address and the Declaration of Independence require neither quotes nor italics, although of course it is no error so to distinguish them.

A more difficult problem is whether to include such words as *the, a,* and *an* in a quoted or italicized title or name. If they are included, they should preferably begin with a capital letter and should be underlined or included within quote marks. Their inclusion or exclusion is a matter of personal preference. You may correctly write *Atlantic Monthly,* the *Atlantic Monthly, The Atlantic Monthly,* or even the "Atlantic Monthly" (see page 114).

(6) Items for special attention.

In order to make your meaning clear, you will occasionally need to refer specifically to a word or phrase by underlining it or placing it in quotation marks. Italics (underlining) are preferred for this purpose (see page 116), but quotes are permissible.

Ivan said "not yet" but I thought he said "nyet."

The phrase "freedom of worship" (*freedom of worship*) has had many interpretations.

The word "ineluctable" (*ineluctable*) is a learned word meaning "inevitable" (*inevitable*).

Once again, do not overuse quotation marks to attract attention to a word or phrase. It is unnecessary, although not incorrect, to use quotes when mentioning terms whose meaning is clear:

He gave a peculiar definition of the word God.

His concept of good is about the same as mine of evil.

(7) Quotation within a quotation.

The standard rule in American practice is to use single quotation marks to enclose a quotation within a quotation. (British practice is usually the reverse.) On the exceedingly rare occasions when it is necessary to punctuate a quotation within a quotation within a quotation, the correct order is double marks, single marks, double marks. If more sets of marks than this are needed, you had better recast your sentence so as not to lose your readers entirely.

The foreman said, "When you say, 'I'll be there on time,' I expect you to mean what you say."

The foreman went on, "Then this worker asked, 'What did the boss mean when he said, "Joe, be there on time"?' "

Further notes on quotation marks:

(1) Use quotes as sparingly as possible but do use them in accordance with the principles outlined above.

(2) Do not use quotation marks to enclose indirect quotations or indirect questions (see page 136).

(3) Always use quotation marks in pairs; a single or double quote can never appear alone except in printed material where the opening quote is sometimes omitted before an initial letter for the sake of appearance.

(4) Place quotation marks correctly with reference to other marks:

a. The comma and period *always* come *inside* quotation marks. This principle applies even when only the last word before the comma or the period is enclosed (but not alphabetical letters or figures).

b. A question mark, or exclamation point, or dash comes *outside* the quotation marks unless it is part of the quotation. The question mark comes *inside* the quotation marks when both the nonquoted and quoted elements are questions.

c. The semicolon and colon come *outside* the quotation marks.

If these statements seem confusing, perhaps these illustrations will clarify them:

"Please lend me the money now," she said. "I won't need it tomorrow."

The prize pumpkin was rated "excellent," but one judge felt it was only "good."

She went to Gate "Y", but her ticket indicated the proper entrance was "G".

Did Jim say, "I have enough money"?

Jim asked, "Have I enough money?"

"Have I enough money?" Jim asked.

What is meant by "an eye for an eye"?

The performance was an utter "flop"!

"My performance was a 'flop'!" she exclaimed.

"Well, I'll be—" she said and then blushed.

He arose confidently, said "My friends"—and then fell to the floor in a dead faint.

Did Jim ask, "Have I enough money?"

Read Thoreau's "Brute Neighbors"; as a nature lover, you will enjoy it.

Study the following in "A Glossary of Applied Punctuation": dialogue, diction, and slang.

Carefully examine several pages of a short story or novel that contain dialogue. Examine the use of quotation marks and their position with respect to other marks of punctuation.

25

SEMICOLON

The semicolon (;) is entirely a mark of separation, or division; that is, it is never used to introduce, enclose, or terminate a statement. It is a stronger mark than the comma, signifying a greater break or longer pause between sentence elements. But it is weaker than the period and other terminal marks (question mark, exclamation point) and cannot be used to end a sentence. Its use indicates that two or more statements are not sufficiently related to require commas but are too closely related to justify being put in separate sentences separated by a terminal mark.

The word *semicolon* is something of a misnomer. The prefix *semi* has a meaning of "half," so that a semicolon might be thought of as "half a colon." Up until about a century ago, colons and semicolons were occasionally used interchangeably, but they have distinctly different uses now. A colon is primarily a mark for introducing or summarizing (see pages 68–71); a semicolon is exclusively a mark of separation. You will have a clearer idea of the essential purpose of the semicolon if you will think of it as a "reduced period," a "half-period," a "semi-period," or as a "double-comma," although no such marks exist. Or you may regard this hybrid mark as a cross between a comma and a period.

The semicolon is a clearly specialized co-ordinating mark of punctuation; it is properly used only between elements of a sentence that are co-ordinate, of equal grammatical rank. Such grammatical terminology and distinction can become a bit troublesome and sticky; perhaps a good general rule is that in

most instances you should insert a semicolon only when use of a period could clearly be justified, despite the fact that the semicolon is exclusively an internal (within the sentence) mark.

Some writers apparently feel that the semicolon is a rather formal, even fussy, mark of punctuation. This opinion may be a holdover from days when the semicolon was related in function to the colon—a mark which is indeed considered somewhat formal even today. But the semicolon actually is a useful device to help speed up reading; its proper use, not overuse, will enable you to dispense with a good many "comma plus conjunction" constructions that often slow down reading. However, as with all other marks of punctuation, don't overdo; one author will never forget being told, as a beginning writer, that he had a severe case of "semicolonitis."

The semicolon, a "semi-period" or "reduced period," may be used to separate:

(1) Two or more complete statements.

A grammarian would correctly point out that "separating complete statements" here means separating independent clauses not joined by one of the familiar co-ordinating conjunctions like *and, but, or, nor, neither,* and *yet.* He might also correctly assert that complete statements are far more often separated by a period than by a semicolon.

But the principle remains: if you wish, you may correctly separate compound clauses by a semicolon, or by the use of a comma and a conjunction, or by a period or other terminal mark. In actual practice, some writers use semicolons where others use periods. In theory, the use of a semicolon is justified only when the relationship between clauses is fairly close; if it is not, a period is called for. In theory and in practice, the following punctuation is justifiable and optional:

In the 19th century, Russia penetrated into the Pacific Northwest; also, people feared Spain might regain her former American colonies.

In the 19th century, Russia penetrated into the Pacific Northwest, and, also, people feared Spain might regain her former American colonies.

In the 19th century, Russia penetrated into the Pacific Northwest. Also, people feared Spain might regain her former American colonies.

The first tinge of gold is in the maples, the first smell of wood smoke is in the air, the tourists are gone. The squirrels are at work, mists drop from the boughs, leaves float down.

The first tinge of gold is in the maples; the first smell of wood smoke is in the air; the tourists are gone. The squirrels are at work; mists drop from the boughs; leaves float down.

The first tinge of gold is in the maples. The first smell of wood smoke is in the air. The tourists are gone. The squirrels are at work. Mists drop from the boughs. Leaves float down.

Probably the majority of careful writers and skilled copy editors would prefer semicolons in these two groups of statements: commas fail to indicate enough separation; periods tend to make the sentences somewhat short and choppy, especially in the second group. But your choice of punctuation can legitimately and correctly be a personal one, depending upon the precise meaning and rhythm you wish to convey.

The punctuation of complete statements does indeed present alternatives. Normally, as has been suggested, such statements are separated by semicolons, by periods, or by commas and conjunctions. But if the statements are short or are very closely related, commas alone may be used. Plutarch attributes this famous series of three complete statements to Caesar: "I came, I saw, I conquered." You must use your own judgment and taste in punctuating such an expression as the following:

We argued, we begged, we pleaded, we lost the decision.
We argued, and we begged, and we pleaded, and we lost the decision.
We argued; we begged; we pleaded; we lost the decision.
We argued. We begged. We pleaded. We lost the decision.

The majority of good writers would probably use commas or semicolons in these sentences. The "comma and conjunction" structure sounds a bit immature, but it might be justified for

some particular stylistic purpose. Certainly periods are justifiable if you wish to add emphasis to the verbs involved.

In short, despite the flat statement that semicolons may appear between complete statements, you should emphasize the word *may*—it is not *must*—and use your own judgment. Other punctuation could be used in some or all of these sentences, but the semicolon is fully justified and is here recommended:

> In most contracts, the large print giveth; the small print taketh away.
>
> Children begin by loving their parents; as they grow older they judge them; sometimes they forgive them.—Oscar Wilde
>
> If you make people think they are thinking, they will love you; if you make them think, they will hate you.—Don Marquis
>
> Life is very short and very uncertain; let us spend it as well as we can.—Boswell's *Life of Johnson*.
>
> Reading maketh a full man; conference [maketh] a ready man; and writing [maketh] an exact man.—Sir Francis Bacon
>
> You cannot run away from a weakness; you must some time fight it out or perish.—Robert L. Stevenson
>
> Lord, I believe; help thou mine unbelief.—Mark
>
> We always like those who admire us; we do not always like those whom we admire.—La Rochefoucauld
>
> We know nothing of tomorrow; our business is to be good and happy today.—Sydney Smith

The semicolon is almost essential for the sake of clarity between complete statements that are lengthy or contain considerable internal punctuation. A period might substitute for the semicolon, but hardly a comma or comma and conjunction, in sentences such as these:

> As long as war is regarded as wicked, it will have its fascination; when it is looked upon as vulgar, it will cease to be popular.—Oscar Wilde
>
> Whatsoever thy hand findeth to do, do it with thy might; for there is no work, nor device, nor knowledge, nor wisdom in the grave, whither thou goest.—Ecclesiastes

It is easy in the world to live after the world's opinion; it is easy in solitude to live after your own; but the great man is he, who, in the midst of the world, keeps with perfect sweetness the independence of solitude.—Emerson

Man is timid and apologetic; he is no longer upright; he dares not say "I think," "I am," but quotes some saint or sage.—Emerson

The days of our years are threescore years and ten; and if by reason of strength they be fourscore years, yet is their strength labor and sorrow; for it is soon cut off, and we fly away.—Psalms

(2) Complete statements with a conjunctive adverb.

Statements of equal rank joined by a conjunctive adverb are usually separated by semicolons. Conjunctive adverbs, special kinds of adverbs which can also be used as conjunctions, include *also, anyhow, as a result, besides, consequently, for example, furthermore, hence, however, in addition, indeed, in fact, instead, likewise, meanwhile, moreover, namely, nevertheless, otherwise, similarly, so, still, then, therefore, thus, yet.*

He tried for two months to learn to use a comptometer; *then* he quit trying and admitted his failure.

This job is not simple; *however,* it is exciting and rewarding.

Jim's sister is a busy girl; *in fact,* she works harder than he does.

When applying the foregoing principle, keep in mind these explanatory comments:

a. Use a semicolon immediately before the conjunctive adverb when the latter comes between independent clauses. The semicolon alone separates the clauses if the conjunctive adverb is shifted in position; enclosing the adverb with commas will depend upon its parenthetic strength.

He tried for two months to learn to use a comptometer; he *then* quit trying and admitted his failure.

This job is not simple; it is, *however,* exciting and rewarding.

Jim's sister is a busy girl; she works harder, *in fact,* than he does.

b. When the conjunctive adverb comes between the clauses, should there be a comma after it? In the absence of an unvarying principle, use as a guide the weakness or strength of the word or phrase, parenthetically, in relation to the second clause. If it is weak, omit the comma; if it is strong, use a comma; if it is mildly strong (like *therefore*, for example), use or omit, depending upon your desire to indicate a pause. Another guide: a comma usually follows a long conjunctive adverb or phrase (*nevertheless, in fact, for example*, etc.), rarely follows a shorter one (*thus, hence, then*, etc.).

I have trained myself to read rapidly and carefully; *thus* I save myself many hours a week.

I did not favor spending the money; *nevertheless*, I did not vote against the proposal.

This climate is subject to sudden weather changes; *consequently* (or *consequently*,) you should bring a variety of clothing.

The soldier was totally unsuited to combat duty; *therefore*, he was transferred to a base camp.

The soldier was totally unsuited to combat duty; he was *therefore* transferred to a base camp.

c. Distinguish between conjunctive adverb and simple conjunction. A conjunctive adverb is both conjunction and adverb; as such it has an adverbial function which no simple conjunction (such as *and* or *but*) possesses. Furthermore, it is used only between independent clauses, or sentences, whereas a simple conjunction may join words, phrases, dependent clauses, independent clauses, or even sentences.

d. Distinguish between a conjunctive adverb placed between independent clauses and a subordinating conjunction (*although, because, since, whereas, inasmuch as*) introducing a dependent clause coming between the two independent clauses. The subordinating conjunction is preceded by a semicolon in such uses only when no pure co-ordinating conjunction joins the independent clauses.

I shall attend the lecture this evening, *although I can ill afford the time*. (Dependent clause follows independent clause.)

I am having trouble with counting money and making change; *because I was never good in arithmetic*, I think that I'll be assigned to another department. (Two independent clauses separated, the second being introduced by a dependent clause. Two sentences might be preferable, since writing should be immediately clear to your reader.)

(3) Other equal parts of sentences.

A semicolon may correctly separate only elements which are equal in rank, but these elements may be less than complete statements. On occasion, a set of dependent clauses or even a group of phrases may be separated by semicolons in the interests of clarity. In such instances, good judgment and not fixed rules should prevail. That is, use semicolons if doing so will add clarity to your writing.

Those chosen to receive awards were Shirley Blackman, who had not missed a day from work; Louise Wether, who had made the most suggestions for improving efficiency; Jack Smythe, who had the best record among all the salesmen.

The officers of the union are John Redpath, president; Susan Dilworth, vice-president; Henry Seeley, secretary; Jane Dulin, delegate to the national convention; Joe Smoley, treasurer.

Among abbreviations not often seen are C.J. (Chief Justice); C.M. (Master in Surgery, from the Latin *Chirurgiae Magister*); and C.S.D. (Doctor of Christian Science).

The Bible readings for the day included Gen. 2:4–6; Judges 2:3; Romans 2:1–4, 7–9.

(4) Overuse of the semicolon.

The semicolon is a particular mark with quite definite uses, which have been indicated in preceding pages. Like all other marks, it should be neither incorrectly used nor overused. Especially avoid using semicolons in the following ways:

a. To set off phrases or dependent clauses unless for specific

purposes indicated above. Ordinarily, the semicolon has the same function as a period: it indicates a complete break, the end of one thought and the beginning of another. One fairly safe guide may be repeated: *no period, no semicolon*. Setting off dependent clauses or phrases with semicolons will confuse your readers.

Wrong: Inasmuch as Joe has a fiery temper; we have to be careful what we say to him. (Dependent clause)

Wrong: The next meeting of the club has been postponed two weeks; because most of the members are on an inspection trip to Detroit. (Dependent clause)

Wrong: Being careful to observe all traffic regulations; I am considered a good driver. (Participial phrase)

Wrong: The excitement of our mock political campaign having died down; we once again turned our attention to our jobs. (Absolute phrase)

To correct semicolon errors like these, use no punctuation or use a comma for the semicolon.

b. As a mark of introduction.

Wrong: My purpose is simple; to succeed in life.

Wrong: (In business letters) Dear Sir; Dear Mr. Woods; Gentlemen;

To correct semicolon errors like the foregoing, substitute colons or commas for the semicolons.

c. As a summarizing mark.

Answering the phone, typing, filing; these were my duties that summer.

Use a dash or a colon instead of the semicolon shown (see pages 68–69 and 97).

26

EXERCISES ON ALL MARKS

I

Periods and related marks. Each entry in the pairs below may contain a mistake in the use of periods, question marks, or exclamation points. In space at the left, use a capital letter to indicate that of the two sentences: A—the first only is acceptable; B—the second only is acceptable; C—both are acceptable; D—neither is acceptable.

1. Will you please refer to the Simmons file for the requested information. As I prepared to drive away, Father asked me if I hadn't forgotten something?

2. Mrs Ethel Richardson agreed to serve as secretary at the meeting. The skid marks measured 18 yd. 2 ft. 4 in.

3. NASA announced a delay of the moon shot because of overcast skies. As soon as Porter arrived, he asked us if we had brought our diving equipment.

4. "Many provisions . . . for governmental intervention in the economy, once regarded as startling and dangerous, have now come to be commonplace and routine . . ." The FRB announced a rise in the bank discount rate to 5.5 percent.

5. The title of his theme, "The Can-Opener Culture," seemed to me too comprehensive for a short essay. On your way out, would you please post this letter for me!

6. How many times have I asked you not to slam that door! Just as Bert had said, there was a good record player in the cabin, but his record collection contained nothing but—ugh!—country music.

7. Instead of addressing the letter to Mr. Henry Tripp, 1256 So. Euclid Ave., you would show your correspondent more respect by spelling out the address fully. A frequent and well-intended social query—haven't you lost some weight lately?—can never actually be pleasing, since it implies that the hearer was too fat before or is too thin now.

8. How can we make you comfortable? Something to eat? A magazine? Television? Or would you like just to be left alone? She was always asking her guests if they didn't believe in extrasensory perception?

9. Did the Weather Bureau say it will rain today? Isn't that a pity?

10. Will you kindly let me know as soon as Emerson returns to his office. You expect me to meet her plane at 2:30 AM? Impossible!

II

Semicolon, colon, dash. Each item begins with a correct sentence; you are to rewrite it as directed. In space at the left, use a capital letter to indicate that the shift from the original to the rewritten sentence requires you to: A—insert, or change a mark to, a semicolon or semicolons; B—insert, or change a mark to, a colon or colons; C—insert, or change a mark to, a dash or dashes; D—take out one of the marks above, or change it to a comma; E—to keep the same punctuation as in the original.

1. The facts of her childhood were hardly ideal; she was born into poverty, abandoned at the age of six, and reared in an orphanage. (Take out *she was*).

2. At high school he starred in all the sports offered: football, basketball, and track. (Take out *all the sports offered.*)

3. Now listen to this carefully: send word to me at once if the drill brings up any gravel or even coarse sand from the well. (Put *now listen to this carefully* after *me*.)

4. The wind had veered to the east and raised a scattering of whitecaps on the bay; a canoe crossing looked too dangerous to try. (Change *had* to *having*.)

5. Not all people, it has been found, can roll the tip of the tongue into the shape of a tube; this ability, being hereditary, cannot be acquired by practice—nor does it appear to be good for anything, for that matter. (Insert *and* after *tube*.)

6. A cat when lapping up milk cups its tongue backward, not, as many suppose, forward, in a rapid series of dipping and raking motions; this fact is one of the curious revelations of high-speed photography. (Take out *this fact is*.)

7. You can hardly be a success in politics without being your own convinced disciple, but the reverse proposition is unfortunately not true. (Change *but* to *however*.)

8. The accident occurred at 12 minutes after three in the afternoon. (Put the time in numerical and abbreviated form.)

9. The army expects of its rank and file one thing above all, and that is obedience. (Take out *and that is*.)

10. Because of a rainy spell construction was halted for a week, so we were free from Monday through Friday. (Change *so* to *consequently*.)

III

Commas to introduce or to separate. Each item below begins with a correct sentence; you are to rewrite it as directed. Make only changes required by the directions. In space at the left, use a capital letter to indicate that the rewritten sentence, compared with the original, has: A—lost a mark of punctuation; B—gained a mark of punctuation; C—changed one mark of punctuation to another (for example, a comma to a semicolon); D—more than

one change in punctuation; E—the same amount and kind of punctuation as before. *Example:* As soon as I get home from work, I will wash the car. (Start the rewritten sentence with the words *I will* . . . *Explanation:* The rewritten sentence reads: I will wash the car as soon as I get home from work. (A comma has been *lost,* so the answer is A.)

1. I have arranged your interview with Adderly, and I will take you to see him on Monday. (Take out the second *I.*)
2. I have arranged your interview with Adderly, and he will see you on Monday. (Take out *and.*)
3. Adderly is the only man you have yet to interview. (Start the sentence: *There is only one man whom you.*)
4. Arrowheads were often made of obsidian (volcanic glass) in the absence of metal. (Start the sentence: *In the absence.*)
5. Yesterday the Sioux City stockyards reported taking in 400 cattle and 300 sheep. (Multiply each figure by 10.)
6. He still owes more than $600. (Multiply each figure by 100.)
7. Willow bark contains various amounts of salicylic acid and was long used as an analgesic before the discovery of aspirin. (Insert *it* after *and.*)
8. "Should I really trust him with the secret?" I wondered aloud. (Start the sentence with *I wondered* and take out *aloud.*)
9. Let me know as soon as the undercoat is dry, and I will finish painting the car. (Start the sentence: *As soon as.*)
10. "For all I know," he said, "I may drive the old car for another year." (Change *For all I know* to *I haven't decided yet.*)

IV

Commas to enclose or set off. Each item below begins with a correct sentence; you are to rewrite it as directed. Make no changes except those required by the directions. In space at the

left, write a capital letter to indicate that the rewritten sentence, compared with the original, has: A—lost one comma, B—lost two commas, C—gained one comma, D—gained two commas, E— the same amount of punctuation as before.

1. My uncle Harvey is a policeman. (Insert *favorite* after *My*.)
2. Mr. Vertigo Spinn
 Churn Agitators, Inc.
 1313 Rolls Avenue
 Centrifuge, Ohio
 (To this address add the zip code number *43605*.)
3. The announced lineup for Tuesday's game had James Carter at second base and Alvin Carter in left field. (Insert the phrase (*no relation*) after *Alvin Carter*.)
4. The new name in the lineup for Tuesday's game was J. Carter. (Put Carter's initial *after* the surname.)
5. Mr. Larkin called while you were out, and in a very bad temper, too. (Insert *you may as well know* after *and*.)
6. The course in English composition is not addressed to a specific and generally agreed-on subject matter. (Insert *like physics or chemistry* after *not*.)
7. I had to stay home that afternoon and supervise the Two Demons, as we call the twins, Mother having decided to get her hair done. (Start the sentence: *Mother having decided*.)
8. The giant panda is not a bear or, for that matter, closely related to any familiar animal. (Insert *as many suppose* after *not*.)
9. There is an association with members on both sides of the Atlantic whose sole purpose is to rescue the reputation of King Richard III from the calumnies of Tudor-minded historians. (Insert *an earnest and active one* after *association*.)
10. In this statement, Mr. Tompkins has raised a question that deserves our earnest consideration. (Change *has* to *you have*.)

V

Restriction and nonrestriction. Each item below begins with a correct sentence; you are to rewrite it as directed. Make no changes except those required by the directions. In space at the left, write a capital letter to indicate that the rewritten sentence, compared with the original, has: A—lost a comma; B—lost two commas; C—gained a comma; D—gained two commas; E—the same number of commas as before (possibly none).

1. A boat which leaks may be dangerous. (Change *A* to *John's.*)
2. The members of the senior class, who were wearing caps and gowns, were enjoying the mingled feelings of pride and absurdity usual on such occasions. (By the management of punctuation alone, make it clear that some members of the senior class were *not* wearing caps and gowns.)
3. About a century ago, a lawless class of young bloods (called "scorchers") who burnt up the streets on high-wheeled bicycles were the subject of angry editorials. (Insert *at speeds as high as 15 miles per hour* after *bicycles.*)
4. I did not call on the Haskins just because Miriam was staying with them. (Make it clear that the speaker did *not* call on the Haskins.)
5. The men of the first group who had already crossed the creek signaled for the others to follow them. (Make it clear that *all* the men of the first group had crossed the creek.)
6. More than half the people who take up the doctor's time, it is said, have nothing specifically wrong with them. (Change *people* to *patients.*)
7. The protein-deficiency diseases which afflict the populations of many backward countries are often caused by lack of a single amino acid, lysine. (Change *The protein-deficiency diseases* to *Diseases associated with underconsumption of proteins.*)

8. Protein-deficiency diseases are often caused by lack of an amino acid, lysine, which is abundant in meat but scanty in some cereals. (Put *lysine* at the end of the sentence.)

9. Since Howard arrived, nobody at our summer hotel has lacked amusement, for he is infinitely diverting. (Put *since Howard arrived* after *amusement.*)

10. Since prices have increased along with them, recent increases in wages may not mean additional purchasing power. (Shift the words preceding the comma to the end of the sentence.)

VI

Quotation marks and related marks. Each sentence below may contain a mistake in the use of quotation marks, italics, or some other mark. In space at the left, write a capital letter to indicate that in the sentence: A—quotation marks are missing, superfluous, or misplaced with respect to accompanying punctuation; B—italic indicators are missing or superfluous; C—some other mark or letter is missing or superfluous; D—a wrong mark is used (for example, italics instead of quotation marks); E—the sentence is acceptable as it stands.

1. There's a favorable review of "The Nylon Jungle," an Italian movie now featured at the Araby Theatre, in today's Chicago *Spectator*.

2. "In those days," she said, "you had to send the children to school in Switzerland in order to qualify as a member of the *haute monde*."

3. With an expression of intense hauteur, she said, "Do you really imagine that eating pie à la mode is the custom of all Americans"?

4. "Who is it," he asked, "that said, 'People will give up making war only when it comes to be regarded as vulgar.'?"

5. She replied, "I think it was Oscar Wilde;" then after a pause, "however, I'd better look it up to be sure."

6. Interviewed aboard the Queen Mary at his departure,

the Prince said, "Americans are very clever people;
they can understand my English but I can't under-
stand theirs."

7. Paraphrasing William James, he said, "If you want to
kick a bad habit, you should enlist pride in support of
will power by announcing the decision publicly."

8. "Different as they look," said Professor Fitts, "the
words sporran and purse are etymologically related."

9. The popular aphorism "nice guys finish last" is attrib-
uted to Leo Durocher.

10. "Are you absolutely sure," demanded the prosecutor,
"that you heard the woman cry, 'It was Gerald—I *saw*
him!?'"

VII

Marks of enclosure. Each sentence below may contain a mistake
in the use of parentheses, brackets, or punctuation associated
with them (e.g., a comma used with a parenthesis). In space at the
left, write a capital letter to indicate that the sentence: A—lacks a
necessary mark or marks; B—has a superfluous mark or marks;
C—uses a wrong mark or marks (some other mark(s) should have
been used); D—misplaces a mark or marks with respect to ac-
companying punctuation or text; E—is acceptable as it stands.

1. It's an interesting coincidence that these same years of
political jitteriness [the middle 50's] abounded also in
sightings of saucers from outer space and other uni-
dentified flying objects.

2. Professor White's exploits as a secret courier during
World War II were recounted in an earlier issue of the
same magazine [see January 26, 1958].

3. "It was with genuine regret," wrote the General, "that
I then lay (*sic*) down the burdens of command."

4. Mrs. Hawkins is the recognized dictator of our little
town's society (that is the same person, believe it or
not, whom you knew in high school as Mary Trotter.)

5. Pentwater, Michigan, once a lumber shipping center

and one of the busiest ports on the lake, is now a quiet resort community.

6. The short stories of Saki (Hector Hugh Munro), are among the wittiest ever written.

7. Writes Professor Bloch: "There can be little doubt that the Whig aristocracy of the eighteenth century led the best *all-around* [my emphasis] life ever enjoyed by any class anywhere."

8. "When Monroe uttered his famous Doctrine in 1822 (actually 1823), he can have had but little idea of the interpretations subsequent administrations would put on it."

9. I know exactly where we left the car; it was just opposite a little shop with the sign, I'm not likely to forget it, "Antiques and Junque."

10. Although Timmy accepted my veto of his plan to trap old Mr. McDowell in an elephant pit, (I said it might break his neck), I could see that he privately regarded my objection as frivolous and cowardly.

VIII

Mechanics. Each sentence below may contain a mistake in the use of hyphens, apostrophes, capitals, abbreviations, numbers, or special marks such as the acute accent, circumflex, or cedilla. A "wrong mark" in the key listed below includes also the wrong form, such as a capital instead of a small letter, a spelled-out number instead of an Arabic figure, and so on. In space at the left, write a capital letter to indicate that the sentence: A—lacks a necessary mark or marks; B—has a superfluous mark or marks; C—uses a wrong mark or form (some other should have been used); D—misplaces a mark or marks; E—is acceptable as it stands.

1. May'nt we come in now?
2. We visited the Trent's last night.
3. Among teen-agers, a passion for nonconformity can coexist comfortably with passive submission to the mores of the clique or gang.

4. I told my Mother I would be home early.
5. There were 4 absentees on Monday.
6. The lowest temperature recorded for this day was on January 12th, 1940.
7. Professor Clark is preeminent in his field.
8. The President appoints the members of the cabinet.
9. It was an easily-forgotten novel.
10. Senora Madura was accompanied by her husband, the Ambassador.
11. He secured a loan at the rate of five and one-half percent.
12. Examples of highly visual writing are easily found in Keats's poetry.
13. You should be more self-reliant and not take second hand advice.
14. The store specializes in boys' and womens' wear.
15. Thucydides' history of the Peloponnesian war is fascinating reading.
16. I finally figured out that he was my ex-brother-in-law's first cousin.
17. The Secretary stated in a hearing of the Senate Foreign Relations Committee that he had no ready-made solutions of our problems in the East.
18. According to Simmons' report, twenty-two cartons are missing.
19. Most under-developed countries lie south of the Tropic of Cancer.
20. Afterwards Father asked me where I had picked up such half-baked ideas.

Answers

I

1. A	3. C	5. D	7. C	9. A
2. B	4. B	6. C	8. A	10. A

II

1. B	3. C	5. E	7. A	9. B or C
2. D	4. D	6. C	8. B	10. A

III

1. A	3. B	5. E	7. B	9. B
2. C	4. B	6. B	8. D	10. C

IV

1. D	3. E	5. D	7. E	9. D
2. E	4. C	6. D	8. D	10. C

V

1. D	3. E	5. D	7. D	9. A
2. B	4. C	6. E	8. A	10. E

VI

1. D	3. A	5. A	7. A	9. E
2. E	4. C	6. B	8. B	10. A

VII

1. C	3. C	5. E	7. E	9. C
2. E	4. D	6. E	8. C	10. B

VIII

1. D	5. C	9. B	13. A	17. E
2. B	6. B	10. A	14. D	18. C
3. E	7. E	11. C	15. C	19. B
4. C	8. C	12. E	16. E	20. E

GLOSSARIES

A. GLOSSARY OF TERMS

This section provides a quick-reference dictionary of terms often encountered in a study of punctuation. Indeed, each of them is used in this book either specifically or by implication. You should refer to this glossary frequently while studying other sections of the book in order to form meaningful impressions of terms which may be strange or generally unclear.

In most instances, terms listed here are defined in the book itself but usually are defined only once. If you come across a term dealing with punctuation which is not immediately defined, then turn to this glossary for a brief explanation and for occasional referral to a fuller discussion within the book itself.

The definitions given here, purposely brief, are intended for only casual use. That is, use this section as need arises, but don't be fully content with what you find. Probably the main reason some people punctuate incorrectly is that they don't concentrate long and hard enough on the specific punctuation problem facing them. Haste and a generally slovenly approach cause far more problems with punctuation—and with spelling and sentence structure and "grammar"—then do ignorance or stupidity.

Common sense will help somewhat with problems in punctuation. A working knowledge of what is loosely called "grammar" will help even more; the comparatively few grammatical terms involved in a study of punctuation are defined in this glossary. Of greatest help, however, will be a sensible tackling of particular *situations* requiring punctuation. Acquire a clear understanding

that punctuation, like spelling, can be mastered with common sense, concentration, a due regard for certain conventions which aren't really sensible, and, most important of all, a genuine desire to make what you write really communicate to your readers.

Absolute expression, phrase. An *"absolute" expression* is one which has a thought relationship, but no grammatical relationship, with the remainder of the sentence in which it appears. An absolute phrase usually consists of a noun or pronoun and a participle: *Dinner being finished*, we washed the dishes.

Accent. This word has several meanings, two of which apply particularly to English speech or writing. We may say that someone has an *accent*, by which we mean his distinguishing regional or national manner of pronouncing or the tone of his voice (a Southern *accent*). *Accent* also means the emphasis (by pitch or stress or both) given to a particular syllable or word when speaking it. Thus we say "Please *accent* that word more clearly" or "The *accent* in the word *refer* is on the second syllable." As a noun, the first syllable of *accent* is stressed; as a verb either syllable may be stressed, according to the use of the word.

Accent mark. An *accent mark* is one used to distinguish between various sounds of the same letter. For example, we add a horizontal stroke above the letter *e* to show that it has a long sound as in *e*ven. In punctuation and mechanics, however, certain words in English which have been borrowed from other languages require an acute accent, or circumflex accent, or grave, etc. The problem of accents is more one of spelling than of punctuation.

Acronym. An *acronym* is a coinage, a word formed from the first letter, or first few letters, of several succeeding words. *ASCAP*, for example, is an acronym widely used in music circles; it stands for the "American Society of Composers, Authors, and Publishers."

Adjective. An *adjective* modifies a noun or pronoun by describing, limiting, or in some other closely related way making

meaning more exact. An adjective may suggest quantity or quality, may set limits or identify. Therefore, adjectives are of three general types: descriptive (a *red* necktie, a *simple* meal, a *damaged* fender); limiting (the *fifth* floor, her *former* position, *several* dollars); proper (a *Chinese* dish; a *Colorado* mine).

Adjective clause. In the following examples each dependent clause is used as an adjective; each italicized group of words functions precisely as would a single adjective:

The suit *which he bought* cost too much. (Clause modifies *suit*.)
People *who rarely think* should say little. (Clause modifies *people*.)
You are the salesman *whom I saw*. (Clause modifies *salesman*.)
He is a man *I never admired*. (Clause modifies *man*.)

Adjective phrase. A phrase may modify a noun or pronoun, may function, that is, exactly as a single adjective functions; such a phrase is called an *adjective* (or *adjectival*) *phrase*.

The farmers *in Maine* need rain. (Here the phrase describes *farmers*; in its place the writer might have used a single adjective: "The *Maine* farmers need rain.")

Adverb. An *adverb* modifies a verb, an adjective, or another adverb. In "A distant bugle sang *faintly*," the adverb modifies the verb *sang*. In "We were *almost* ready to start," the adverb modifies the adjective *ready*. And in "Open this jar *very* slowly," the adverb modifies the adverb *slowly* (which, in turn, modifies the verb *open*). Adverbs have the following characteristics:

(1) Adverbs are commonly distinguished from corresponding adjectives by the suffix *-ly: bad, badly; sure, surely; easy, easily*.

(2) Certain adverbs are distinguished from corresponding nouns by the suffixes *-wise* and *ways: sideways, lengthwise*.

(3) Certain adverbs are distinguished from corresponding prepositions in not being connected to a following noun:

Adverb: He walked *up*.
Preposition: He walked *up* the street.

(4) Like adjectives, but unlike nouns and verbs, adverbs may be preceded by words of the *very* group (intensifiers):

The *very smartly* dressed girl . . .
He went *right by*.

Adverbial clause. Dependent clauses function as *adverbs* in these sentences:

I shall pay the bill *when you send it*. (Clause modifies the verb *shall pay*.)
We are working harder *than you are*. (Clause modifies the adverb *harder*.)
He was braver *than the other salesmen were*. (Clause modifies the adjective *braver*.)

Adverbial phrase. An adverbial phrase modifies a verb, an adjective, or an adverb and may function exactly like a single adverb.

Rain fell *on the parched fields of corn*. (Here the phrase states where the rain fell; it modifies *fell* just as a single adverb would.)

Affix. A term embracing both *prefixes* and *suffixes*, which see, below.

Ampersand. This is the name for a character (&) meaning "and." It is a corruption of *and per se and*; that is, by itself it means *and*.

Anglicizing foreign words. English has been borrowing words and word roots from other languages for centuries. The process by which they are assimilated into English is called *Anglicizing*, that is, bringing them into some sort of conformity with English usage. Many borrowed words retain their foreign form and pronunciation (*hors d'oeuvre*); others are in a transitional stage (*maneuver, manoeuvre*); still others are so useful that they have

almost replaced their English equivalent; *ersatz* for *substitute*. Some foreign words require both accent marks and italics.

Appositive, apposition. A substantive (usually a noun or pronoun) added to another substantive to identify or explain it. The appositive signifies the same thing and is said to be "in apposition."

One important trait, *courage*, he had in abundance. (*Courage* is in apposition with *trait*.)

Arabic numerals. Also called *Arabic figures*, these numerals were introduced into general European usage many centuries ago. They are the numerals (1, 2, 3, 4, 5, 6, 7, 8, 9) with which we are most familiar.

Articles. The articles (*a, an, the*) may be classed as adjectives because they possess limiting or specifying functions. *A* and *an* are indefinite articles; *the* is the definite article: *a* phonograph, *an* error, *the* physician. The initial sound of the word following the article determines the choice of *a* or *an*: *an* is used before words beginning with a vowel sound (including silent *h*): *a* is used before consonant sounds (except silent *h*) and before initial vowels that have both consonant and vowel sounds.

an orange an hour a hint a European visitor

Cardinal numbers. These are the numbers (numerals) used in simple counting or in answer to the question, "How many?" These numbers—three, 3, III; ten, 10, X—may be, as shown, either Arabic or Roman and are contrasted with *ordinal numbers* (see page 182).

Case. *Case* is one of the forms that a noun (or pronoun) takes to indicate its relation to other words in the sentence. There are only three cases in English: nominative (subjective); genitive (possessive); and objective (accusative).

A noun or pronoun is in the *nominative* case (subject of a sentence) when it indicates the person or thing acting; in the *possessive* case when it denotes the person or thing owning or

possessing; in the *objective* case when it indicates the person or thing acted upon. There is no change in the *form* of a noun to denote the nominative and objective cases. Word order in the sentence provides the only clue:

The child rode his tricycle. (*Child* is in the nominative case, *tricycle* in the objective.)
The tricycle was ridden by the child. (*Tricycle* is in the nominative case, *child* in the objective.)

The possessive case does involve a change in the form of a noun. See *Genitive* (*possessive*) case.

Citation. The act of quoting is called *citation*. The term also means "a reference to an authority or a precedent." A *footnote* (which see) is usually a citation.

Clause. A *clause* is a group of words which has both subject and predicate. Clauses are of two kinds: *independent* (or *main*, or *principal*) and *dependent* (or *subordinate*).

(See *Adjective clause* and *Adverbial clause*, *Dependent clause*, *Independent Clause*, *Noun clause*, and *Restrictive and nonrestrictive clauses*.)

Close and open punctuation. Writing in which as few marks of punctuation as possible are used is said to be punctuated in *open* style; writing which employs no incorrect marks but nevertheless omits none at all that could legitimately be used is called *close* in its punctuation. As noted several times elsewhere, writing today tends to become more and more "open" in its punctuation.

The terms "open" and "close" have a somewhat specialized meaning when applied to business letters or, indeed, to correspondence of any kind. Punctuation of the heading and of both inside and outside addresses may follow the *open* or the *close* system. In the open system, no commas or final periods, except after abbreviations, are used after the separate lines, and some letter writers prefer, also, to omit the colon after the salutation and the comma after the complimentary close. In the closed system, commas are used after each line of the heading and

inside address, except the last, at the end of which a period is used. Because of timesaving and convenience, most letter writers now use open punctuation.

Colloquialism. A colloquialism is a primarily conversational expression that is permissible in, and frequently indispensable to, an easy, informal style of writing and speaking. If it is used only in familiar talk and informal writing, there is no objection. Colloquialisms are necessarily used even in the formal writing of dialogue to aid in developing the characteristics of speakers.

Dictionaries mark words as colloquial (*Colloq.*) when in the judgment of the editors they are more common in speech than in writing or more appropriate in informal than formal discourse. Because editors differ in the interpretations of their findings and because formal English has a far wider range than formerly, this label may apply to many kinds of words. (See *Level of usage*, below).

Comma fault. This is not an ordinary misuse of the comma; it refers to the specific error of using a comma to join two sentences, two *complete statements* (which see). The comma "splices" or links statements which logically and "grammatically" should be separated. Specifically, the comma fault is the error of using a comma between two independent clauses not joined by a pure or simple conjunction. The following illustrates a comma fault; a period or semicolon should be substituted for the comma:

The meeting is scheduled for the noon hour, be sure to come.

Complement. A word or expression used to *complete* the idea indicated or implied by a verb. A *Predicate complement* (sometimes called *subjective complement*) may be a noun, a pronoun, or an adjective that follows a linking verb and describes or identifies the subject of the linking verb.

That salesman is *an idiot*.
The leaves of this tree are *red*.

An *object complement* may be a noun or adjective that follows the direct object of a verb and completes the necessary meaning:

We are painting our house *gray*.
Our neighbors named their baby *Maryann*.
The bowling team elected Schmidt *captain*.

Complete statement. This is a term usually applied to a *sentence* or to an *independent clause*. It may consist of a single word, such as "No," or run to great length; basically, it expresses a complete idea or a group of closely related ideas. By reason of completeness it is considered a primary unit in writing and is usually ended with a terminal mark of punctuation.

Complex sentence. A sentence containing one independent clause and one or more dependent clauses.

Compound sentence. A sentence containing two or more independent clauses.

Conjunction. A *conjunction* is a linking word used to connect words or groups of words in a sentence. Conjunctions are of two main kinds: *co-ordinating*, which join words or groups of words of equal rank, such as *and, but, for, or, nor, either, neither, yet; subordinating*, which join dependent clauses to main clauses, such as *if, since, because, as, while, so that, although, unless,* etc.

Certain co-ordinating conjunctions used in pairs are *correlative* conjunctions. Most frequently used of these are *both . . . and; either . . . or; neither . . . nor; so . . . as; whether . . . or; not only . . . but also.*

Another kind of conjunction is the *conjunctive* adverb, an adverb used as a connective. Examples are *accordingly, anyhow, indeed.* (See the next entry.)

Conjunctive adverb. This is a certain kind of *adverb* (which see) that can also be used as a conjunction co-ordinating two independent clauses. Commonly used conjunctive adverbs are *also, besides, consequently, furthermore, hence, however, likewise, moreover, nevertheless, still,* and *therefore*.

Consonant. A *consonant* has a sound in which the breath is somewhat restricted or even stopped. Consonant sounds may be contrasted with *vowel* sounds, which are made with less friction and fuller resonance. The vowels in our alphabet are *a, e, i, o, u,* and sometimes *y.* All the other letters are consonants: *b, c, d, f,* etc. (See *Vowel.*)

Contraction. A shortened form of a word, such as *can't* for *cannot, I'll* for *I shall* or *I will.* Many contractions seem out of place in standard English except when used to convey the actual tone and flavor of dialogue.

Co-ordinating conjunction. A *conjunction* (which see) relating words or phrases or clauses of equal grammatical value or importance.

Co-ordination. This word means "harmonious combination," "due ordering or proper relation." In grammar, it involves the relationship between two or more elements of the same grammatical rank.

Declarative sentence. A sentence that states a fact, a condition, a possibility. (See *Sentence,* below.)

Dependent clause. A *dependent clause* is not capable of standing alone; it depends upon the remainder of the sentence for its meaning; it is subordinate. Dependent clauses function as *nouns, adjectives,* or *adverbs.* Like an independent clause, a dependent clause contains a complete predication (subject and verb), but it shows its dependence by the linking word which joins it to the independent clause.

Diacritical mark. A diacritical mark, point, or sign is attached to a letter or character to distinguish it from another of the same form or to give it a particular phonetic value, indicate stress, etc. For example, diacritical marks are used to show the sound of *a* as in *cär* and *a* as in *āble.* Every good dictionary employs diacritical marks: study those in your dictionary until you are familiar with them.

Diagraming. This is a mechanical device by which you are

aided in identifying words as parts of speech, in identifying phrases and clauses, and in indicating the uses or functions in a sentence of these words, phrases, and clauses. These purposes are accomplished through the use of lines: horizontal, perpendicular, slanting, etc. The practice of diagraming was once the principal method of studying sentence structure.

Dialect, dialectal. A *dialect* is the speech customs (pronunciation, vocabulary, grammatical habits, etc.) characteristic of a region. Thus we might refer to Scotch (Scots) dialect or mountaineer dialect, etc.

Dialectal is an adjective that applies to dialect words. An expression is dialectal when it attracts no notice in the region where it is used but seems out of place elsewhere.

Dialogue. Conversation, talking together. *Dialogue* (also spelled *dialog*) refers to the passages of talk in a story, novel, play, etc. Fixed rules apply to the paragraphing and punctuation of dialogue.

Diction. The choice and use of words for the expression of ideas. *Diction* comes from Latin *dictio*, meaning "saying," "word." You are familiar with this root word; it appears in *dictionary*, *dictate*, *dictator*, and *dictaphone*.

Direct address. In this construction, also called the *vocative*, the noun or pronoun shows to whom speech is addressed:

Paul, where are you?
When we finish rolling the court, *Fred*, we'll still have time for two sets of tennis.

Direct quotation. A quotation that reproduces the exact words written or spoken by someone.

Father wrote, "I'll be there on Friday."
"Please use your dictionary more often," the office manager said. "You don't spell very well."

Division of words. This term means the marking off, or separation, of the parts of a word. These parts are *syllables* (which see), a letter or group of letters constituting the smallest possi-

ble portion of speech and writing. Definite rules exist for the breaking of words at the ends of lines; this division is as often a printing problem as one of punctuation and mechanics.

Ellipsis. The omission from a sentence of a word or words which would fulfill or strengthen meaning. To show such omission, *ellipsis periods* (. . .) are normally used; *asterisks* may also be used for this purpose, but ellipsis periods are preferred. *Dashes* may be used to indicate omitted words, but in special situations only. *Apostrophes* indicate omitted letters in *contractions*, which see, above.

Elliptical clause. From *ellipsis*, a clause from which a word or words have been omitted; the omitted element is not needed because it is understood from other words or from context. An elliptical clause is occasionally an independent clause; usually it is a dependent clause with its subject and part of its predicate omitted, since these are clearly understood from the main clause. In the following examples, the words shown in brackets are often omitted in speaking and writing.

While [we were] drifting downstream, we grounded on a sand bar.
He was 40 years of age, his brother [was] 44 [years of age].
Although [he is] in New York frequently, my brother rarely goes to the theater.

Em, en. An *em* is a printing term that originally meant the portion of a line occupied by the letter *M*. As a unit of measurement in printing it is frequently employed. In punctuation it lends its name to the *em dash*, which is represented on the typewriter and in handwriting by two hyphens. An *en dash* (from the letter *N*) is one-half the length of an em dash and is made by using one hyphen.

End-stop. This is a general term that refers to any and all marks used at the end of a sentence. The most common end-stops are the period, the question mark, and the exclamation point. A dash (a double or 2-em hyphen) may be used as an end-stop when a speech is broken off or interrupted. Ellipsis periods act

as an end-stop when a sentence is intentionally left unfinished. An *end-stop* is synonymous with *terminal mark*.

Exclamatory sentence. A sentence expressing surprise or strong feeling is known as *exclamatory*. (See *Sentence*, below.)

Footnote. A note or comment at the foot of a page, referring to a specific part of the text on the page, is a *footnote*. Such notes are occasionally grouped at the end of an entire chapter or book.

Foreign words in English. Our language has been borrowing words and expressions from other tongues for many centuries. Most borrowed words are now so much a part of our language that they can hardly be told from native expressions. Those not yet assimilated cause some trouble—in spelling, pronunciation, forming of plurals, etc. Some of them require accent marks; all of them should be italicized (underlined) when used in English. Words still considered to be foreign are so marked in dictionaries. Find out what system your dictionary employs for making this distinction.

Fused sentence. This is a term applying to the writing of two grammatically complete sentences (statements) with no mark of punctuation whatever between them. The "fused" or "blended" sentence is considered a serious error and should be corrected by the use of an end-stop (terminal mark) or by at least a semicolon between the separate statements.

Gentive (possessive) case. The term *case* refers to one of the forms that a noun or pronoun takes to indicate its relation to other words in a sentence. There are only three cases in English: nominative or subjective; objective or accusative; and genitive or possessive. The first two cause relatively little trouble in writing and none whatever in punctuation. The possessive (genitive) case, which denotes ownership or possession, often involves the use of apostrophes. (See *Case*, above.)

Grammar. This term applies to the science that deals with words and their relationships to each other. It is a descriptive statement of the way a language works. Grammar includes a

discussion of the forms of words, their use in phrases, clauses, and sentences, their tenses and cases. In short, "English grammar is the English way of saying things." Actually, the term involves *how* things *are* said and written, not how they *should* be said or written. The science of grammar has nothing to do with correctness as such. Even so, a working knowledge of grammar is an enormous help in achieving effective punctuation.

Illiteracy. A term referring to words and phrases not normally acceptable in standard or even colloquial usage. An illiteracy is characteristic of uneducated and sometimes vulgar speech.

Imperative sentence. A sentence expressing a command or a strong request is called *imperative*. (See *Sentence*, below.)

Indefinite pronoun. *Indefinite* pronouns are somewhat less exact in meaning than other pronouns. Among the more frequently used indefinite pronouns are *another, any, anyone, anything, everybody, everyone, everything, few, many, nobody, none, one, several, some, someone*, and *something*. Compound forms built upon the pronoun *one* or the element *-body* take the possessive form (*anyone's, everybody's*).

Indention or Indentation. Setting in, or setting back, as is done with the first line of a paragraph. (See *Paragraph*, below.)

Independent clause. An *independent clause* makes a complete statement and may stand alone; that is, it makes reasonable sense if the remainder of the sentence is omitted.

I watched TV.
Although I should have been working last night, *I watched TV*.

Sometimes there may be more than one independent clause in a sentence.

John worked, but *I watched TV*.

Indicative. The mood (or mode) of a verb expressing a fact or what seems to be a fact.

Indirect object. A noun or pronoun that precedes the direct

object of a verb and before which the word *to* or *for* is understood. When an indirect object follows the direct object, a preposition (*to, for*) is actually used.

Yesterday I bought *him* a coat.
Yesterday I bought a coat for *him*.

Indirect question. An indirect question is a question restated at second hand.

Direct: When can you report for work?
Indirect: The foreman asked me when I could report for work.

Inflection. This word has several meanings, but as it applies to pronunciation and punctuation it means modulation, or regulation, of the voice by a change in *pitch* or *tone*, which see, below.

Interjection. The interjection is a part of speech that has two distinguishing qualities: (1) it expresses emotion—dismay, anger, fear, surprise, etc.; (2) it has no grammatical connection with the sentence in which it appears. Some interjections appear also as other parts of speech: *well, goodness, my*. Others are always interjections and never appear in speech or writing with any other function: *alas, oh, ouch, psst, tsk-tsk, whew*.

Internal marks. This is a general term used to refer to all marks of punctuation which may appear *within* a sentence. The most important and most common of these are the *comma*, the *semicolon*, the *colon*, the *dash*, and *parentheses*. Internal marks may be contrasted with those which appear at the ends of complete statements: the period, question mark, exclamation point. These latter are known as *terminal marks* or *end-stops*. These two main groups of punctuation marks are not mutually exclusive: a period *may* appear *within* a sentence, for example, and a dash may be a terminal mark.

Internal punctuation. Most of us know that normally we begin a sentence with a capital letter and end it with a terminal (endstop) mark. Within the sentence, punctuation is considerably more complicated. Sometimes, it is needed to prevent misreading; sometimes to show a grouping of words as distinct

from other groupings; sometimes merely to conform to the arbitrary conventions of punctuation and mechanics. Primarily, internal punctuation, as indicated by one or more of the *internal marks* (which see, above) singly or in pairs, acts as a road sign or marker. Such punctuation suggests "Slow, Curves Ahead," "Trucks Entering on Right," "Resume Speed," "End of Pavement," "Watch Out for Falling Rocks," "Deer Crossing," and the like. Road signs help to prevent accidents and to promote happy motoring; internal punctuation helps to prevent misunderstanding and to promote communication.

Interrogative sentence. A sentence that asks a question and is followed by a question mark is interrogative. (See *Sentence*, below.)

Irony. A figure of speech in which the literal (denotative) meaning of a word or expression is the opposite of that actually intended. *Irony, sarcasm*, and *satire* agree in indicating derision of someone or something. In *irony*, emphasis is upon contradiction: one thing is said but another is meant. "Lovely day, isn't it?" is an ironical remark when uttered during a blizzard. In *sarcasm*, emphasis is upon the harsh or cutting quality of what is said: "You couldn't catch a ball in a bushel basket." *Satire* essentially exposes or attacks vices and follies in a malicious or playful spirit: making a *satirical* comment on drivers who ignore traffic regulations. Ironical or sarcastic remarks sometimes call for the use of quotation marks.

Leaders. In printing, this term refers to a row of dots (usually periods), or short lines, designed to "lead" the eye across a space, usually from the left to the right-hand side of a page.

Level of usage. Each of us employs a different level of usage (word choice) depending upon whether we are speaking or writing, upon who are our audience, upon the kind of occasion, etc. Different levels of usage are combinations of cultural levels and functional varieties. Included generally in such levels are dialect, ungrammatical speech, slang, illiteracies, and even colloquial language, as well as technical terms and scientific expressions.

Lower case. Small letter type used in priting as distinct from capital (upper-case) letters. The name comes from such type being kept in the lower of two cases of type.

Manuscript. Literally, a letter, report, document, book, etc. written by hand (from Latin words for "hand" and "writing"). *Manuscript* is now used to mean composition prepared by hand or on the typewriter, as contrasted with type.

Mechanics. The technical aspect of something as, in writing, the mechanical aspects of paragraphing, capitalization, use of italics, figures for numbers, etc.

Miscellaneous punctuation. This is a general term used to embrace several marks of punctuation and mechanics that belong to neither of the two main groups, *internal* and *terminal*. Among miscellaneous marks, serving miscellaneous purposes, may be included the apostrophe, capital letters, the hyphen, italics (underlining), and quotation marks. Even more "miscellaneous" marks of mechanics and conventions of spelling are abbreviations, accent marks, asterisks, the bar (virgule), the brace, brackets, the caret, compound words, ditto marks, ellipsis, the representation of numerals, and word division. (See *Structural punctuation*, below.)

Modify. To limit, describe, or qualify a meaning in some other specific and closely related way, adjectives are used with nouns and pronouns and adverbs are used with verbs, adjectives, and other adverbs. Limiting: *six* people, the *only* girl; descriptive: *sunny* skies, *small* amounts. Certain phrases and clauses also act as adjectival and adverbial modifiers.

Monologue. Talk or discourse by one person is called *monologue*. For example, an entire poem may consist of the speech (thoughts) of one person; in a play, a single actor may speak for a considerable time. The talk of two or more persons is known as *dialogue*, which see, above.

Monosyllable. A word of one syllable, such as *yes, through, itch, roast*. Words of two or more syllables are called *polysyllables: yesterday, throughout, itching, roasted*.

Nonrestrictive. A modifier that does not limit but does describe or add information is said to be *nonrestrictive*. (See *Restrictive and nonrestrictive clauses, phrases*, below.)

Noun. A *noun* names a person, place, or thing, a quality, idea, or action. Common nouns name all members of a common group: *man, officer, city, building, state*. Proper nouns name particular members of a group: *Mr. Ward, Jefferson Davis, Dallas, Parthenon, Ohio*. Some common nouns are concrete: *book, candy, hammer, sweater*—names of objects which can be perceived by the senses of touch, sight, taste, hearing, or smell. Some are abstract nouns: *honesty, intelligence, grace, strength*—names of things which cannot be perceived by the senses. Some are collective nouns: *crew, family, assembly, union*—names used for groups considered as units.

Noun clause. In the sentence, "*What you paid* was too much," the dependent clause in italics is used as a noun, the subject of the verb *was*. The writer could have used a single noun instead of the clause to make the same statement: "The *price* was too much."

Noun phrase. A phrase may be used in a sentence just as a noun is used—as subject, object, etc.

Whistling for a taxi was his special delight.

Used as a noun, the phrase is called a noun phrase. It functions in the sentence exactly as a single noun functions. In the example quoted, the italicized phrase serves as a name—a name for the particular activity which is a "special delight." It acts as the subject of *was*.

Number. The change in the form of a noun, pronoun, or verb to show whether one or more than one is indicated. (See *Singular, Plural*, below.)

Object. The noun, pronoun, or noun clause following a transitive verb or following a preposition is called an *object*.

Your bread is in the *toaster*. (Object of preposition)
I have sent the *check*. (Object of verb)
Please bring me *what I ordered*. (Noun clause, object of verb)

Object complement. See *Complement*, above.

Open and close punctuation. See *Close and open punctuation*, above.

Ordinal numbers. Such numbers are usually formed by adding -*th* or -*eth* to the name of the corresponding *cardinal number* (which see). Examples: *4th, fourth; thirtieth, 30th.*

Paragraph. A *paragraph* is a group, or bundle, of sentences developing either one single topic or idea or a specific part of a larger topic. The purpose of the paragraph is to aid in communicating thought by setting off the single topic that it develops or by providing clear distinctions between the separate parts of a longer piece of writing.

Every paragraph should be indented (see *Indention*, above). Dialogue and quoted conversations require separate paragraphing.

Parenthetical statement. A word, phrase, clause, or sentence, by way of explanation, which is inserted in or added to a statement grammatically complete without it. Such a statement is usually enclosed by marks of parenthesis, commas, or dashes.

Participial phrase. A phrase introduced by a *participle* (which see) or an adverbial modifier combined with a participle.

Working steadily, I soon finished the task.
Carefully watching the lights, we made our way home safely.

Participle. A *participle* is a word that has the function of both verb and adjective. The *present participle* always ends in -*ing* (*speaking, singing*). The *past participle* has various forms (*spoken, sung, walked, set*); it is regularly in the passive voice. The *perfect participle* consists of *having* or *having been* plus the past participle (*having spoken, having been sung*); it is either active or passive in voice.

The participle, since it is a form of the verb as well as an adjective, can take an object and can be modified by an adverb. The participle resembles the adjective in that it can be modified by an adverb and can itself modify a noun or pronoun.

The ball *kicked* by the player went into the stands.
The boy expertly *riding* the horse is named John.
The tree *swaying* in the breeze is lovely.

Period fault. A phrase or a dependent clause cannot be written as a complete sentence. To write and punctuate (end with a terminal mark) such an expression is called a "period fault."

Personification. A figure of speech in which human attributes are given to an animal or to an inanimate object, or the representation of an idea or quality in the form of a person: the paths of Glory, a comptometer performing like a mathematician, a dog with a soul.

Phrase. A *phrase* is a group of related words that does not contain both a subject and a predicate. A phrase is used as a part of speech, the equivalent of a noun, adjective, or adverb.

Pitch. The degree of height or depth of a tone or of sound, depending upon the relative rapidity of the vibrations by which it is produced. Thus we may say of someone that he has a "high-pitched" or "low-pitched" voice.

Plural. A classification of nouns, pronouns, and verbs to indicate two or more units or members: *women, they, they speak.*

Position of marks of punctuation. Using the right mark of punctuation in a given sentence situation is difficult and important, but *placing* a mark can also occasionally cause trouble. Most problems in placing marks of punctuation and mechanics arise when quotation marks also are used; for example, commas and periods always come *inside* quotation marks but other marks may or may not. Study carefully the *position* of marks used in illustrative sentences throughout this book. When the problem is especially confusing, comment and discussion appear at appropriate places in this text, especially on pages 141–142.

Possessive (genitive) case. This is a case form of nouns and pronouns indicating, usually, ownership. It may also apply to certain idiomatic expressions such as extent of time or space:

the boy's cap, a week's trip, five years' experience, a stone's throw. (See *Genitive (possessive) case*, above.)

Predicate.　The verb or verb phrase in a sentence which makes a statement—an assertion, an action, a condition, a state of being—about the subject is called a *predicate*.

Prefix.　A syllable, group of syllables, or word joined to the beginning of another word to alter its meaning or to create a new meaning. Thus, the prefix *pre-* added to *heat* forms *preheat*.

Preposition.　A *preposition* is a linking word used to show the relationship of a noun or pronoun to some other word in the sentence. Prepositions show position or direction (*at, with, to, from*) or indicate cause or possession (*because of, of*).

The preposition is always followed by a noun or pronoun (or the equivalent), with which it forms a unit. The only apparent exception is the use of prepositions in certain structures with *who (whom), which,* and *what*: "Whom are you going with?" "What's it made of?"

Pronoun.　A *pronoun* substitutes for a noun or a noun-equivalent. Every pronoun refers directly or by clear implication to a noun or a noun-equivalent (called the *antecedent* of the pronoun) and agrees with that antecedent in person, number, and gender (but not necessarily in case): "Each boy present will please raise *his* hand."

Pronouns in common use are *I, me, mine, you, yours, he, him, his, she, her, hers, it, its, we, us, ours, they, them, theirs; myself, yourself, yourselves, himself, herself, ourselves, themselves; each other, one another; this, that, these, those, such; each, either, both, some, few, many, much, none, several, all, any, most, anybody, anyone, anything, somebody* (etc.), *everybody* (etc.), *nobody, nothing, one, two, three* (etc.).

Pronouns which are used in all the grammatical functions of nouns (as object, subject, etc.), are of several kinds: *personal, relative, demonstrative, interrogative, reflexive (intensive), indefinite,* and *reciprocal*.

Pronunciation.　The act, or result, of producing the sounds of speech. *Pronunciation* is complex and many-faceted; it in-

volves, among other things, levels of pronunciation, dialect, spelling, and even punctuation. Concerning pronunciation, the single best piece of advice is this: acquire a good dictionary and study its pronunciation key thoroughly.

Provincialism. A *provincialism*, or *localism*, is a word or phrase understood in only a particular section or region of the country.

Pure conjunction. A short or simple and commonly used coordinating conjunction: *and, but, or, nor, neither*, etc. (See *Conjunction*, above.)

Question. See *Indirect question*, above.

Quotation. See *Direct quotation*, above.

Restrictive and nonrestrictive clauses. If a dependent clause is essential in order to explain or identify the word to which it refers, the clause is called *restrictive*. If the dependent clause is not necessary, if it is in the nature of a parenthetical remark which could be removed from the sentence, leaving the essential meaning intact, it is called *nonrestrictive*. Nonrestrictive clauses are always set off from the remainder of the sentence by commas.

The man *who spoke at our Forum* is a member of the Securities and Exchange Commission.

The dependent clause is here restrictive, for it is necessary as a means of identifying the particular man. But in the following sentence the clause is nonrestrictive; the identification is made by the use of the proper name.

Captain Stiles, *who spoke at our Forum*, is a member of the Securities and Exchange Commission.

Restrictive and nonrestrictive phrases. If a phrase is essential in order to explain or identify the word to which it refers, the phrase is called *restrictive*. If the phrase is not absolutely necessary, it is called *nonrestrictive*. Nonrestrictive phrases are always set off by commas from the remainder of the sentence.

The citizens' committee gains in *political stature.*

In this example, the adverbial phrase is *restrictive* because it tells the particular way in which the committee gains.

The citizens' committee, *gaining in political stature,* began to demand reforms within the city government.

Here the adjective phrase is *nonrestrictive* because it is not essential to the writer's purpose in telling what the committee began to demand.

Roman numerals. The numerals in the ancient Roman system of notation, still used in special situations such as dates on public buildings and on tombstones. They may be written in lowercase letters but appear more often in capitals: I, IV, X, XXV, L, etc.

Sarcasm. Harsh or bitter derision. (See *Irony,* above.)

Schoolgirl style. A rather unchivalrous and unkind term for a manner of writing characterized by gushiness, exaggeration, and an overuse of intensives. Triple underlinings, exclamation points, and dashes are used generously. As indicated, maturity is at a premium. Mechanical forms of emphasis are nearly always self-defeating.

Sentence. A *sentence* is a group of words containing a complete, independent thought or a group of closely related thoughts. It may also be defined as a group of words (or even one word) conveying to reader or listener a sense of complete meaning. A sentence must contain a *subject* and a *predicate,* expressed or understood. The subject is the name of the person or thing about which the verb makes a statement. The predicate is what is said of the subject; it must contain a verb that can make a complete, independent statement.

Sentences may be classified according to grammatical structure as *simple, compound, complex,* or *compound-complex.*

A *simple sentence* contains only one subject and one predicate and expresses only one thought.

The sun is shining.
The boy and the girl talked and danced.

A *compound sentence* contains two or more independent clauses. The clauses of a compound sentence are grammatically capable of standing alone, but they are closely related parts of one main idea.

The hours are good but the pay is poor.
She read and I wrote letters.

A *complex sentence* contains one independent clause and one or more dependent (subordinate) clauses.

The woman said that she had walked for over an hour.
He is an athlete whose muscles are unusually supple.

A *compound-complex sentence* contains two or more independent clauses and one or more dependent clauses.

Since the day was unpleasant, we stayed indoors; Ned studied, and I worked on my stamp collection.

Sentences may be classified according to *meaning* and *purpose*:

A *declarative sentence* states a fact or makes an assertion.

The store has twelve windows.

An *interrogative sentence* asks a question.

Does the store have twelve windows?

An *imperative sentence* expresses an entreaty or command.

Please come as soon as possible.

An *exclamatory sentence* expresses strong feeling.

Oh, if he were only here!
Thank goodness, you are here at last!

Sentence fragment. A word, or group of words, not expressing completeness of meaning. Some sentence fragments—such as exclamatory sentences, answers to questions, and broken conversation—are justifiable. All other fragments are not. (See *Period fault*, above.)

Singular. The number classification of nouns, pronouns, subjects, and predicates to indicate *one: girl, boy, tree, he, is, has, pays.*

Slang. A particular kind of colloquialism or illiteracy. Formerly the term was applied to the cant of gypsies, beggars, and thieves, or to the jargon of any particular class of society. Now, *slang* is defined as language which consists of widely current terms having a forced or fantastic meaning, or displaying eccentricity. It is markedly colloquial language below the range of standard or cultivated speech.

Stress. As applied to pronunciation, and consequently to punctuation, *stress* means the relative force with which a syllable is uttered. In English, normally we have *primary* (or strong) stress; *secondary* (or light) stress; *zero* stress (lack of stress or reduction of stress).

Structural punctuation. In one sense, all punctuation is *structural* since it helps to shape, arrange, and build word patterns into groups meaningful to readers. Sometimes, however, *structural punctuation* is used to refer only to those marks of punctuation which indicate relations within a sentence, between sentences, and between paragraphs. Consequently, the term includes all of the major marks of punctuation: comma, period, etc. Specifically, three kinds of punctuation and mechanics may be listed: (1) structural punctuation; (2) quotation marks, ellipsis periods, and other devices that are not primarily structural; (3) mechanical items having perhaps more to do with spelling than with punctuation, as such: the division hyphen, the hyphen in compound words, the apostrophe, the abbreviation period. (See *Miscellaneous punctuation*, above.) It is just as well to consider all punctuation and mechanics as an organic, structural part of writing: proper marks and devices do help to structure expression so that it will be immediately clear to readers.

Subject. The person or thing (noun, pronoun, noun phrase, noun clause) about which a statement or assertion is made in a sentence or clause. A *simple subject* is the noun or pronoun

alone. A *complete subject* is a simple subject together with its modifiers. A *compound subject* consists of two or more nouns, pronouns, noun phrases, noun clauses.

The green *house* is for sale. (Simple subject)
The green house on the hill is for sale. (Complete subject)
The green house and two acres of land are for sale. (Compound subject)
What you say and what you do are no concern of mine. (Compound subject)

Substantive. An inclusive term for noun, pronoun, verbal noun (gerund, infinitive), or a phrase or a clause used like a noun. The practical value of the word *substantive* is that it saves repeating all the words included in this definition. The following italicized words are examples of substantives:

My *dog* is three *years* old. (Nouns)
They will arrive tomorrow; in fact *everyone* is arriving tomorrow. (Pronouns)
Your *coming* is looked forward to. (Gerund)
To improve myself is my *aim*. (Infinitive, noun)
From Chicago to San Francisco is a long distance. (Noun phrase)
What you say is no concern of mine. (Noun clause, noun phrase)
Do *you* know *that he was here yesterday?* (Pronoun, noun clause)

Suffix. A sound, syllable, or syllables added at the end of a word or word base to change its meaning, give it grammatical function, or form a new word: *-er* in *stronger, -ness* in *boldness*.

Syllable. A *syllable* is a segment of speech uttered with one impulse of air pressure from the lungs. In writing, *syllable* refers to a character or set of characters (letters of the alphabet) representing one sound. In general, *syllable* refers to the smallest amount or least portion of speech or writing.

Technical term, word. Such an expression has a special meaning for people in particular fields, occupations, and professions.

Special subject labels are attached by dictionaries to such terms in the fields of engineering, finance, etc.

Terminal punctuation. This is a general term for all marks which may appear at the end of a complete sentence (statement). (See *End-stop*, above.)

Tone. In pronunciation and in the effect of pronunciation on punctuation, *tone* refers to the intonation, pitch, modulation of the voice that expresses a particular meaning or feeling. That is, tone indicates a manner of speaking or writing which shows a certain attaitude: a venomous *tone*, a *tone* of anger.

Transposition. In writing and speaking, *transposition* means a change in the usual, or normal, position of words. For example, "Into the room charged he" is a transposition of the more normally positioned "He charged into the room." When a transposed element appears in a sentence, punctuation is sometimes affected:

The lovely, fragile girl was unequal to the task.
The girl, lovely and fragile, was unequal to the task.

Underlining. This is the act of drawing a line beneath a word or words for the purpose of emphasizing the underscored material or for indicating that such words would be placed in italics if they appeared in print. Underlining in longhand or on the typewriter is equivalent to italicizing in printing.

Upper case. This means a capital as distinguished from a small letter. (See *Lower case*, above.)

Verb. A verb asserts, or says, something. It may make a statement, give a command, or ask a question. A verb expresses action or a state of being. This definition may not be particularly helpful, but you can see that, according to this definition, italicized words in the following sentences are verbs: the first says something; the second asks a question; the third gives a command.

They *bought* a new house.
Is supper ready?
Get there on time.

Verb phrase. A verb together with its auxiliary or auxiliaries or a verb with its modifiers is known as a *verb phrase: is trying, was completed, will have seen, shall have been finished.*

Vocative. This is a case form which a noun or pronoun takes to indicate the person or thing addressed. (See *Direct address,* above.)

Voice. Verbs are classified as to *voice*—active or passive. A verb is *active* when the subject is the performer of the action or is in the state or condition named. It is *passive* when it stresses the recipient of the action.

The sales manager *set* a quota for the month. (Active)
A quota for the month *was set* by the sales manager. (Passive)

Vowel. A speech sound uttered so that there is a clear channel for the voice through the middle of the mouth. In writing, a vowel is a letter representing such a sound: *a, e, i, o, u.* (See *Consonant,* above.)

Word. The smallest grammatical element which can stand alone as an utterance.

Zeal. A word implying interest, devotion, and enthusiasm, *zeal* is what you need in learning to "punctuate it right."

B. GLOSSARY OF
APPLIED PUNCTUATION

When you have a problem in punctuation, ask yourself these questions:

(1) Exactly what is it here which requires punctuation? (A complete statement? What kind of statement? What kinds of elements within the sentence? What kinds of relation between sentence elements?)

(2) What purpose do I wish my punctuation to serve? (Termination? Introduction? Separation? Enclosure? Clearness? Some special stylistic effect?)

(3) What punctuation mark or marks will best accomplish my purpose and be of most help in communicating this purpose to my reader?

After answering the first of these questions for yourself, you can find brief answers to the other two by consulting the following entries. The information provided here is designedly brief, rarely complete. The figures in parentheses refer to sections providing more detailed suggestions, discussion, comment on exceptions, and illustrations.

1. **Abbreviations.** (*a*) Use a period after a standard abbreviation.(22(4)) (*b*) Use commas with initials after a person's name.(11.3) (*c*) Use capital letters with initials and with certain abbreviations.(8.8)

2. **Absolute phrase.** Use commas.(11.3)

3. **Acronyms.** (*a*) Use capital letters for some, lower case with others.(1) (*b*) Use no period.(22(4))
4. **Act–scene.** Separate by a colon.(10.2)
5. **Added material.** (*a*) Use a caret to indicate the addition of unintentionally omitted material.(9) (*b*) Depending upon purpose and stylistic intent, enclose added material with commas (11.3) or parentheses.(21(1)) (*c*) For material added to quoted matter, use brackets.(7)
6. **Addresses.** (*a*) Use standard abbreviations in some addresses.(1.1) (*b*) Use capital letters.(8.17) (*c*) Use hyphens with some addresses.(18(4))
7. **Adjectives.** Two or more adjectives modifying, coordinately, the same noun, separate by commas.(11.2) (See also *Series*, below.)
8. **Adjective clauses.** See *Clauses, dependent*, below.
9. **Adjective phrases.** See *Phrases*, below.
10. **Adverbial clauses.** See *Clauses, dependent*, below.
11. **Apposition.** Use commas.(11.3) For long or emphatic appositional phrases, use dashes.(13.5)
12. **Art objects.** Use quotation marks to enclose names of art objects such as paintings, statuary, and the like.(24(5))
13. **Beginning a sentence.** (*a*) Begin nearly all sentences with a capital letter.(8.2) (*b*) Do not begin with a figure.(20(1))
14. **Break or shift in thought.** Use a dash.(13.3)
15. **Calendar divisions.** (*a*) Use standard abbreviations for.(1.2) (*b*) Use capital letters with.(8.1)
16. **Cancellation.** Erase or draw a line through the material. Do not use marks of parenthesis to cancel.(16(7), 21(5))
17. **Cardinal numbers.** Use either figures or words depending upon circumstances.(20)
18. **Change of speaker in dialogue.** Use quotation marks. (24(3))
19. **Chapter headings, titles.** Enclose in quotation marks. (24(5))
20. **Clauses.**
 Independent clauses. (*a*) Joined by pure co-ordinating conjunction, use a comma. If the clauses are long with complicated internal punctuation, use a semicolon.(11.2, 25) (*b*) Not

joined by any conjunction, use a semicolon.(25) (*c*) Joined by a conjunctive adverb, use a semicolon.(25) (*d*) Used parenthetically, enclose in dashes or parentheses.(13, 21) (*e*) Between contrasting independent clauses, use a comma. (11.2)

Dependent clauses. (*a*) Adverbial clause preceding independent clause, use a comma.(11.2) (*b*) Adverbial clause following independent clause: if restrictive, use no punctuation; otherwise, use commas if adverbial clause is nonrestrictive or fairly long.(11.2) (*c*) Adjective clause: if nonrestrictive, use commas; if restrictive, omit punctuation.(11.3) (*d*) Noun clauses: used as subject or object or complement, no punctuation.(11.5) (*e*) Dependent contrasting clauses, use a comma. (11.2)

21. **Company names.** (*a*) Use accurate abbreviations.(1.6) (*b*) Use capital letters.(8.10)

22. **Complete statements.** (*a*) Separate by a period.(22(1)) (*b*) If related in thought to a preceding statement and not begun with a capital letter, separate by a semicolon.(25) (*c*) With conjunctive adverb, use semicolon.(25(2)) (*d*) If broken off or interrupted, use a dash.(13.3) (*e*) If interrogative, use a question mark.(23(1)) (*f*) If exclamatory, use an exclamation point.(17(1))

23. **Complete sentence.** See *Clauses, dependent*, above.

24. **Compound predicate.** With two members only, usually no commas; with three or more, use commas. (See *Series*, below.)

25. **Compound words.** May be written with a hyphen, solid, or as two or more separate words.(12)

26. **Conjunctions, co-ordinating.** (*a*) Pure conjunctions joining independent clauses, use a comma before, but not after.(11.2) (*b*) Pure conjunctions joining two words or two phrases, no punctuation; joining three or more, commas.(11.2) (*c*) Conjunctive adverb (see *Conjunctive adverb*, below). (*d*) Correlative conjunctions: apply same principle as for pure conjunction.(11.2)

27. **Conjunctions, subordinating.** Never place a comma or a semicolon after, unless for other reasons; place a comma

before if the clause is adverbial, is nonrestrictive, and follows the independent clause.(11.2, 11.5, 25)

28. **Conjunctive adverb.** Use a semicolon before when placed between two independent clauses. Use a comma or no mark after, depending upon parenthetic strength.(25(1), 25(2))

29. **Connecting lines, other items.** Use a brace.(6)

30. **Contractions.** (a) Use an apostrophe.(3.1) (b) No period with.(22(4))

31. **Contrasted co-ordinate elements.** Use a comma.(11.2)

32. **Dates and places.** (a) Enclose in commas when they explain preceding dates and places.(11.3) (b) Figures or words may represent.(20)

33. **Decimal.** Use a period preceding.(22(5))

34. **Declarative sentence.** Normally, use a period to follow. (22(1)) (See *Sentence*, below.)

35. **Deity, names for.** Use capital letters.(8.15)

36. **Dependent clause.** See *Clauses*, above.

37. **Dialect.** (a) Use an apostrophe to indicate omitted letters. (3.1) (b) Use a hyphen to represent.(18(3))

38. **Dialogue.** (a) Use quotation marks.(24) (b) Use commas. (11.1)

39. **Diction.** Use quotation marks, on occasion, with slang expressions, unusual technical terms, provincialisms.(24(4))

40. **Direct address.** Use commas.(11.3) See *Vocative*, below.

41. **Direct question.** (a) Use a comma to precede.(11.1) (b) Use a question mark to terminate.(23(1))

42. **Direct quotation.** (a) Use a capital letter to begin.(8.2) (b) Use a comma or colon to introduce.(11.1, 10.1) (c) Enclose in quotation marks.(24(1))

43. **Directions and references.** (a) Asterisk may indicate.(4) (b) Figures or letters in parentheses may show divisions.(21(1), 21(2)) (c) Italics may be used to indicate specific directions, etc.(19(8), 19(9))

44. **Division of words.** Use a hyphen.(15)

45. **Dollars and cents.** Use a period between.(22(5))

46. **Doubt or uncertainty.** Use a question mark enclosed in parentheses to indicate.(23(3))

47. **Emotion, strong.** Use exclamation point to follow.(17(1))

48. **Emphasis.** (*a*) Exclamation point may follow.(17(1)) (*b*) Italics may be used to show.(19(9)) (*c*) Quotation marks may indicate.(24(6))

49. **Ending a sentence.** Most sentences end with a period, but an interrupted one may end with a dash.(13.2) For other methods of terminating, see *Sentence*, below.

50. **Exclamatory sentence.** Use an exclamation point.(17) (See *Sentence*, below.)

51. **Festivals, holidays.** Use capital letters.(8.7)

52. **Figures.** (*a*) Four or more figures, use a comma in front of each three numbers. (11.2, 20) (*b*) Do not begin a sentence with.(20(1)) (*c*) Use figures or words depending upon circumstances.(20)

53. **First word.** (*a*) In direct quotation, use a capital letter.(8.2) (*b*) Following colon, use capital or small letter.(8.2) (*c*) Do not use numeral as first word.(20(1)) (*d*) Of a sentence, use a capital letter.(8.2)

54. **For.** (*a*) As a conjunction, use a comma preceding.(11.2) (*b*) As a preposition, use no punctuation.(11.5)

55. **For example, for instance, namely, etc.** Used parenthetically, enclose in commas unless they are followed by an independent clause; then use a colon or semicolon before, a comma after.(10.4, 11.3, 25(2))

56. **Foreign money.** Use standardized abbreviations to represent.(1.5)

57. **Foreign words, expressions.** (*a*) Use accent marks where appropriate.(2) (*b*) Use capitals correctly with.(8.3) (*c*) Indicate by italics (underlining).(19(7))

58. **Fractions.** Use a hyphen between the numerator and denominator.(12(8))

59. **Geographic names, terms.** (*a*) Use standard abbreviations for.(1.3) (*b*) Capitalize correctly.(8.4)

60. **Governmental terms.** Use appropriate capital letters to begin.(8.5)

61. **Hesitation in speech.** Use hyphens to represent.(18(2))

62. **Historic events, eras.** Use appropriate capitals.(8.6)

63. **Holidays, festivals.** Use capital letters.(8.7)

64. **Hour–minutes.** Separate by a colon.(10.2)

65. Imperative sentence. Use a period to terminate unless it expresses a vigorous command; then use an exclamation point.(22(1)) (See *Sentence*, below.)

66. Indirect question. (*a*) Use no comma to precede.(11.5) (*b*) Terminate with a period, not a question mark.(22(2)) (*c*) Do not place within quotation marks.(24(1))

67. Indirect quotation. Use no quotation marks.(24(1))

68. Initials. (*a*) Use correct capitals for.(8.8) (*b*) Use commas with.(11.3) (*c*) Do not divide on separate lines.(15(10))

69. Inserted material. See *Added material*, above.

70. Interjection. (*a*) If mild, use a comma; if strong, use an exclamation point.(17(4)) (*b*) Use proper capitalization with.(8.9)

71. Interpolated material. See *Added material*, above.

72. Interrogative sentence. If truly interrogative, end with a question mark; if no actual question is asked with expectation of direct answer, use a period.(23(1), 23(5)) (See *Sentence*, below.)

73. Interruption in thought or dialogue. Use a dash.(13.3)

74. Introduction. Before a word, phrase, or clause being introduced, use a comma, colon, or dash.(11.1, 10.1, 13.4)

75. Irony. Occasionally, indicate by a question mark within parentheses or by an exclamation point. (23(4), 17(3))

76. Legal cases. Use italics (underlining) in citing.(19(5))

77. Measurements. (*a*) Use correct abbreviations for time, quantity, etc.(1.4) (*b*) Use figures and words in combination to represent.(20)

78. Mispronunciation. (*a*) Use a hyphen to prevent.(12(12)) (*b*) Use a hyphen to represent in careless or dialectal speech.(18(3))

79. Misreading. Use a comma between words or other elements which may be misread.(11.2)

80. Modifying adjectives, adverbs. Use a comma with two or more in a series.(11.2)

81. Money. (*a*) Do not divide sums of money.(15(10)) (*b*) Include sums in parentheses for strict accurarcy.(22(5)) (*c*) Periods may aid in representing.(21(3)) (*d*) Use suitable abbreviations.(1.5) (*e*) Use words or figures to indicate.(20)

82. **Monosyllable.** Do not divide words of one syllable. (15(3))

83. **Namely.** See *For example*, above.

84. **Names and titles.** (*a*) Use abbreviations for certain names and titles. (1.6) (*b*) Use capital letters with proper names. (8.10) (*c*) Use commas with initials following names. (11.3) (*d*) Use italics for certain scientific and other specialized names. (19(6)) (*e*) Use italics or quotation marks for certain titles. (19, 24(5))

85. **Nonrestrictive elements.** Enclose with commas. (11.3) (See *Clauses*, above, and *Phrases*, below.)

86. **Nouns, compound.** May be written as two words, solid, or with a hyphen. (12)

87. **Nouns of kinship.** Written with capital letters only under certain conditions. (8.10)

88. **Numbers.** See *Figures*, above.

89. **Numerals.** (*a*) Use a hyphen if they are written out (from twenty-one to ninety-nine). (12(7)) (*b*) Use figures or words, depending upon circumstances. (20)

90. **Object.** Use no comma or other punctuation between a verb and its object, except for additional reasons. (11.5)

91. **Oh.** As a mild interjection, use a comma following. As a strong interjection, use an exclamation point. Before a *vocative* (which see), *O*, written thus, is followed by no punctuation. (17(4))

92. **Omission.** (*a*) In a contraction, use an apostrophe. (3.1) (*b*) Other omitted letters, use a dash. (13.6) (*c*) To show omission of words, use, preferably, ellipsis periods. (16) (*d*) Other less conventional methods of indicating omitted words: asterisks(4); commas(11.4). (*e*) Use a caret to indicate a word omitted unintentionally. (9) (*f*) Do not use parentheses to enclose words to be omitted. (See *Cancellation*, above.)

93. **Ordinal numbers.** (*a*) Capitalize only when used with a specific name. (8.11) (*b*) Use figures or words depending upon circumstances. (20) (*c*) Use no period with. (22(4))

94. **Parenthetical material.** If weak, use no punctuation. If fairly to moderately strong, use commas. If strong and emphatic, use dashes or parentheses. (11.3, 13.5, 21(1))

95. **Peoples, races.** Use capitals.(8.12)
96. **Personification.** Use capital letters in rare instances.(8.13)
97. **Phrases.** (*a*) An introductory modifying phrase containing a verb form, use a comma; not containing a verb form, use no punctuation, unless fairly long and then use a comma.(11.2) (*b*) Nonrestrictive phrases, use commas; restrictive phrases, use no punctuation.(11.3)
98. **Places.** See *Dates and places*, above.
99. **Plurals.** Formed by adding *s, es*, or change in form. Never use an apostrophe, except to form the plurals of words as words, of letters, and of figures.(3.3)
100. **Poetry, quotation of.** (*a*) Begin separate lines with capital letters.(8.2) (*b*) Enclose in quotation marks.(24) (*c*) Use a bar (virgule) to separate lines of poetry quoted in prose.(5)
101. **Political parties.** Use capital letters.(8.14)
102. **Possessive case.** Use an apostrophe in forming the possessive case of nouns and indefinite pronouns. Do *not* use an apostrophe in forming the possessive of other kinds of pronouns.(3.2)
103. **Prefixes.** (*a*) May or may not require a hyphen when attached to a root (base) word.(12) (*b*) May be separated from base word at end of a line.(15(9))
104. **Preposition and object.** Use no comma or other punctuation between.(11.5)
105. **Proportion.** Use a colon in representing.(10.2)
106. **Provincialisms.** See *Diction*, above.
107. **Publications, names of.** (*a*) Use capital letters.(8.19) (*b*) Indicate by italics (underlining).(19(1), 19(2), 19(4))
108. **Queries, series of.** Use question marks.(23(2))
109. **Question.** After a direct question, use a question mark; after an indirect question, use a period.(23(1), 23(5))
110. **Quotation.** (*a*) Enclose a direct quotation in quotation marks; use no quotation marks with an indirect quotation.(24(1)) (*b*) A short direct quotation is set off by a comma; an indirect quotation is not set off by a comma.(11.1) (*c*) A long formal quotation is introduced by a colon.(10.1) (*d*) Place a quotation within a quotation in single quotes.(24(7))

(*e*) Surround a correction in quoted matter with brackets. (7)

(*f*) Indicate an omission from quoted material by using ellipsis periods. (16)

111. **Quotation extending over one paragraph.** Use quotation marks at the beginning of each paragraph but at the end of only the last. (24(2))

112. **Races, peoples.** Use capitals. (8.12)

113. **References and directions.** See *Directions and references*, above.

114. **Religions, religious writings, names of.** Use capital letters. (8.15)

115. **Request.** If vigorous, use an exclamation point or question mark. Ordinarily, terminate with a period. (17(2), 23(5), 22(2))

116. **Restrictive clauses, phrases.** See *Clauses, Phrases*, above.

117. **Roman numerals.** (*a*) Use rarely but in accord with conventions. (20(4)) (*b*) Use no periods following. (22(4)) (*c*) Usually capitalized and always when following a proper noun. (8.11)

118. **Sacred writings.** Use capital letters. (8.15)

119. **Salutation.** In a business letter, use a colon after; in a friendly letter, use a comma or a colon. (10.2)

120. **Sarcasm.** Occasionally, indicate by a question mark within parentheses or by an exclamation point. (23(4), 17(3))

121. **Scientific names.** (*a*) Use capitals with some scientific terms. (8.16) (*b*) Italicize (underline) certain names. (19(6))

122. **Sentence.** (*a*) After a declarative sentence, use a period. (22(1)) (*b*) After a mildly imperative sentence, use a period; if it is vigorous, an exclamation point. (22(1), 17) (*c*) After an interrogative sentence, use a question mark. (23(1)) (*d*) After an exclamatory sentence, use an exclamation point. (17)

123. **Series.** Three or more words or phrases or clauses, separate by commas, including one before but not after the conjunction. (11.2) When the conjunction joins each two members of the series, except independent clauses, use no punctuation. (11.2) (See *Clauses*, above.)

124. **Shift or break in thought.** Use a dash.(13.3)
125. **Slang.** See *Diction*, above.
126. **Stage directions.** If desired, may be enclosed in brackets.(7)
127. **Statements, complete.** See *Complete statements*, above.
128. **Streets, roads, etc.** See *Addresses*, above.
129. **Stuttering.** Use hyphens to represent.(18(2))
130. **Subjects, college and school.** (*a*) May be abbreviated in informal writing.(1.7) (*b*) Capitalized only if derived from proper names or if referring to specific courses.(8.10)
131. **Subject—predicate.** Use no comma to separate unless parenthetic elements requiring commas intervene.(11.5)
132. **Subtitle.** Use a colon to separate from main title.(10.2)
133. **Suffixes.** May be separated from base word at end of a line.(15.9)
134. **Summarizing final clause.** Use a dash to precede.(13.1)
135. **Surprise, strong emotion.** Use an exclamation point.(17(1))
136. **Suspended elements.** Use commas, usually.(11.3)
137. **Technical words.** See *Diction*, above.
138. **Time.** (*a*) Use ellipsis periods to indicate passage of time.(16(3)) (*b*) Use figures or words to indicate.(20) Separate hour and minutes by a colon.(10.2)
139. **Titles and names.** See *Names and titles*, above.
140. **Trade names.** Use capital letters.(8.20)
141. **Transposed elements.** Use commas, usually.(11.3)
142. **Uncertainty or doubt.** See *Doubt or uncertainty*, above.
143. **Unfinished statement or word.** Use a dash or ellipsis periods to indicate.(13.2, 16(4))
144. **Verb—object and verb.** (*a*) Use no comma or other mark of punctuation to separate a verb and its object.(11.5) (*b*) Occasionally, a comma may indicate the omission of a verb.(11.4)
145. **Vocative.** This is another term for "direct address." Use a comma, or commas, to separate.(11.3)
146. **Word division.** Use a hyphen.(15)
147. **Worried, perplexed?** If you don't know what mark of punctuation to use in a given situation and can't find the

answer in this glossary, then use no punctuation at all. Modern punctuation is "lighter" (more open) than that of fifty years ago and the trend toward less punctuation will probably continue. Also, punctuation is both organic and dynamic; more often than not, too little punctuation impedes communication less than does overpunctuation.

INDEX

Abbreviations, 23–35
 apostrophes with, 42
 capitalizing, 58
 periods after, 130
 standard, 129–130
Absolute phrases, commas and, 82
Accent marks, 36–40
Acronyms, 24, 32–35
 periods after, 130
Acute accents, 37
Additions, brackets and, 51
Addresses
 abbreviating, 24–25
 hyphens and, 112
Adjectives, proper, capitalizing, 56
Administrative bodies, capitalizing, 57
Adverbs, conjunctive, 147–149
Affixes, 103
Aircraft, italics (underlining) and, 114
Alliances, political, capitalizing, 61
Alphabetical letters, plural, 44
Ampersands (&), commas with, 86
Announcements, abbreviations on, 30
Apostrophes, 41–45
 contractions with, 24
 omission of letters and, 105
Appositives, commas enclosing, 82
Arabic numbers, Roman numerals versus, 121
Asterisks, 46
 omissions indicated by, 105

Bars (virgules), 47–48
Bible, books of, 70, 140

Blank spaces, 46, 107
Book titles. *See* Titles, literary.
Braces, 49
Brackets, 50–51
Business letters. *See* Correspondence.

Calendar divisions
 abbreviating, 25, 48
 capitalizing, 53
Canadian provinces, abbreviating, 27
Capitalization, 52–66
 of abbreviations, 24
 compound words, 92–93
 hyphens with, 93
 titles or names, 140
Carets, 67
Cases (legal), italics (underlining) and, 115
Cedillas, 37–38
Chemical symbols
 abbreviating, 31
 braces with, 49
 periods after, 130
Circumflex accents, 38
"Coined" verbs and participles, abbreviated, 42
College subjects, abbreviating, 31
Colons, 68–71
 capitalization following, 54
 introducing words or statements, 98
 quotation marks with, 141–142
 replacing dashes, 97
Commands. *See also* exclamation points.
 periods after, 129

ABOUT THE AUTHOR

HARRY SHAW is well known as an editor, writer, lecturer, and teacher. For a number of years he was director of the Workshops in Composition at New York University and teacher of classes in advanced writing at Columbia, at both of which institutions he has done graduate work. He has worked with large groups of writers in the Washington Square Writing Center at NYU and has been a lecturer in writers' conferences at Indiana University and the University of Utah and lecturer in, and director of, the Writers' Conference in the Rocky Mountains sponsored by the University of Colorado. In 1969, Mr. Shaw was awarded the honorary degree of Doctor of Letters by Davidson College, his alma mater.

He has been managing editor and editorial director of *Look*, editor at Harper and Brothers, senior editor and vice-president of E.P. Dutton and Co., editor-in-chief of Henry Holt & Co., and director of publications for Barnes & Noble, Inc.; and also an editor at W.W. Norton & Co., Inc. He has contributed widely to many popular and scholarly national magazines and is the author or co-author of a number of books in the fields of English composition and literature, among them *Spell It Right!* and *Errors in English and Ways to Correct Them*.